The Triumph of
of
Art Nouveau
Paris Exhibition 1900

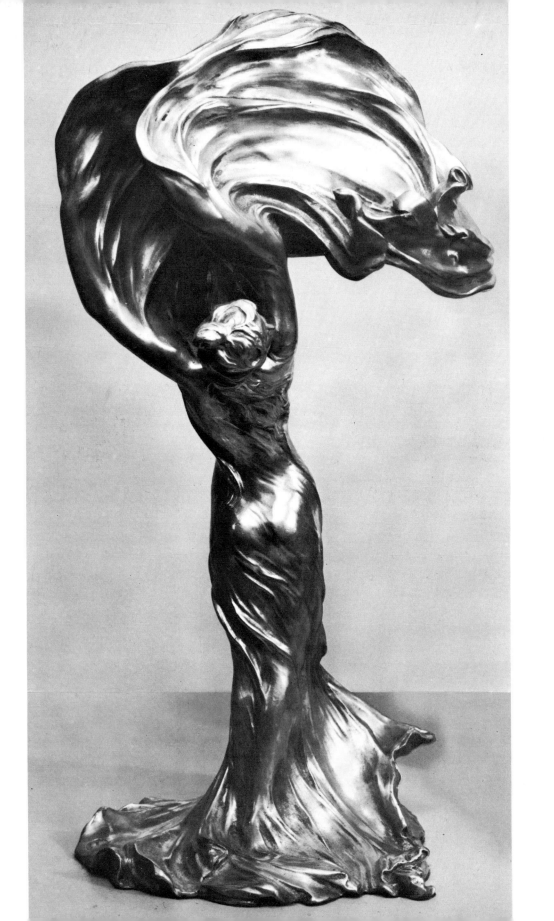

Philippe Jullian

The Triumph of
Art Nouveau
Paris Exhibition 1900

PHAIDON

1 (*frontispiece*) Gilt bronze statuette of Loïe Fuller by
François-Raoul Larche. Loïe Fuller and her butterfly
dance seemed to epitomise the spirit of the exhibition.

Translated by
Stephen Hardman

Phaidon Press Limited, 5 Cromwell Place, London SW7 2JL

First published 1974
© 1974 by Phaidon Press Limited
ISBN 0 7148 1606 X

Filmset and printed in Great Britain by
BAS Printers Limited, Wallop, Hampshire

CONTENTS

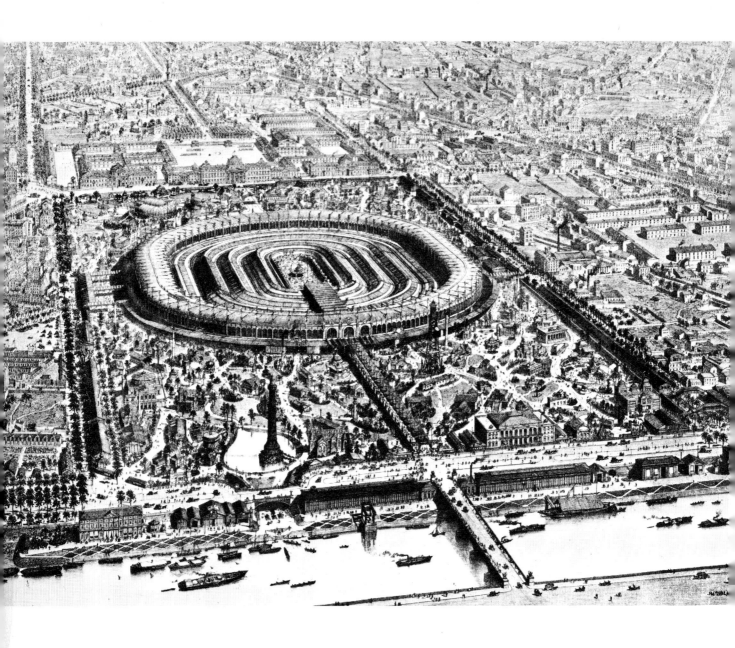

2 Bird's eye view of the Exposition Universelle held in Paris in 1867 on the Champ de Mars.

INTRODUCTION

INTERNATIONAL EXHIBITIONS

The nineteenth century has bequeathed us countless opera-houses, gasometers, railway stations, casinos, mile upon mile of fine avenues, and public gardens filled with statues; today the intentions underlying these constructions, and sometimes even their beauty, are beginning to gain recognition. But the cathedrals of the nineteenth century are mostly of mediocre quality, since the edifices erected for the cult of the great myth of that epoch, Progress, were essentially temporary in character. Approximately every ten years, at first in England and then chiefly in France, with a faith in this Progress similar to that of the medieval master-builders,

3 The Crystal Palace was sited near Prince's Gate, north of Kensington Road and south of the park drive called Rotten Row. The house in the foreground provided power to work the various steam-driven machines on display in the Great Exhibition of 1851.

the engineers constructed glass domes on cast-iron pillars and interminable galleries like hothouses to accommodate the flower of industry and to encourage commerce. In this time of optimism, nationalism and capitalism coexisted happily. By 1850 the idea of Europe as the mistress of the world, spreading universal bliss through commerce and education, had become a veritable dogma. The principles learnt from philosophers such as Bentham, Fourier and Saint-Simon endowed the Industrial Revolution with the necessary ideal. Economic development, it was thought, would lead to a sort of earthly paradise, and the crowds flocked under the huge rotundas of the exhibitions to admire the contributions made by science, labour, economics and exploration to the realization of this ideal.

Art played only a secondary role in these edifices, being used merely to disguise and embellish the products of industry; the presence of Gothic motifs on a copper boiler or of Rococo ornament on a sewing-machine was simply a concession to the Romantic era's taste for historicism. Beside the prodigious invention of the engineers who were the architects of the new cathedrals, painters and sculptors were of little consequence; their work, whether academic, anecdotal or exotic, was hardly more important than the coloured paper in which a piece of stock merchandise is wrapped. This attitude remained general until towards the end of the century and the Paris Exhibition of 1900, when Art, both the best and the worst, nearly always occupied first place. Then the machines themselves seemed to yield to the new style which, during the past ten years or so, had been supplanting historicism and camouflaging the functional.

If the Great Exhibition held in London in 1851, at the Crystal Palace in Hyde Park (3), marked the apotheosis of the industrial era, the exhibitions staged in Paris since the beginning of the century faithfully reflected the evolution of industry and of the decorative arts. These early exhibitions are worth mentioning, for each had its own special character and they proved increasingly successful. The first one was held at the Louvre in 1798, during the Directory, and in character bore a close resemblance to the recently-built Conservatoire des Arts et Métiers. Before 1855 there were eleven exhibitions, held either in the courtyard of the

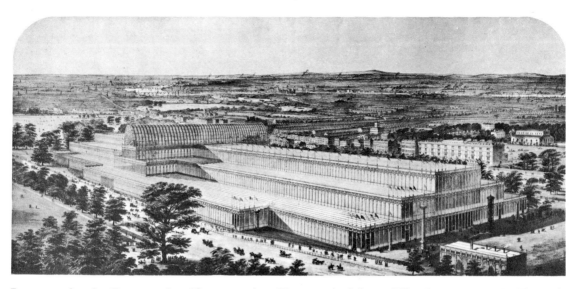

Louvre, in the Louvre itself, or on the Champ de Mars. The first, a purely French affair, lasted three days and attracted 110 exhibitors; the exhibition of 1823 lasted fifty days and drew 1,642 exhibitors, while that of 1849, held on the Champs-Élysées, lasted six months with 4,532 exhibitors and 3,738 prizes. Hitherto, other nations had not often been invited to participate, for fear that they might copy French products and take France's customers, as until the Revolution of 1848 the French economy was largely dependent on peasants and artisans. With the development of the railways and the advent of Napoleon III, everything changed. This sovereign, whose reputation still suffers from a generous but incoherent foreign policy and from an internal policy founded on a police force, was susceptible to all the enthusiasms of his century; as befitted a Bonaparte, he took as much interest in social problems and in scientific or historical discoveries as in the army. Only the fine arts held no appeal for him—in this respect he was overshadowed by the British Prince Consort, whose genuine interest in everything showed itself by his organization of the Great Exhibition in 1851.

The four international exhibitions held in Paris before that of 1900 (1855, 1867, 1878 and 1889) all more or less faithfully reflected the ideas which had dominated the organization of the Crystal Palace: the basis was an enormous basilica in which, arranged either by nationalities or by products, were amassed the latest achievements of a world that was moving with increasing speed. The other, backward parts of the world, already largely colonized, were represented by picturesque pavilions in which 'natives' indulged in innocent pastimes such as weaving, music and pastry-making, under the stares of onlookers, rather like animals in a zoo. These metal edifices also had annexes, machine galleries, palaces of fine arts and hothouses, not to mention the amusement parks which at first were of little importance (the early

exhibitions had mostly been serious affairs), but which became increasingly numerous and sensational. Places of pilgrimage have always attracted mountebanks. The word 'pilgrimage' is not used ironically. With the same fervour as the peasant going to Lourdes, hordes of respectable middle-class citizens, chemists, notaries, teachers and gendarmes, took the train to Paris to meditate in the temple of Progress where miracles abounded. Foreigners came to see if their country was rendering sufficient homage to the new God and, above all, to enjoy themselves in Paris—it was at this time that the capital acquired the name 'Ville Lumière', the 'City of Light'. Victor Hugo's introduction to the guidebook for the exhibition of 1867 admirably expresses the illusions cherished by Frenchmen every time a new exhibition drew visitors to Paris in their hundreds of thousands:

> O France, adieu! You are too great to be merely a country. People are becoming separated from their mother, and she is becoming a goddess. A little while more, and you will vanish in the transfiguration. You are so great that soon you will no longer be. You will cease to be France, you will be Humanity; you will cease to be a nation, you will be ubiquity. You are destined to dissolve into radiance and nothing at this hour is so majestic as the visible obliteration of your frontier. Resign yourself to your immensity. Goodbye, people! Hail, man! Submit to your inevitable and sublime aggrandizement, O my country, and, as Athens became Greece, as Rome became Christendom, you, France, become the world!

In the western part of the capital, the promenade between the Champs-Élysées and the Seine, the Esplanade des Invalides and the Champ de Mars provided sufficiently broad spaces for the construction of these temporary cities without obstructing traffic and without demolition being necessary. In this respect Paris enjoyed an immense advantage over capitals where exhibitions always had to be held in a suburb. In 1855, admittedly, the Champs-Élysées and the Cours la Reine were occupied by a very bad imitation of the Crystal Palace, which disfigured the Champs-Élysées until 1900, when it was demolished to make way for the Grand Palais and the Petit Palais. During these forty-five years the Salon and even the

Horse Show took place in this building, known as the Palais de l'Industrie. In spite of its size the Palais was not big enough and at the last minute a long machine gallery had to be built. There were 9,500 French exhibitors and 10,500 from abroad. Although France was at war with Russia, the organizers had courteously invited the Russian manufacturers. An exhibition of the greatest French painters of the nineteenth century provoked a fierce battle between the supporters of Ingres and Delacroix. When his two pictures had been rejected, Courbet erected near the Palais des Beaux-Arts his own Pavillon du Réalisme, from which was to emerge all the modern painting that eventually triumphed over official art some fifty years later. In the meantime, Berlioz had his *Symphonie Triomphale* and his cantata *L'Impériale* (also known as the *Symphonie Industrielle*) performed by an enormous number of musicians. The mystique of labour manifested itself for the first time at this exhibition, for the Emperor had decided that the workers should be encouraged to participate by the offer of competitions, prizes and tickets at reduced prices. Opened by the Empress Eugénie in the full bloom of her beauty, and visited by Queen Victoria, the exhibition of 1855 proclaimed the energy and the prosperity of the recently born Second Empire. With a similar zeal Baron Haussmann carved a new city from the old capital. The exhibition was both an international congress and a market.

The atmosphere was quite different in 1867, when a festive mood prevailed. Everything was more brilliant, as if to conceal the difficulties that heralded the end of the regime. A huge palace had been erected on the Champ de Mars (**2**), and a journalist of the time echoes the amazement of visitors:

This Palace measures 482 metres at its longest and 370 metres at its widest, covering 148,990·78 square metres in area, of which 63,640 square metres are occupied by France and 6·60 by the grand duchy of Luxembourg. There are fifteen entrances. Seven ellipsoidal galleries divide it into seven sections: the galleries of machines, raw materials, clothing, furniture, the liberal arts, the fine arts, and the gallery of the history of labour which borders on a central open-air

garden decorated with fountains and statues and groups of marble or bronze, in the middle of which stands the pavilion of coins, weights and measures. Under the canopy surrounding this garden run four large avenues crossing the seven galleries at right-angles and leading to the outer ring of the Palace. Between these four avenues run galleries which traverse the different countries represented at the Exhibition. Walking along the galleries, you can study the same art or the same industry as practised by the different nations; or, by following the avenues, you can study the same nation in its different arts and industries. If the taste of the Palace on the Champ de Mars leaves much to be desired, it must be admitted that it would be impossible to imagine a more convenient and practical arrangement. The entire world—Europe, Asia, Africa, America and Oceania, with their different human types, their animals, plants, minerals, natural produce, industry, sciences and fine arts—is contained within these forty hectares. A prodigious number of edifices of every shape, style and period spring up amid the trees; domes, steeples, blast-furnace chimneys, towers, lighthouses, cupolas and minarets stand out against the sky; great masses of green crowned by the resplendent glass canopies of the winter gardens; and in the centre of this confusion, the arch of an enormous ellipse.

The exhibition of 1867 represented the triumph of the *polytechniciens*; everything was classified and labelled and, as in 1855, an effort was made to put the working class on a footing with the employers. The workers' delegations had a strong influence on the development of trade-unionism. An important place was also given to education. The Red Cross had a pavilion. In one gallery the best contemporary European painters had been invited to exhibit their works; it was at this time that the French discovered the Pre-Raphaelites, but Manet, who had been rejected, was to erect his own pavilion and thus provoke a new battle against official art. There were forty thousand exhibitors. All the sovereigns of Europe came to Paris to pay homage to the Emperor, at the same time observing the signs of his weakness. People also came to enjoy themselves in the Paris of Offenbach which boasted more

than four hundred dance-halls, but the Parisians grumbled and complaining voices were to be heard at every exhibition, however successful: 'Here you can see Paris at the mercy of the barbarians, the cook-shop owners sharpening their kitchen knives to cut their customers' throats or at least to skin them, the obsequious head-waiters, the insolent cabmen, the eternally crowded omnibuses, with all the noise, sun and dust, a boisterous, teeming horde, their thirst never satisfied, as at a Flemish fair; coloured glass, Venetian festivities, fireworks, and at the same time a general weariness, disgust and bitter recriminations, with someone swearing solemnly that the Exhibition that has just ended will definitely be the last.'

Eleven years later (the interval prescribed by an international committee), another exhibition was held, but in an utterly different atmosphere. After the defeat of 1870 and the Commune, France wanted to show that she was still capable of attracting the whole world to Paris. The new exhibition took place on the Champ de Mars and on the hill of Chaillot, also called Trocadéro, on the other side of the Seine. An extremely unprepossessing brick palace was erected at the top of the hill; the central part was to be demolished and the wings camouflaged for the exhibition of 1937. The building recalled the Alhambra and the Romanesque cathedrals. In 1878 the exotic arts played a major role; the cult of Japanese art was established and from Paris spread over all Europe. The style of the buildings and of the exhibits remained distinctly Second Empire, but heavier; however, ceramic art assumed a great importance in the architecture, adding a little gaiety. There were sixteen million visitors and Marshal MacMahon, the President of the Republic, was able in his closing speech to congratulate himself on the revival of France. The absence of Germany was noted; on the other hand, the United States, which had entered the era of exhibitions at Philadelphia in 1876, enjoyed an outstanding success. France exhibited the head of the Statue of Liberty, by Bartholdi, before sending it to New York. People began to speak of a civilization based on electricity, with Edison as its hero. This was also a year of political tranquillity, the general mood being highly conservative.

The exhibition of 1889 marked the centenary of the French Revolution and

celebrated the success of the Republic, which induced the majority of European monarchies to stay away. It occupied the Champ de Mars and the Esplanade des Invalides. President Carnot performed the opening ceremony at the height of ministerial crises, anarchist crimes and financial disasters, and the enthusiasm which the exhibition aroused helped to dispel political anxieties during the summer months. Dominated by the 300 metres of the Eiffel Tower rather than by the triumph of the Republic, this exhibition represented the victory of science. The engineers supplanted the architects in nearly all the pavilions. The machine gallery was 145 metres high, 115 metres wide and 415 metres long. The iron was no longer disguised by mosaic or staff; the electric lighting dazzled the visitors and in the evenings, from the top of the new tower, projectors of all colours cast their beams over the pavilions. The conquest of this new world predicted by Jules Verne was achieved by means of the machine (weapons of war were being perfected at an alarming rate); soon the Nautilus diving-bells would be plunging into the sea and the flying machines taking to the sky. At a time of intensive colonial expansion, to console herself for the loss of Alsace and Lorraine, France covered the Esplanade des Invalides with multicoloured pavilions. The rebuilt Rue du Caire attracted a public eager for exotic experiences and the donkey-drivers did a roaring trade. In a corner of this 'Metropolis' a young glass-artist from Nancy, Émile Gallé, exhibited for the first time the entrancing glassware that captivated the Symbolist poets.

The world of the future represented by the iron of the Eiffel Tower seemed monstrous to refined tastes, but the exhibition was a tremendous success—nearly 400,000 visitors on the final day, which gave the organizers some consolation for the absence of the foreign heads of state and of a large representation of European industries. From the aesthetic point of view, a new art was finally taking shape with the exhibits of Whistler and Goodwin. Among foreign painters Burne-Jones won high praise for his *King Cophetua and the Beggar Maid*. Watts and Alma-Tadema were both greatly admired. Although the Impressionists were still ignored by the official adjudicators, the Naturalists won critical acclaim. (It was at this time that Zola published his story about a locomotive, *La Bête Humaine*.) The workers

played a much more prominent role here than at previous exhibitions; they were creating the city of the future and, under the influence of socialism, labour was beginning to be regarded as something sacred. The workers in their overalls were invited to the festivities, haranguing the President of the Republic and dining with M. Eiffel and his engineers on the day a flag was placed at the top of the tower. Since it was built to celebrate the fall of the Bastille, it was fitting that this exhibition should be an openly democratic occasion.

During the last three decades of the century, exhibitions which claimed to be 'universal', and which were so in varying degrees, took place with increasing frequency. There were many highly successful ones in Belgium (it was in this country, which has retained an essentially nineteenth-century ideology, that Europe's most recent international exhibition was held, in 1958). There was also a great exhibition at Vienna in 1873. The United States had a number of large exhibitions or World Fairs: that held in Chicago in 1893 revealed a whole new school of architecture where the buildings of Sullivan were much more advanced than any to be seen in Paris in 1900; there had been one at Philadelphia in 1876 when an iron balustrade with a sunflower motif that came from Norwich, England, looked ahead to the Art Nouveau style; and San Francisco's exhibition of 1894 was held to celebrate the city's revival after the earthquake. Even Spain wanted to appear up-to-date; the Barcelona exhibition was certainly interesting, but that in Madrid in 1894 seemed a distinctly modest affair. Such unlikely places as Crete and Guatemala also had their little exhibitions. In France, in 1894, Lyons had a highly successful exhibition-fair.

The dominant features of the four great Parisian exhibitions of the nineteenth century are to be found again in that held in 1900, and yet this one was in many ways different, not only in its sheer size, but in the impression which it made on people's imaginations and on the art of the time. In the exhibition of 1900 the optimism of the Second Empire was rediscovered, an optimism revived by great prosperity. In that year Paris was almost as amusing a city as in the time of Offenbach; the spirit of revenge predominant in 1878 had become the pride of a powerful

15

nation. The process of democratization was even more marked: there were frescoes and statues representing the workers (**4, 6**); in this cathedral which they had built they were honoured at last, in accordance with the spirit of Tolstoy and Ruskin. The organizers had wanted to gather together all the achievements of the nine-teenth century. Above all, this exhibition marked the triumph of thirty years of Republican France. The mechanical Utopia of 1889 remained, but curiously trans-formed into a kind of fairyland magic. The word 'magic' (*féerie*) comes quite naturally to the normally prosaic pen of Charles Simond, a writer of the time, who gives this eye-witness account in his *Paris sous la IIIème République*:

> The public was expecting a fair with sensational shows and it was offered a sort of dream-city, serious in conception and possessing an attraction not immediately apparent, a shimmering city of décor in which all the sections of every nation, inspired by the example they had been given, tried to outdo each other in the imaginative richness of their luxurious displays. . . . And in the galleries, the pavilions and the palaces, the machines in operation and the products of ancient and modern manufacture, laid out side by side, completed this impression of quiet industry, a serenity of mind which seemed to have brought all the nations together in a common effort expressing their aspiration towards an ideal of noble happiness and peace. . . . If the organizers had succeeded in spreading the magic of life over its vast surface, this was because a new force, electricity, had given them the assistance of a mysterious power.

This book will be rather like a walk round a Tower of Babel lit by electricity. All the great myths of the closing nineteenth century found expression in the different sections of the Paris exhibition: history in 'Old Paris' and in the Petit Palais; science in the Champ de Mars; exoticism, or more precisely colonization, at the Trocadéro; academic art at the Grand Palais, Art Nouveau on the Esplanade des Invalides, and gaiety along the Seine. In moving from one section to another, the author has chosen various guides: official guides, sometimes pompous and always full of statistics; enlightened guides such as the critic André Hallays; and naïve

guides such as Hachette's *Almanach*. But the eye-witness whose steps have been most readily followed is the most brilliant chronicler of the Paris of 1900, Jean Lorrain (**121**). His style has the ornaments and convolutions of the rings of Lalique which he wore on his fingers. A frequent visitor, equally capable of enthusiasm and contempt, and never missing a detail, Lorrain has left the most vivid picture of this exhibition which he called 'the great bazaar'. His descriptions console us for the fact that neither Proust, Gide nor Claudel found the exhibition worthy of their interest. It should also be remembered that this 'Babel-on-Seine' gave Oscar Wilde his last joys. At the risk of making this book something of a mosaic, articles and reports of the time have always been preferred to descriptions based on photographs. In this way, it is hoped, the Paris exhibition of 1900 will be viewed with the illusions of those who watched it being built and not with the scorn shown by Paul Morand forty years ago; and it will be seen how this ephemeral city may be considered an important stage in the history of art, for it was the capital of Art Nouveau, a movement of which it marked both the apotheosis and the decline.

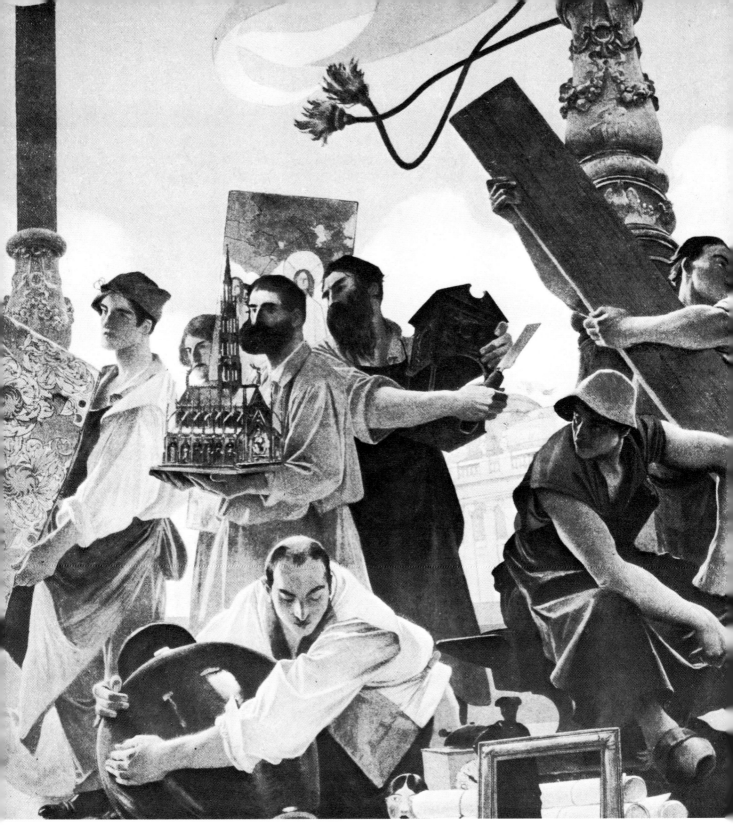

4 François Flameng: Fresco in the Salle des Fêtes.

1

Tower of Babel

DECISIONS AND DISCUSSIONS Since the defeat of 1870 France had been seeking every opportunity to increase her prestige by enterprises which often ran counter to her historic vocation or her habits. The colonial empire assembled during the last twenty-five years of the century was the most dazzling of these enterprises, a succession of victories which had however failed to erase the memory of Sedan. Many new buildings were needed to replace those destroyed by the Commune, and abundant opportunities for public festivities were required to celebrate the prosperity of the country and to conceal the defects of the regime. An international exhibition, epitomizing both

the greatness of France and all the glorious achievements of the closing nineteenth century, thus seemed essential to the Republic. After all, were not such exhibitions held every eleven years? If the most recent, in 1889, had proved a great success in spite of meagre participation by foreign nations, the exhibition of 1900 would be truly 'universal' and make Paris, at least for a few months, the capital of the world, as Victor Hugo had wished in 1867.

Great Britain was too sure of itself to think that it had anything to gain by such an undertaking; in any case, it organized its own imperial exhibitions in London from time to time. But Germany, led by an Emperor who had a genius for public relations (and a talent for startling gaffes), wanted the apotheosis of the nineteenth century to take place in its own capital, the capital of the most powerful country in Europe. The French anticipated Germany's decision by inviting the whole world to Paris for the spring of 1900, in a decree of July 1892 which Republican eloquence imbued with proud accents: 'This will be the end of a century of prodigious scientific and economic effort. It will also be the threshold of an era whose grandeur is prophesied by scholars and philosophers and whose actual achievements will doubtless surpass our wildest dreams.' For once this was no empty rhetoric; the nations of the world replied promptly to the invitation and all those who worked to prepare the exhibition did so with genuine enthusiasm. The response to her invitation and the generous subsidies granted by the majority of countries for their pavilions reassured France, who had felt politically isolated in spite of the Franco-Russian alliance. The Triple Alliance had united Germany, Austria and Italy; relations with Britain had been tense since the encounter at Fashoda between Marchand's expedition and Kitchener's troops, resulting in a humiliating retreat for which France was to avenge herself by insulting the aged Queen Victoria at the time of the Boer War.

Under the chairmanship of M. Émile Picard, a number of high-ranking civil servants organized the various committees for the exhibition. If the world of French politics was composed largely of dubious speculators and short-sighted careerists, the administrative personnel of the Third Republic was, in contrast, the very essence of intelligence and integrity, comprising men moulded in the school of great

economists such as Frédéric Le Play and Jean-Baptiste Say. The products of one or other of the great colleges, the École Polytechnique, École Centrale or École des Sciences Politiques, hard-working and patriotic, these men of the upper bourgeoisie had really only one failing: an almost total lack of artistic sensitivity. But, since they possessed a certain sense of grandeur and a taste for novelty, though the edifices they built were often pretentious, they did not obstruct the emergence of a new art. None of them had the breadth of vision of Haussmann or of his colleague Alphand, but then, under the Republic, pomp and splendour were less favoured than under the Empire.

The estimated expenditure was one hundred million francs, triple what had been spent in 1889. The State would provide twenty million; the City of Paris would give another twenty million and in return acquire the Petit Palais; finally, a company was authorized to issue sixty-five million lottery bonds which also included tickets for the exhibition. From the outset the bonds fared badly on the Bourse and the expenditure proved much higher than anticipated. The Chamber of Deputies voted the estimates without too much fuss, seeing the exhibition as a peaceful conquest of the world. The opposition came from the Right. Maurice Barrès declared that the money would have been better spent on making cannons and torpedo-boats. 'In the end this mighty fair will be merely a hotbed of curruption', respectable people repeated after him.

It must be admitted that during the past ten years the Third Republic had advanced so far in corruption that many thought it would not survive much longer. In 1892 the Panama scandal had discredited the Chamber of Deputies, revealing the power wielded over governments by the world of business. Two years later, the Dreyfus affair had discredited the army and the judiciary, dividing Frenchmen against each other and leaving Europe aghast. The bourgeoisie was becoming alarmed at the progress of socialism, panicking at the crimes of the anarchists and fearful for the safety of religion, which was being threatened by the Freemasons. The Left, also distinctly middle-class in origin, lived in fear of the Jesuits. This divided nation, which was being held together only by patriotism and hard work, experienced

so many ministerial crises that it might well have grown weary of politics if a few remarkable men, like Barrès on one side and Jaurès on the other, had not constantly bolstered its hopes and supported its demands.

In 1896 it was thought that the moderation of the Méline government would allay anxiety after the successive falls of the Bourgeois and Ribot ministries and the resignation of Casimir Perrier, President of the Republic; but the Dreyfus affair poisoned everything and first the Méline government, then the Brisson government, collapsed. The death of the President, Félix Faure, in scandalous circumstances in February 1899 almost led to a dictatorship of the Right. Along the route of the funeral procession the chauvinist poet Déroulède tried to persuade the troops to march to the Élysée. Although the troops refused to follow the League of Patriots, the latter felt that it had gained a dazzling revenge when, at the racecourse, one of its members struck President Loubet, who had succeeded Félix Faure, with his stick. Shortly afterwards, on 11 June 1899, the anarchists were pillaging the Pavillon d'Armenonville, an elegant restaurant, and Waldeck Rousseau, a cold and clever man, was forming a new government. His first duty was to quell by peaceful means a group of the extreme Right which was resisting the police in a building nicknamed 'Fort Chabrol'. When, in November of the same year, President Loubet inaugurated Dalou's fine monument to the Republic on the Place de la Nation, red flags were waved (for the first time since the Commune) and the black flags of the anarchist movement were also to be seen.

The President, a small man with a white goatee who came from the south of France, was no more impressed by the flags than by the assault with the stick. Thanks to him and to Waldeck Rousseau, France was regaining her confidence. Dreyfus was pardoned. Unfortunately, in January 1900 the absurd campaign waged by the Freemasons against the religious communities rekindled smouldering hatreds. Thus, the exhibition was staged in a deplorable political climate. Business, on the other hand, was thriving and France was returning to the prosperity she had enjoyed under the Second Empire. The success of the exhibition, despite all those elements which desired its failure, was such that it was made to appear the

crowning achievement of a model government when, in fact, it was the work of high-ranking civil servants. A newspaper which devoted an article to the exhibition's chairman, M. Picard, shortly before the opening day, gives an accurate impression of the ups and downs of this skilfully organized enterprise:

At first people get excited and chauvinism erupts. The newspapers poke fun at Germany and gloat over its disappointment. In ringing sentences they proclaim the peaceful victory we have gained: 'We shall prove to Europe', they exclaim, 'that our country is marching in the vanguard of progress.' Soon this fine fire is extinguished. Another fire is lit. These same projects which were wildly acclaimed are now attacked indiscriminately. Leagues are being formed and campaigns planned. The provinces are rebelling against Paris. You know the argument: 'The national activity is rushing to the nation's head and its limbs are withering. While the capital enriches itself, the departments are being ruined and depopulated.' . . . 'Stop shouting', replies M. Picard. 'You shall have the best part of the money that will be spent in Paris. Where, I ask you, will the poultry, the cutlets, the wine, the milk, the fruit and the cheese which will be consumed there come from? The gold of visitors from all over the world will swell the woollen stocking of Jacques Bonhomme. . . .' The assault, repulsed on this point, redoubles in fury and tries to open another breach. The detractors of the Exhibition brandish the spectre of competition. . . . M. Picard, unmoved, summons figures to his aid: 'In 1888 French exports were 3,200 millions; in 1890 they exceeded 3,700 millions, and 3,500 millions in 1891.' . . . Surely the Parisians, for whose advantage he is carrying on this struggle, will show him some gratitude? Not at all. They simply grumble, blaming him for the cluttered streets, the waggon-loads of stones that furrow them, the Métropolitain which is stripping them of their paving. . . . Finally, they keep in reserve one supreme objection, the most terrible of all: 'After every exhibition, food is more expensive . . .'— 'That is true', says M. Picard, 'a kilo of beef cost 2 Fr. 58 in 1888 and 2 Fr. 63 in 1890.' Already they are gloating. 'But', he adds, 'veal fell from 2 Fr. 27 to 2 Fr.

5　The organizers received some very fanciful suggestions for the decoration of the 'Exhibition of the Century'. The most curious were those which proposed to camouflage the Eiffel Tower with a statue or a terrestrial globe. Some, such as number 2, were far in advance of their time.

26.' The veal silences them. All they can do now is to condemn the immorality of international exhibitions. This is the only subject which M. Picard refuses to discuss. . . . He merely smiles . . .

PROJECTS FANCIFUL AND SERIOUS

As soon as the 'Exhibition of the Century' was announced, a profusion of engineers, artists and inventors erupted into activity. The theoreticians of architecture saw it as an opportunity to impose their own ideas and submitted the most extraordinary plans (**5**). The century that had begun with the Utopias of Boullée and the imaginary cities of Ledoux was ending in fantasies borrowed from Jules Verne (the industrial style of the 1889 exhibition) and also from a draughtsman of great verve, Robida, whose album *En l'An 2000*, which had appeared in 1890, had contained some astonishing predictions—an enormous palace with long vistas of iron pillars in the style of the Crystal Palace, but also some prophetic inventions such as the framework of aluminium covering the whole of the Champ de Mars. The lightness of this recently discovered metal made possible all manner of bold designs. Most of these fantastic structures suggest the inventions of a Piranesi turned mechanical engineer, while others resemble the sets which Cecil B. de Mille was to construct for the film *Metropolis*. There were many who wanted to camouflage the Eiffel Tower, with a palace whose domes would rise to the level of the second platform, or by transforming it into a gigantic clock, or by crowning it with a terrestrial globe surmounted by a sphinx, or (the strangest suggestion of all) by hiding the upper half of the tower with a statue of a woman in the style of Flaubert's *Salammbô*, 150 metres high, with electric projectors shining through the eyes, while the base would be disguised by a waterfall higher than the Niagara Falls. One engineer suggested linking the tower with the Trocadéro by means of a huge iron bridge. Another, to avoid spoiling Paris, suggested an underground exhibition 2,000 metres deep, which would also avoid heating costs. There was a plan for a merry-go-round 1,200 metres in circumference, and the idea was briefly considered of

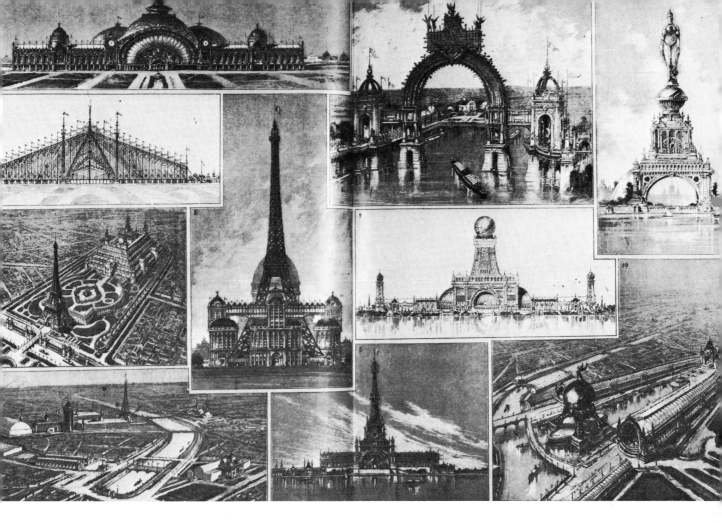

erecting a French Valhalla on the terrace of Saint-Germain with a hundred colossal statues of great Frenchmen. When one actually sees these designs, one realizes that they were all simply revivals of the ancient myths of the Tower of Babel.

The only projects to receive serious consideration were those submitted by the architects of the École des Beaux-Arts, usually collaborating in twos or threes. This institution dominated the exhibition, but, since it was a matter of temporary buildings—simply festival pavilions, in fact—its architects were able to display an imaginative verve lacking in their more permanent constructions. United by the bonds of freemasonry in a career whose crowning glory was election to the Institute, the architects of the École des Beaux-Arts, like their painter and sculptor colleagues, had been schooled in the arts of Rome. Their ideal remained either the ornate classicism of which the best example was Garnier's Opéra built thirty years earlier, or, for the more advanced among them, the designs of Viollet-le-Duc, who had been the first to understand the possibilities of iron and had given a new variety to the repertoire of architectural decoration.

6 Frieze of workmen. This high relief decorating Binet's triumphal gateway could be an illustration of a novel by Zola and of the Gospel of Work, which played such an important part in the aesthetic conception of the exhibition and is also reflected in **4** and **11**.

And so, perfectly at ease in the framework provided by their architect friends, the painters from the studios of Gérôme and Bouguereau gaily set about sketching their enormous allegorical frescoes. The sculptors also adopted allegorical subjects in making the rough plaster models for the groups that were to be cast in bronze, carved in marble, or simply moulded in staff. Here again, the temporary nature of the enterprise gave a much freer rein to imagination. However, despite the bonds of freemasonry and the École des Beaux-Arts, there were a number of clashes. The architects complained of having to listen to the suggestions of numerous different committees and of having to work with painters and decorators whose tastes did not coincide with their own (they were much more receptive to Art Nouveau, as they were in favour of stylization and colourful architecture). They also grumbled at the lack of money and time. In fact, they had barely two years in which to design and build their edifices.

THE GOSPEL OF WORK

Most of the artists who received commissions for the decoration of the exhibition had to glorify the workers, for the movement initiated by Napoleon III had become an act of faith: the workers were to take part in the Great Festival of Progress which their energies had made possible. The first painting celebrating Work was probably that of the Pre-Raphaelite, Ford Madox Brown, dating from the 1850s. Since then the theories of William Morris and Ruskin, the novels of Tolstoy and the articles of a now-forgotten writer, Jean Lahor, on art and socialism had given Work a sacred aura—as had the novels of Zola, who dominated the last quarter of the century with *Germinal, La Bête Humaine* and *La Terre*. In every part of the exhibition were to be found representations of workmen, some in a realistic style as in the high reliefs of Guillot (**6**), a sort of Panathenaea of the proletariat framing the monumental gateway, and statues symbolizing the various trade corporations, such as the carter and the omnibus driver, against the striped background of the Palais du Génie Civil. In the Belgian pavilion the greatest admiration was reserved for

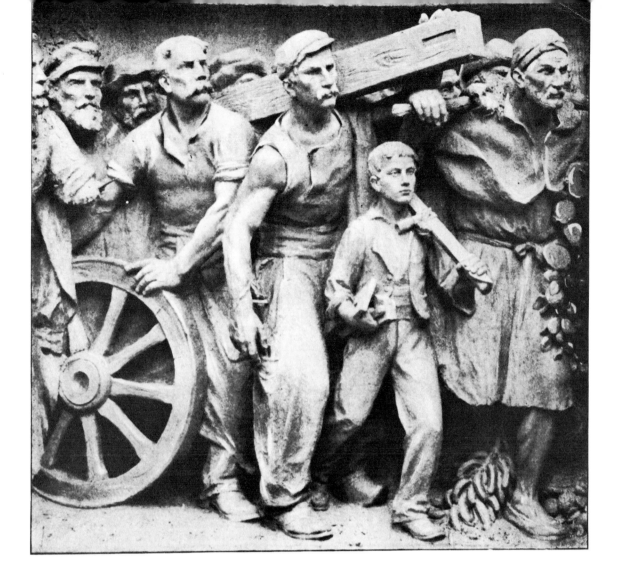

Constantin Meunier's bronze figures of workmen, stylized rather than idealized. Max Nordau wrote at the time: 'The workman is today what the noble savage was in the eighteenth century.'

The painters also glorified the workman, as in the great Salle des Fêtes (**4**) so exactly described by *Le Figaro Illustré*:

> As for the industries of decorative art, which are so numerous, it was not possible, owing to lack of space, to represent them in such a precisely detailed fashion. Flameng has characterized them solely by their products, but he has presented them in a very skilful manner. In front of the superintendent of the Exhibition, M. Picard, whose slender outline adorns the foreground, and in front of the collaborators of the great Manitou of the World's Fair, the architects Bouvard and Raulin, accompanied by the medallist Chaplain who has been offi-

7 *Horticulture* by Albert Maignan. A reassuring image of the world of manual labour and a symbol of the fertility of the land of France. It decorated the Salle des Fêtes.

cially commissioned to commemorate their work, passes a whole procession of workmen from the various corporations. Kneaders of clay and metal pattern-makers, potters, goldsmiths, art metal-workers, cabinet-makers, picture-framers, gilders and masons, all appear in turn and, under the gaze of the official organizer, display their glazed vases, wallpapers, carved wood, reliquaries, bronzes, and so on. The composition is completed, to the right, by a factory interior where, in glass alembics joined by large angled tubes, simmer the poisons which modern chemistry manufactures, which all sorts of industries utilize and which medicine, by dividing them into small doses, uses to cure us. In all this there is not a hint of the past, not even a modest use of those outmoded, banal formulas which art has employed for too long. Neither pretentious allegories nor symbols, but observation, truth and life.

Another artist, Cormon, painted a canvas representing Civil Engineering:

The oblique course of the river, crossed by a metal bridge, and its waters furrowed by barges and smart passenger-steamers, suggest a whole series of works which engineers normally carry out. In the foreground, strongly-built workmen load coal on to the waggons of a little train whose engine smokes and spits as it gets under steam. Close by, sturdy stevedores combine their efforts to slide an enormous mass of hewn stone along wood rollers.

More cheerful were Albert Maignan's pictures representing Fishing and Horti-culture (**7**), and more poetic the painting of the Fine Arts by Rochegrosse, and they were therefore less admired. Magazines such as *L'Illustration* and *Le Figaro Illustré*, or the more popular *Petit Journal*, kindled the enthusiasm of the public with illustrations of the construction-sites of the exhibition. Workmen with the broad red sash across their bodies, corded trousers and striped vests were shown standing at the edge of metal girders, the vast areas of the building-sites below them, welding the iron bars, hoisting up the rearing horses of a chariot, and gilding an enormous star. Others, looking like miners, were seen digging tunnels and sinking

piles into the Seine to support the palaces. Though less exotic, these pictures foreshadow the great compositions that Sir Frank Brangwyn was soon to paint in England and in America. An extraordinary example of this type of composition is still to be seen in Paris—the restaurant of the Gare de Lyon.

The construction-sites were huge, extending over 1,500 acres in all. They lay along both banks of the Seine, from the Place de la Concorde to the Trocadéro, covering the Esplanade des Invalides, the Champ de Mars and the gardens of the Trocadéro; the side-shows overflowed beyond the Champ de Mars. It had been necessary to demolish only one large building, the very ugly Palais de l'Industrie erected in 1855. The Trocadéro, a memento of 1878, was preserved, as were the vast Machine Gallery of 1889 and, of course, the Eiffel Tower. The earthworks began early in 1896, but the ceremony marking the commencement of the main construction work, the laying of the first stone of the Pont Alexandre, was performed on 6 October of that same year, by the Emperor of Russia and President Félix Faure. Cantatas, poems by José Maria de Heredia recited by a member of the Comédie Française and speeches celebrating the Franco-Russian alliance followed one after another, creating a mood of magnificent boredom which was certainly not enlivened by the inscrutable countenance of the Empress, dressed in white lace. To commemorate this ceremony a large canvas was commissioned from Alfred-

Philippe Roll, the painter of Republican pomp, a picture that was to be one of the most admired four years later in the Grand Palais (**8**).

The Grand Palais and its counterpart, the Petit Palais, smaller and more elegant in design, were built quite quickly on each side of the avenue that was to lead from the Champs-Élysées across the new bridge to the Invalides. As they were to be built to last, in ashlar masonry, they were started before the more temporary structures. Today it is beginning to be appreciated that, in spite of their rather banal and sometimes grandiose architecture, encumbered by decoration which is largely in poor taste, these two palaces and the Pont Alexandre form one of the most beautiful vistas in Paris, possessing a truly Baroque breadth.

In a Paris shaken by the Dreyfus affair and the death of the President of the Republic, and troubled by fears of a dictatorship or of religious persecution, the various projects for the exhibition provided abundant opportunities to attack the government. In 1898 the building work slowed down considerably:

> The navvies employed on the construction work for the Exhibition had gone on strike, taking with them the other workers of the building industry. For more than a week the districts on the left bank nearest to the Champ de Mars and the Esplanade des Invalides looked like a city that has just been occupied by a victorious army. The pavements were lined with piles of rifles; detachments of infantry were guarding the building-sites to protect the workmen from the attacks of the strikers.

The following year the same reporter was able to write:

> It is a miracle how, in an atmosphere so pervaded with riots, a place where people can work exists in Paris. But it seems that the long wooden wall serving as an enclosure for the future Exhibition is smothering the noise of our domestic troubles. From the Avenue d'Antin to the Trocadéro and from the Invalides to the Champ de Mars, a cosmopolitan multitude of architects, engineers and workmen is in a frantic turmoil, creating along the banks of the Seine the symbol

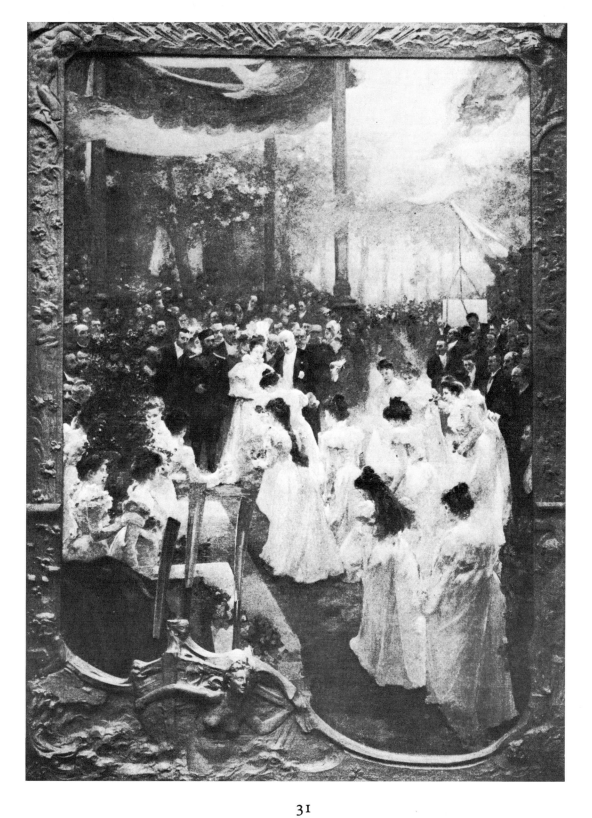

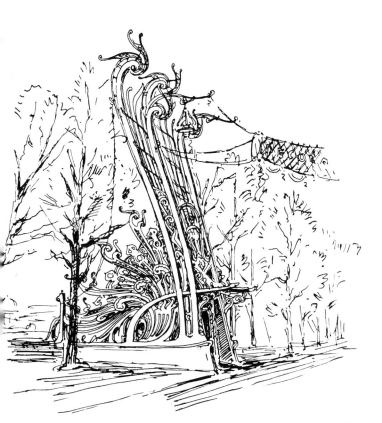

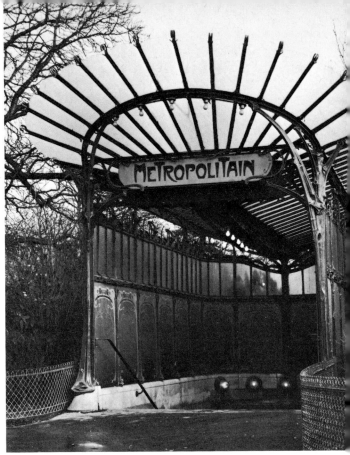

of universal brotherhood—an ephemeral symbol, alas, like the palaces of staff which they are erecting. Here and there a question of detail leads to petty disputes. For a time the Porte Binet, which must surely bring a jarring note to the majestic panorama of the Place de la Concorde, is threatened; the pylons of the Pont Alexandre III, which will obstruct the view of the palace of Mansart, are the subject of a parliamentary inquiry; the disfigurement of the Esplanade by the erection of the Gare de l'Ouest is arousing much protest among the lovers of Parisian trees; but the Exhibition's supervisory committee is allowing all the discussion to exhaust itself in a vacuum and is continuing its work.

One of the main problems confronting the organizers was transport. The real centre of Paris at this time was some distance from the Place de la Concorde; only horse-drawn omnibuses served the Champ de Mars and the Trocadéro. How were the tens of thousands of visitors expected daily to be transported to the entrance-gates situated much farther away than the Porte Binet, which was being built on the Place de la Concorde and therefore at quite a distance from the centre of the exhibition? Work was speeded up on the Métropolitain, the Paris underground (the Porte-Maillot–Bastille line), whose iron entrances, designed by Guimard, still bear witness to the art that flourished at the exhibition (10).

9, 10 Gateway on the Quai d'Orsay by the architect Collin (*far left*). The wrought-iron gates have unfortunately been destroyed. This was one of the most typically Art Nouveau structures at the exhibition and was a more extravagant version of the gateways which Guimard designed for the Métro (*left*). The Métro was inaugurated at the time of the exhibition.

The Gare d'Orsay was built on the ruins of the Cours des Comptes, which had been destroyed during the Commune. There were plans for trams running on aerial cables, as in Chicago; enormous omnibuses, the 'Paulines', drawn by four horses and holding thirty passengers accommodated under striped awnings, carried batches of tourists to the exhibition after having taken them on a tour of the chief monuments of Paris. But there was much grumbling about the inadequacy of public transport, especially when the doors were closed: the unlucky ones would then have to queue for at least an hour before finding room on a bus.

THE INAUGURATION

Of course, pessimistic rumours gathered momentum as the opening-day approached. A few days before the inauguration Jean Lorrain wrote an article entitled 'Plâtras et Patatras' (Rubble and Din). Lorrain was a nationalist and began by deriding the exhibition: 'Nothing will be ready; France has invited the whole world to a festival and will be able to offer only a muddy building-site.' Above all, however, he was an artist, and soon changed his mind. Other journalists protested because workmen had been brought from the colonies, Indo-Chinese, Madagascans and Senegalese, shivering with cold as they built their countries' pavilions. Russia had also sent a large number of labourers whom the Tolstoyans were eager to meet (they must have been bored). Persons of good taste were appalled when M. Bouvard, who had succeeded Alphand as supervisor of the gardens of the exhibition, had the dreadful idea of fixing paper camellias to the trees, half-stripped by the autumn, for the laying of the foundation-stone of the Pont Alexandre. It was the general opinion that if the year 1900 was to be remembered, it would be for having witnessed the première of *L'Aiglon*, written by the young national poet Edmond Rostand and with the fifty-five-year-old Sarah Bernhardt sublime in the role of Napoleon's son.

At last the day of the inauguration arrived, 14 April:

C

In the Avenue de la Motte-Picquet the omnibuses and trams are forced to stop to let the long lines of carriages pass; inside them can be seen uniforms, dazzling white shirt-fronts, the red robes of magistrates, the green tails of Academicians and the gowns of the faculties. And when these various officials alight, the bizarre spectacle in the entrance-hall is really picturesque. The scene is enhanced by the presence of the foreign commissioners and officers, studded with decorations and wearing gold braid, some in silver helmets, others in caps of astrakhan or scarlet fez. We come into the great hall. The decoration is sober, but the general appearance of the hall gives an impression of grandeur. The pylons and the balustrades of the galleries are adorned with flags held by scrolls bearing the initials R.F. The presidential dais, built against the entrance gateway, stands out against a background of red drapes on which the flags of the gallery form a tricolour crown. . . . The President of the Republic, dressed in black with the ribbon of the Legion of Honour on his chest, is received by M. Millerand, minister of commerce, surrounded by M. Fallières, president of the Senate, M. Paul Deschanel, president of the Chamber, M. Picard, superintendent of the Exhibition, etc., etc. . . . Immediately the orchestra of the Conservatoire, conducted by M. Taffanel, launches into the opening bars of the Marseillaise; then, when the applause has died down, M. Millerand rises and, amid general silence, delivers a speech which is greeted with long applause. M. Loubet speaks in his turn. A warm reception is given to his speech, after which no more are made. The orchestra and the choirs play and sing the *Hymn to Victor Hugo* by Saint-Saëns and the *Heroic March* by Théodore Dubois. The President rises, followed by his numerous retinue. He goes along the central aisle through the hemicycle and climbs the staircase lined by the double formation of Paris Guards and leading to the reception-room on the first floor, where there takes place the presentation of the foreign commissioners and the chairmen of the bureaux of the Exhibition's principal groups. At this moment the ceremony proper was completed. But since, to return to the Élysée via the Pont Alexandre III, the official procession had to pass through some part of the city, protocol had

prescribed a route which it followed with scrupulous punctuality. The procession crossed the Champ de Mars and, to the strains of the Marseillaise, passed in front of the Palais de l'Électricité, the Château d'Eau (unfortunately still dry), the Palais des Fils et Tissus, the Palais des Lettres, Sciences et Arts, etc. At the fourth Marseillaise, it passed below the Eiffel Tower; at the fifth, it crossed the Pont d'Iéna. The sixth Marseillaise was just beginning to ring out when the procession started to break up, at the landing-stage on the Seine.

Public opinion was not duped by official optimism. Everything went badly at the exhibition:

The architect had to drive the labourers frenziedly, overworking them until they were dizzy, in order to have the Salle des Fêtes ready, though it was still dripping with damp plaster and the decoration was unfinished. In the speeches made there the President of the Republic appealed to human solidarity and the minister of commerce, in a sort of final invocation, extolled the glory of human labour. All these fine words cannot conceal the futile frenzy of this activity. Outside, the Esplanade des Invalides and, in particular, the Champ de Mars are still cluttered with scaffolding; inside, most of the sections offer only the emptiness of their great halls. In the haste to complete everything, accidents are frequent; a foot-bridge has collapsed and fire caused by short-circuits has damaged the electric cables. Evening visits are spoilt by the lack of lighting. Warned of the unfinished state of the building-work and of the fittings, people in the provinces and foreigners are delaying their arrival. Everything is conspiring against the success of this Exhibition which, crammed with objects ancient and modern on two floors and with expensive entertainments between which curiosity hesitates, seems too vast, out of proportion with what people's legs can stand and their purses spend. The classification, very intelligently conceived but difficult to arrange in reasonable groups over too scattered an area, is extremely fatiguing for anyone wishing to follow it. It really seems that the predictions of ultimate failure are going to be fulfilled. The distribution of handfuls of prizes and medals deceives no one.

11 Lithograph illustrating the excellent German publication on the exhibition by the socialist
artist Steinlen.

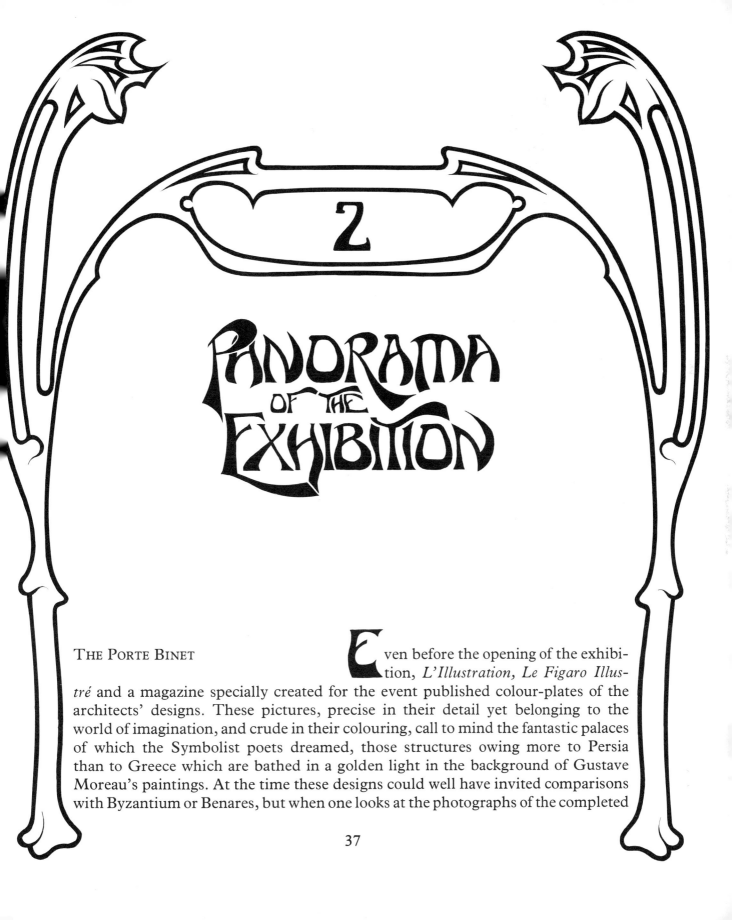

2

PANORAMA OF THE EXHIBITION

THE PORTE BINET

Even before the opening of the exhibition, *L'Illustration, Le Figaro Illustré* and a magazine specially created for the event published colour-plates of the architects' designs. These pictures, precise in their detail yet belonging to the world of imagination, and crude in their colouring, call to mind the fantastic palaces of which the Symbolist poets dreamed, those structures owing more to Persia than to Greece which are bathed in a golden light in the background of Gustave Moreau's paintings. At the time these designs could well have invited comparisons with Byzantium or Benares, but when one looks at the photographs of the completed

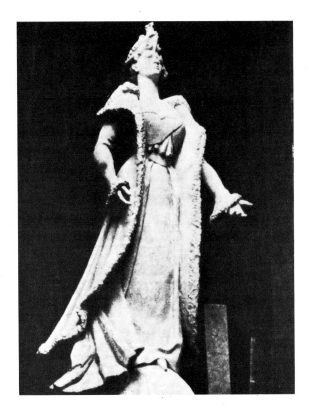

12, 13 The Porte Binet, monumental gateway on the Place de la Concorde. This gigantic edifice designed by the architect Binet was generally considered to be the ugliest of the entire exhibition, when in fact it was the most daring. Unfortunately the polychrome decoration and the statuary were not on the same level as the architecture. The plaster statue of *La Parisienne* by Moreau-Vauthier, some fifteen feet tall, dominated the whole. It was harshly criticized and regarded as the triumph of prostitution. The robe was the creation of the great couturier Paquin *(left)*.

buildings, one is reminded rather of the Casino at Monte Carlo. Of all these constructions in which the use of light materials gave a free rein to fantasy, none was more extraordinary and more discussed than the triumphal gateway erected by the architect Binet on the Place de la Concorde, at the end of the Cours la Reine (**13, I**).

The Porte Binet comprised a dome resting on three arches: a high entrance arch and two narrower arches under which were situated the fifty-six ticket-offices. The main arch was adorned with the prow of the ship which figures in the coat-of-arms of the city of Paris and, dominating the prow, the gigantic statue of the 'Parisienne' welcoming the world (**12**). 'On each side of the gateway the substructures abutted against two high minarets which terminated the hemicycle and served as beacons. Their slender pyramids were studded with crystal cabochons that sparkled in the rays of the sun in the daytime and at night blazed with an interior light' (*L'Exposition du Siècle*).

Nothing could be further from the colonnades of Gabriel; indeed, this was the most typically 1900 monument in the entire exhibition—in other words, the strangest, the most ornate and the most lacking in taste. It bore Byzantine motifs and ceramic ornamentation reminiscent of Persia. Everything seems to have been chiselled by a megalomaniac jeweller. Yet it was from Science that the architect

had sought his inspiration. 'For years it has been M. René Binet's passion to frequent the Museum, to bury himself in an enthusiastic study of both living and inorganic bodies; he has read the admirable *Philosophy of Palaeontology* by Gaudry; he has observed the laws of transformism and has noted how, with the lower beings, the natural kingdoms converge and intermingle; finally, and most important of all, he has met Haeckel (*Kunstformen der Natur*) and discovered what an unfathomable treasure of forms nature has given to art.'

Although one can recognize the vertebrae of the dinosaur in the porch, the cells of the beehive in the dome and the madrepores in the pinnacles, it is rather the erudite but unfettered imagination of Flaubert that this gateway calls to mind. It could almost have been built for the Temple of Baal or for the entrance of the Queen of Sheba. The statue of Electricity is a hieratic and barbarous Salammbô (**50**). As we visit the exhibition of 1900, this will not be the only example of the Salammbô style, which is to be found in decorations such as those of Alfons Mucha and in the motifs disguising the metal frameworks. There are rams, tiaras, peacocks, poppies and cabochons. The Porte Binet was known as the Salamander, for it resembled the squat, elaborately decorated salamander-stoves fashionable at this period.

39

14 The precincts of the exhibition are indicated by a dotted line and included: on the right bank, the gardens south of the Champs Elysées containing the Porte Binet (*Entrée Principale*) on the Place de la Concorde and the Grand and Petit Palais (marked *Beaux-Arts* and *Arts Français*); the embankment west to the Trocadéro Gardens which contained the colonial exhibits; on the left bank the whole of the Champ de Mars and the embankment eastward to the Esplanade des Invalides.

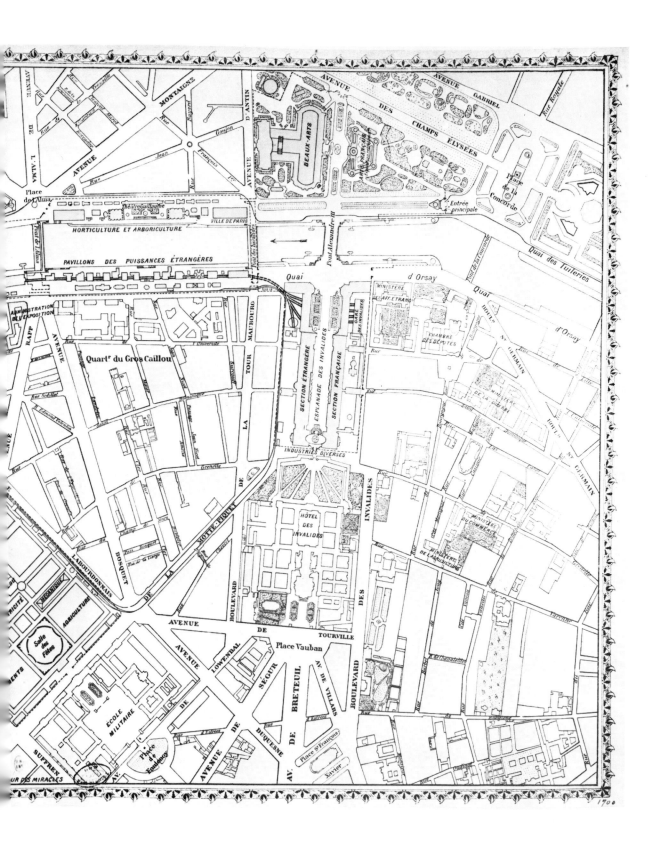

15 Deglane: Principal façade of the Grand Palais. A Neo-Baroque décor hides the admirable iron framework.

In spite of his reservations Rémy de Gourmont, the critic of *Le Mercure de France*, had to admit the merits of an edifice which, had it not been demolished, would today be compared with the weirdest constructions of Gaudí who, like Binet, was fascinated by natural forms and biology.

The Binet style represents the exhibition's striving for novelty. When the quest for the new produces only this, it is doubtless a sad sign of decadence; but, such as it is, the Binet style has at least the merit of Baroque extravagance and absurdity—it is a hideous carnival mask, but quite original in its hideousness. The conventional style is of a lower order and is typified in the Pont Alexandre, that gigantic set of Louis XVI fire-irons. Here it is purely and simply a matter of copying the past. . . . The gateway is decadence, the bridge is impotence. . . . The third style, the artificial, is where the Exhibition triumphs. The same artists, incapable of innovating tastefully or of imitating intelligently, are marvellous fakers.

This extravagant monument at the entrance to the exhibition immediately plunged visitors into a world of fantasy; eventually it was admired. On the other hand, the statue of the 'Parisienne' by Moreau-Vautier was so ridiculed that there was talk of having it removed—it was as if Salammbô had been dressed by Paquin with the Ship of Paris as her head-gear. Some said that Sarah Bernhardt, the incarnation of France, had posed for the statue; others regretted it was not an allegorical nude. But to everybody it seemed, for better or for worse, the ultimate in modernity.

THE GRAND PALAIS AND THE PETIT PALAIS

So that visitors would not have to queue, street-vendors peddled tickets of admission and they also tried to palm off guidebooks (**11**), most of which were designed to publicize the exhibition. The best was that published by Hachette, which resembled the almanacs that were the encyclopedias of the lower class for some fifty years. On entering, visitors came into an avenue planted with flowers and palm-trees

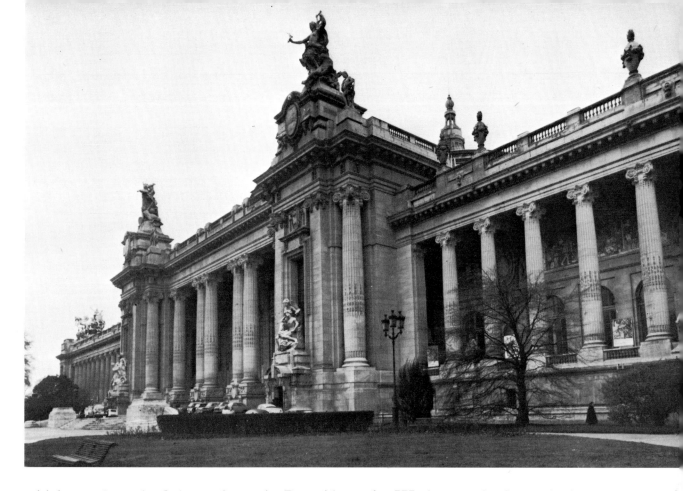

which ran along the Seine as far as the Pont Alexandre III. Among the flower-beds the section of funeral monuments discreetly displayed a choice of tombstones at all prices.

Public opinion was rather severe on these two palaces situated on each side of the new avenue. The *Revue des Arts Décoratifs*, which was preaching Art Nouveau, wrote:

> What can one say about the Grand Palais, a sort of railway station where masses of stone have been piled up to support what?—a high, thin roof of glass. A bizarre contrast of materials! It is as if a giant were flexing his muscles, stiffening his arms and making a tremendous effort to raise a simple head-dress of lace above his head! Admittedly, the palace is adorned with polychrome decorative motifs which are a commendable attempt at originality, a pretty mosaic frieze and another of glazed stone. As for the Petit Palais, opposite its heavy and awkward big brother, it has the look of a delicate miniature, a sweet-box from the showcase of a collector of eighteenth-century trinkets. Here, at least, French grace has triumphed. No attempt at novelty. Nothing original. Simply the art of the Trianon with its familiar effects derived from classical formulas. But what exquisite elegance

16 *The Triumph of Apollo* by Recipon on one of the corners of the Grand Palais. This enormous quadriga of weathered bronze is now considered one of the most fascinating sculptures in Paris.

and charm in this delicate, appealing architecture accompanied by motifs carved with a perfection recalling the best periods of our past styles!

At the same time, Jean Lorrain was admonishing his snobbish readers who were disparaging the exhibition:

> But there are some marvellous things which you do not want to see in this Exhibition: the two palaces on the Champs-Élysées, especially the smaller one. This is the continuation of the Trianon style at its purest; the proportions are exquisite. But you are blinded by bitterness: it is the government you are shunning through the Exhibition. The span of this palace is unique when seen from the Champs-Élysées. And the bridge, the Alexander III bridge, how its curve soars into the void! But it is as beautiful as a theorem in geometry, this ellipse of steel spanning the width of the river. I am less fond of the bronzes of the lampstands, that is for sure: the ornamentation is overloaded; but the four pylons at each end with their gold lions have a proud aspect; and when the Exhibition is finished and the sponge-cakes have been swept from the Esplanade, if the trusses of the roofs of the two palaces are just gilded very lightly, to rid them of their appearance of a glass-covered market and make them blend with the dome of the Invalides, you will see that all will be well—perfect, in fact. Believe me, this will then be a corner of twentieth-century Paris that you will be able to compare with the Place de la Concorde and with the two palaces of Gabriel.

Without going as far as this, one must admit that the Grand Palais (**15**) has aged quite well. Since the Opéra, the glory of the Paris of Napoleon III, it is the only building of prestige to have been erected in France. It is the image of the official France of the time, rich, with a sense of quality, a taste for the solid and even a certain industrial boldness, but artistically it is quite mediocre, except in the iron-work on the doors and staircases, which is unrestrainedly Art Nouveau. The decline since Garnier's Opéra is evident.

Yet, despite the heaviness of the colonnades and the mediocrity of the sculpture, the Grand Palais is an excellent example of the Neo-Baroque style that flourished

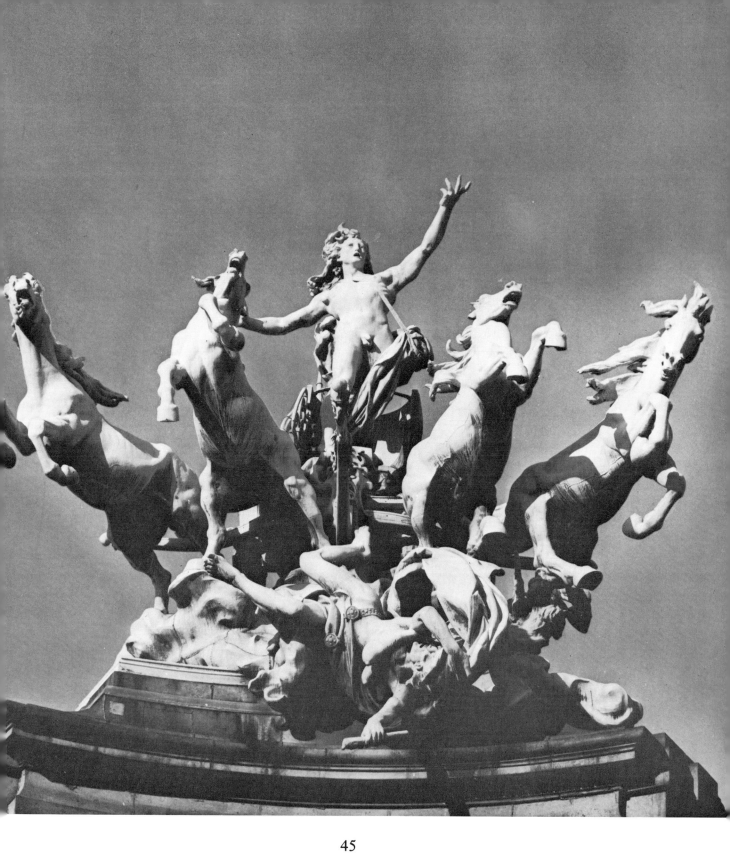

45

in Europe at this time and of which the most outstanding achievements are the Victor Emmanuel monument in Rome, the new Hofburg and the museums in Vienna, the New Museum in Berlin and, more discreet, the monument to Queen Victoria in front of Buckingham Palace. When seen from below, the bronze chariots, the work of a very bad sculptor, Georges Recipon, and which are now covered with verdigris, are comparable with the most spirited inventions of Bernini (**16**). The Baroque is also to be found in the fondness for allegories—Inspiration, Ceramics, Art and Nature, Art in the Eighteenth Century—which call to mind the equally numerous allegories in Jesuit churches (**17**). All round the edifice, extending over several hundred metres, a frieze of polychrome faience, inspired by the friezes brought back from Persia by Mme Dieulafoy, retraced the great epochs of art, from the construction of the pyramids to the building of Versailles. Visitors could recognize the figures of Phidias, Michelangelo and Voltaire. Between the great men, women in chariots, surrounded with period attributes and drawn by lions or slaves, represented different stages of history. The cult of Civilization was replacing

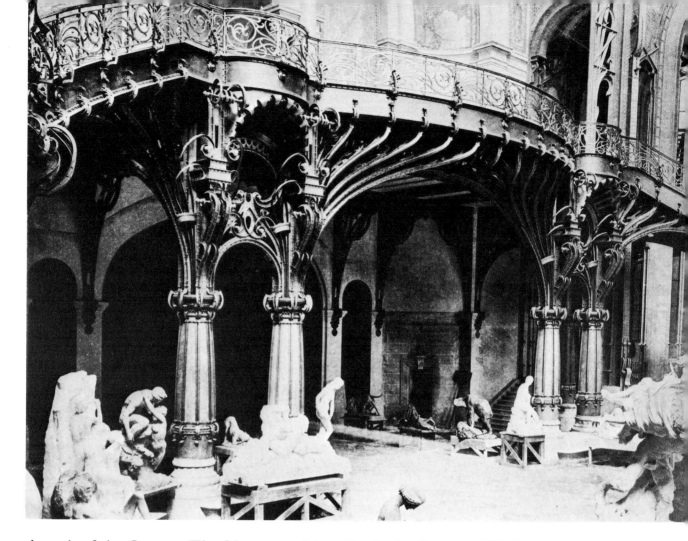

the cult of the Creator. The friezes proclaimed both the Gospel of Work and the deification of great men which had begun during the Revolution. They were also a monument to the masonic thinking which inspired the world of officialdom. Their model was Chenavard's fresco 'The History of Humanity', painted at the Panthéon amid the humanitarian fervour of 1848. The building was nicknamed the 'Terminus of Caracalla', for it suggested both a railway station and the Baths of Caracalla as they must have appeared at the time of their splendour.

If the exterior recalls the style that has always been associated with the glory of empires, the interior (**18**), all iron and glass, was of a truly modern audacity—that is to say, it was perfectly adapted to its purpose: an exhibition hall for sculptures, a track for horse shows and, later, the Motor Show. More elaborate and mannered elements, such as the admirable wrought-iron banisters, gave a certain elegance to this railway-station architecture (at this same time and in the same style—a framework of iron behind a stone façade—the Gare d'Orsay was being built). In the Grand Palais, every ten years, was held the great Exhibition of Fine Arts in

19–22 The Petit Palais. The dome seen from the courtyard (*left*). The pink marble colonnade of the internal courtyard (*below*) was inspired by that of the Grand Trianon. The garlands are made of gilt bronze and the ornamental ponds of blue mosaic. The entrance hall (*right top*) was decorated by Besnard in the Neo-Baroque style, while the staircase (*right bottom*) was an excellent example of the adaptation of the classical style to that of Art Nouveau.

which all countries took part. The innumerable rooms of paintings will be described later in this book, and it is not worth giving much consideration to the hall where, in a mass of dusty white marble, allegories and equestrian statues, nudes and figures of great men, were accumulated in a grandiose disorder reminiscent of the cemetery at Genoa. Alexandre Falguière was the triumphant sculptor; Rodin was not represented.

The Petit Palais (**19, 20**), designed by the excellent architect Giraud, housed the great exhibition of French art. Here there was no glass, but a sort of Louis XVI cloister with five sides and a colonnade of pink marble that delighted visitors familiar with Massenet's opera *Manon*. Indeed, Giraud was to architecture what Massenet

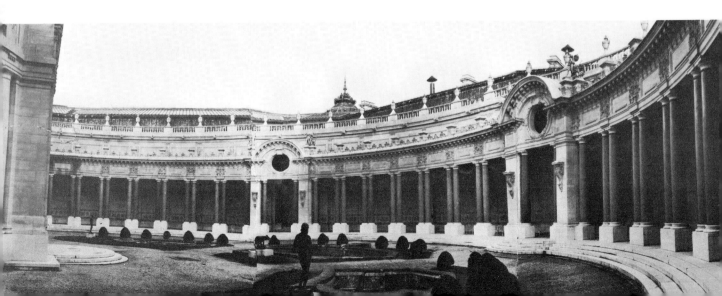

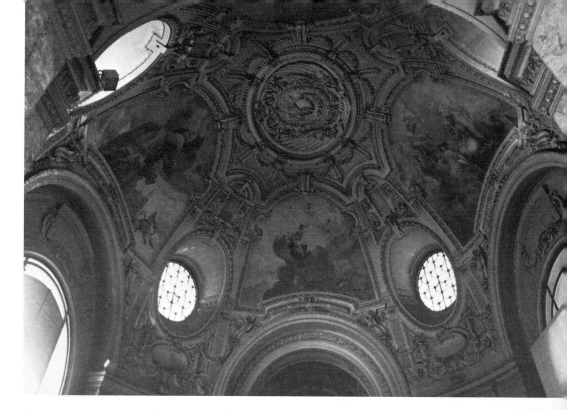

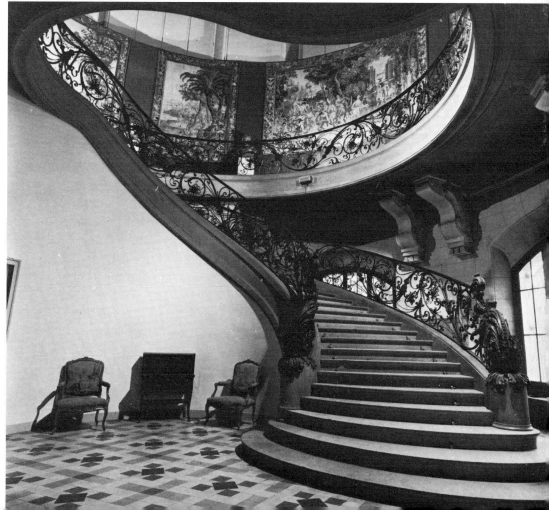

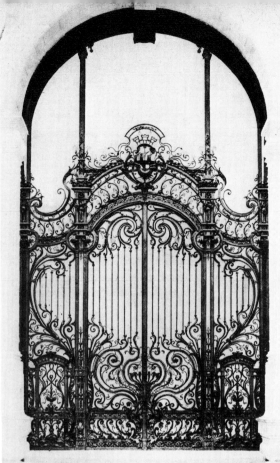

23–5 Gateway of the Petit Palais by Giraud. Though a masterpiece of Art Nouveau, Giraud's design nevertheless fits in very well with the classical façades. The ironwork (details *above left and right*) can be compared with the famous iron gates of Lamour at Nancy.

was to music—superficial, but well-designed and solidly constructed. The Petit Palais is also a combination of everything admired by persons of taste at this period, with echoes of the stable at Chantilly and the Grand Trianon. Here again, all the details were executed with great care and the ironworkers were able to adapt their wonderful technique to Art Nouveau (**22–5**). As for the decoration of the entrance-hall by Albert Besnard and Paul Albert Laurens (the two painters who were the vanguard of Academicism), it remains the only surviving example of the great decorative ensembles which vanished with the temporary pavilions, and it will possibly be mentioned with respect in the histories of art written twenty years from now (**21**).

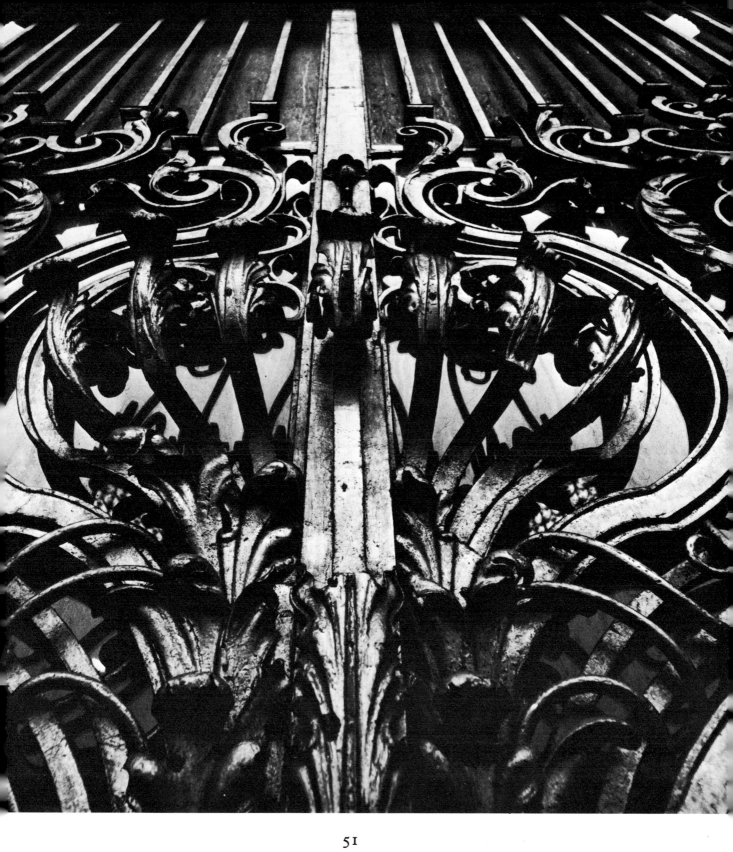

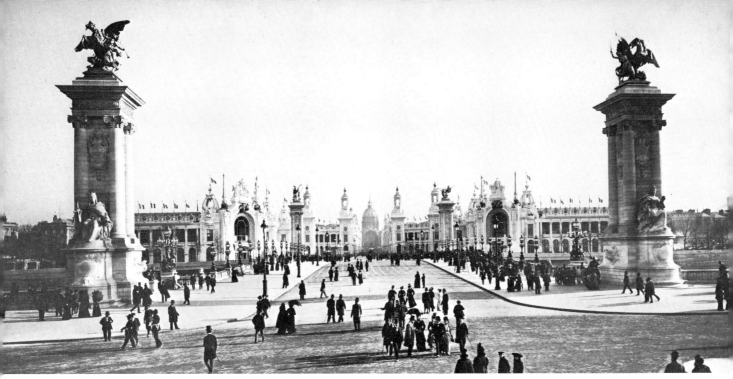

26, 27 Contemporary photographs of the Pont Alexandre III.

From the Invalides to the Trocadéro

The Pont Alexandre, designed by Resal and Alby, is one of the most important monuments in Paris (**26–7**, **30**). Although Jules Dalou himself carved only a lion, all the allegories reveal the influence of the one great official sculptor of the time (**28**). The Esplanade des Invalides was bordered by two long, symmetrical buildings, overloaded with plaster reliefs and containing the sections devoted to the decorative arts. Mischievous persons nicknamed the Esplanade the 'Village suif' ('Village of lard'—there was a 'Village suisse' among the attractions), for 'the buildings seemed to be made of lard which a romantic butcher had twisted into a variety of shapes'. Without crossing the bridge, one can look over on to the left bank, where the foreign pavilions tried to outdo each other in splendour (**II**), and continue along the right bank, passing by the pavilion of the City of Paris, where the historical exhibition served as an annexe to the museum in the Hôtel Carnavalet. Its vaguely Louis XVI style disappointed everybody. Visitors would pass among the greenhouses erected in the middle of the flowering borders, and would perhaps avoid the Rue de Paris with its theatres and fair-stalls, for it was amusing only in the evenings. This promenade over the site of the Cours la Reine, with its flowers, palm-trees and benches, must have been rather like the esplanade of a spa, a place where one could rest and where there was less dust than in the other parts of the exhibition. At the Place de l'Alma we cross the Seine, for 'Old Paris' must be seen

52

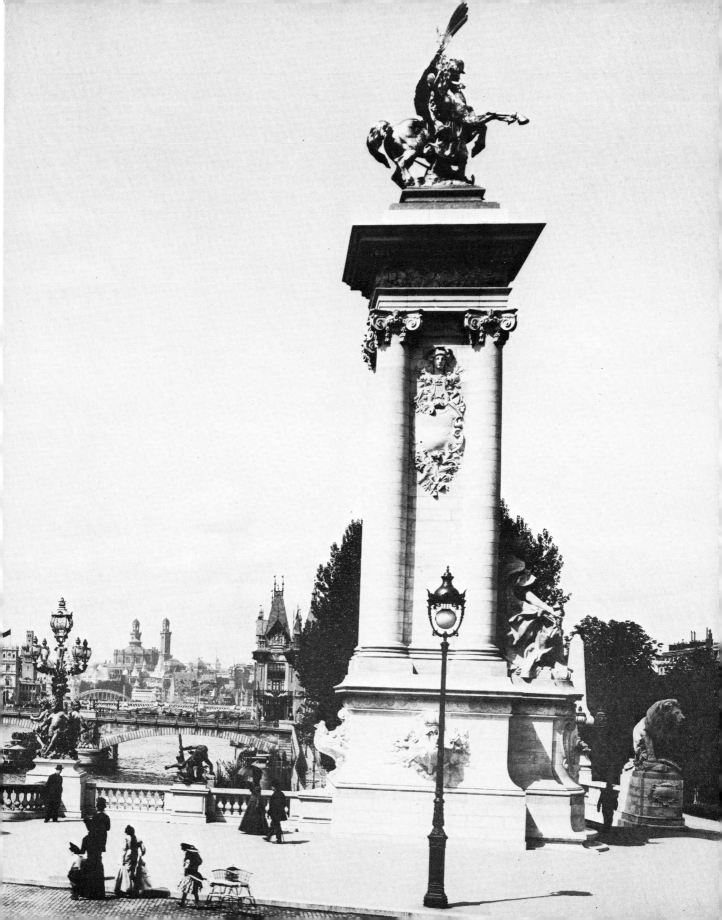

28–30 (*left*) Raoul Larche: Sculpture from an ornamental pond in eighteenth-century style, although the treatment of the hair is Modern Style. It can be compared with the allegory of the Seine in bronze which decorates the centre of the Pont Alexandre III (*right*). The cast-iron putti round the lamp-stands of the bridge (*opposite*) are imitations of the bronze round the pools at Versailles.

from the left bank; distance softens the crudity and exaggerated picturesqueness of the reconstruction. Patriots (and who was not a patriot at this time?) felt obliged to make a conscientious tour of the massive buildings devoted to the army and navy (**34**). A self-styled negro visitor observed:

> The engines of destruction used by the civilized nations are real gems; shells cut in two show what they are like inside: the bullets are arranged in the most orderly manner in compartments of polished copper. The cannons and machine-guns are very clean, even luxurious. And yet I wonder; I have a vague idea that the governments, at least the foreign governments, have not exhibited their best material and are saving their discoveries for the battlefield. This is why it would be wise not to distribute the medals until after the next war (*Journal d'un nègre à l'Exposition*).

After admiring the half-section of a destroyer which stood against the façade of the Pavillon de la Marine, and the complete collection of Prussian uniforms sent by the Kaiser (a warning or simply lack of tact?), visitors could gaze in wonder at the metal

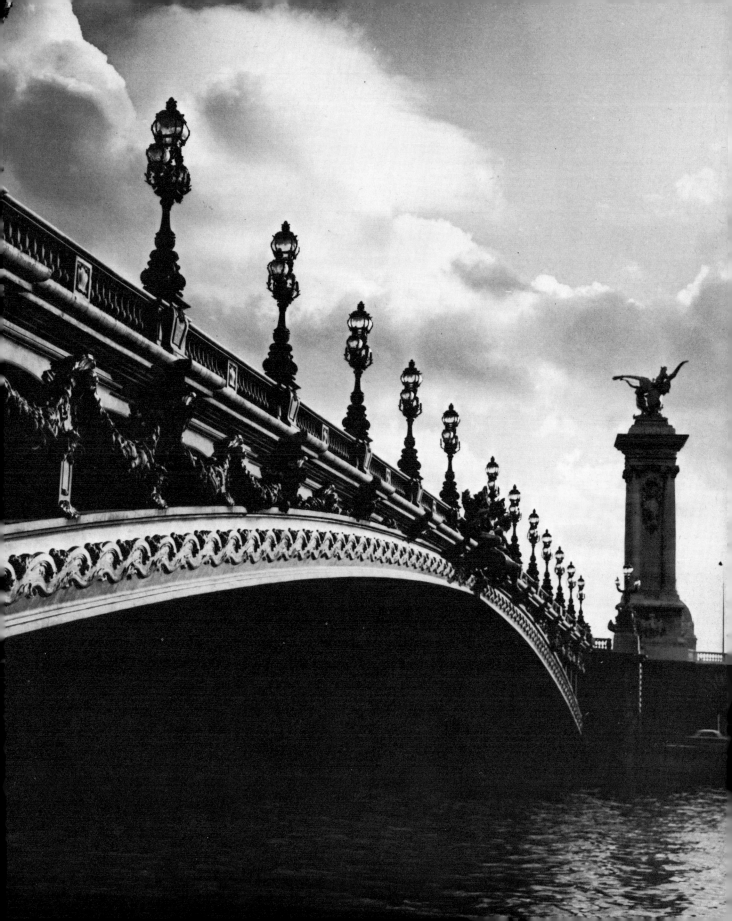

dome covering the cannons manufactured at Le Creusot and then go across a foot-bridge to look at the pleasure-boat harbour with its gondolas, junks and steamers crammed with tourists. The next thing was to stop at one of the big restaurants which occupied this part of the Quai de Billy, overlooking the Seine: the Pavillon Bleu (**117**), very modern in style, La Belle Meunière and the British Pavillon de Thé which, much better than the official British pavilion, showed the French the one thing they wanted to learn from the English—comfort—with furniture from Maple's and Waring and Gillow. Here visitors could relax before tackling the colonial section in the gardens of the Trocadéro.

In these gardens, under the peaceful chestnut-trees, they found a jumble of pagodas and mosques, a buzzing of exotic music, and the smell of strange foods. The Kremlin which housed the vast Russian and Siberian section dominated the rest of Asia with its profusion of furs that made the ladies lose their heads. But these exotic displays deserve a chapter to themselves.

Returning along the fountains of the 1878 palace, which were decorated with bronze animals by imitators of Barye, let us pause on the terrace to contemplate the panorama of the Champ de Mars beyond the Eiffel Tower. Anatole France describes the scene in words that might almost have been intended as a modern prayer on the Acropolis:

'Behold this spectacle,' said M. Bergeret, showing his disciple the panorama of the Exhibition from the steps of the Trocadéro; 'Look: domes, minarets, steeples, towers, pediments, roofs of thatch, of glass, of tiles, of coloured earthenware, of wood and animal hides, Italian terraces and Moorish terraces, palaces, temples, pagodas, kiosks, huts, cabins, tents, water-towers, contrasts and harmonies of all kinds of human habitation, the fever of work, the wonderful workings of industry, the enormous amusement of the genius of man, who has planted here the arts and crafts of the universe.'

Other Academicians who were among the first visitors readily praised the mighty enterprise. Melchior de Voguë writes: 'The Exhibition smothers its disparate parts in an ensemble which can be accused of everything except lifelessness; life

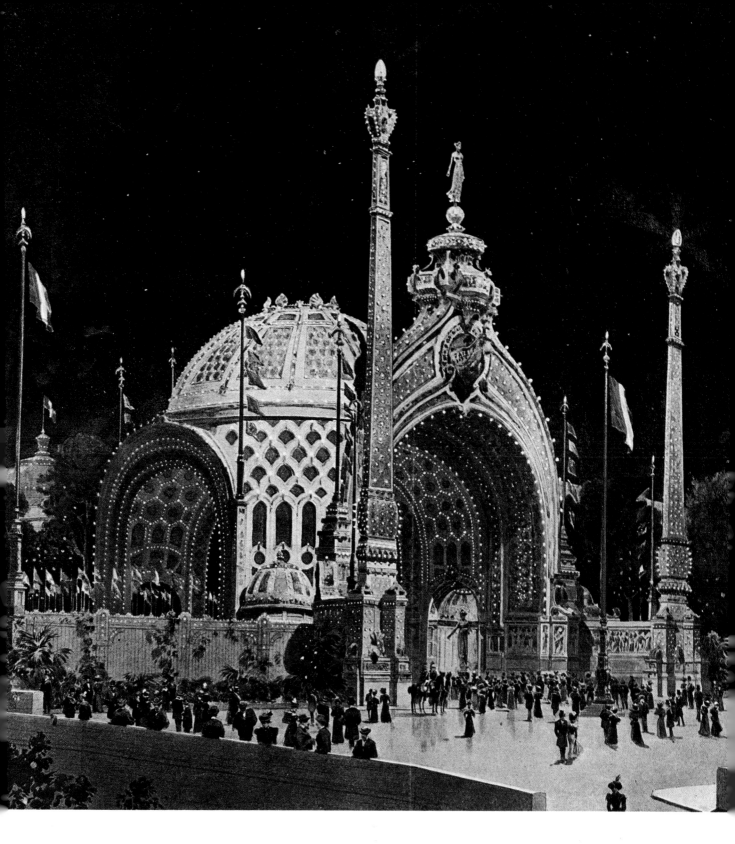

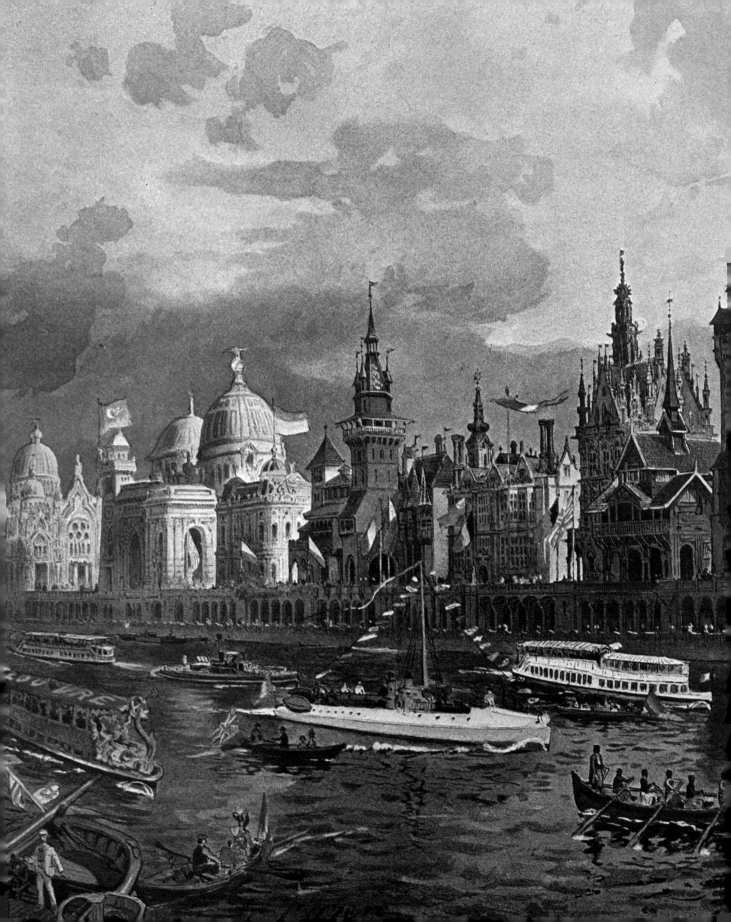

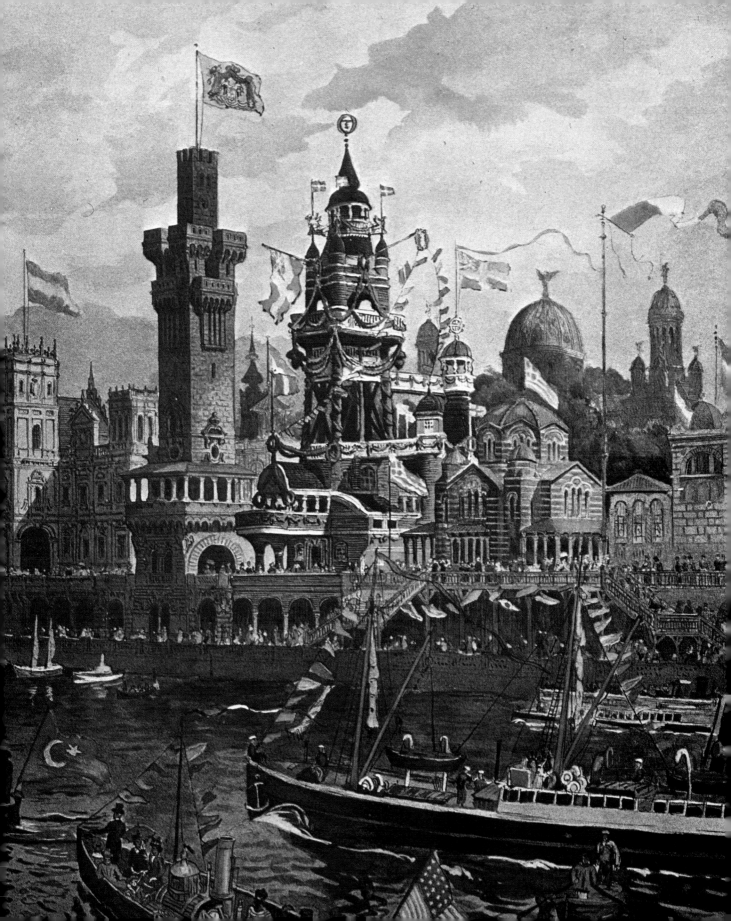

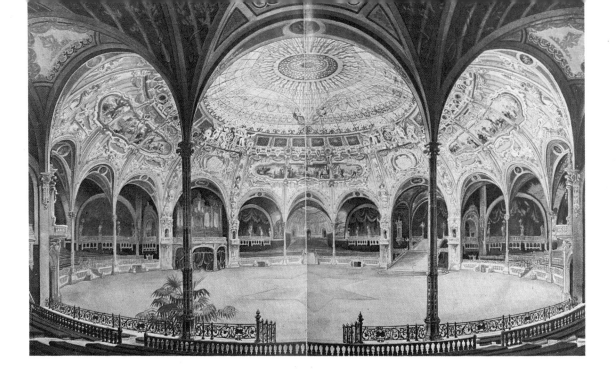

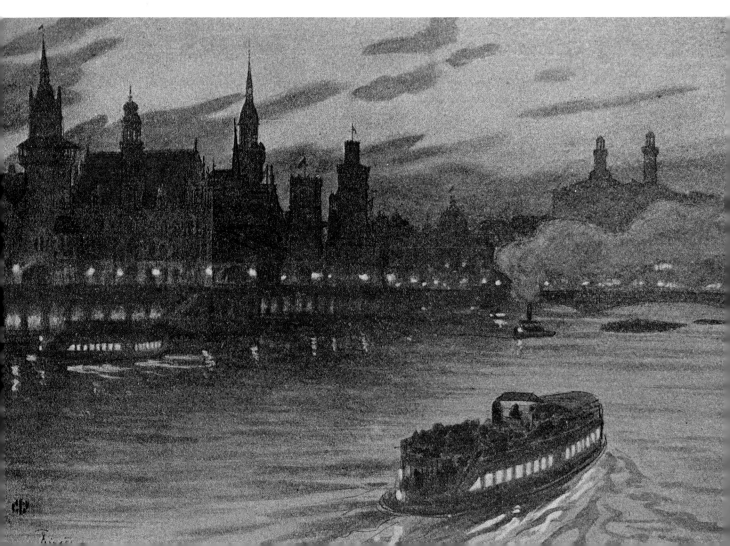

III Salle des Fêtes. This huge rotunda was decorated
with paintings glorifying Work. A dome of coloured glass
crowned the iron framework. It was here that the official
ceremonies and the most important conferences were held.

IV *Rue des Nations at Night* by Henri Rivière. One of
the best landscape painters of Symbolism shows that, at
certain hours of the day, the exhibition could assume an
unreal beauty and enchant poets.

seethes in this immense reservoir of energy and that's the main thing.' Ludovic
Halévy speaks of 'a too violent magnificence'.

Society people, alas, continued to turn up their noses: 'But the palaces on the
Champ de Mars, this hurly-burly of plundered toy-boxes, this hotchpotch of
domes and cupolas stuck here and there at random, you call that beautiful, this
crazy mushroom-bed of sham Kremlins and pagodas?'—'But you are simply
snobs', replies Jean Lorrain. 'What you say is all the more pointless because none
of all this will remain. It's simply the Nijni-Novgorod fair for the Cook and Lubin
agencies.'

THE CHAMP DE MARS

The general public who tramped round with the Hachette guide in their hands
had only to refer to it to discover both what they could see from the top of the
Eiffel Tower and what they should think of it all:

Beyond the river, like the sons of Allah at prayer, the domes of the Tunisian
and Algerian Palaces rise up. Like the legendary sanctuaries of the houris, the
edifices of festivity, feasting and prayer of Arabia, supported by the shafts of
slender colonnades, crown Moorish or Spanish Alhambras. By turning to the
left of the platform, so that you are facing the Champ de Mars station, and
leaning over, you can see gathered together at the foot of the iron mastodon:
the Palace of Woman, the red and green roof of the Tyrolean Castle, the Pavilion
of Russian Alcohol, the Palace of Ecuador, and the Touring Club Chalet on a
rock beside a pretty little lake; and further away, nearer the Seine, you see the
Cinéorama, the Maréorama, the spherical mass of the Terrestrial Globe which
resembles a dead world that has fallen from the sky; beside the Transatlantic
Panorama, Venice offers its polychrome towers and openwork loggias; the great
painted entrance of the Palace of Optics faces the dazzling whiteness of the
Palace of Morocco, where, on the battlemented terraces, the eye seeks in vain

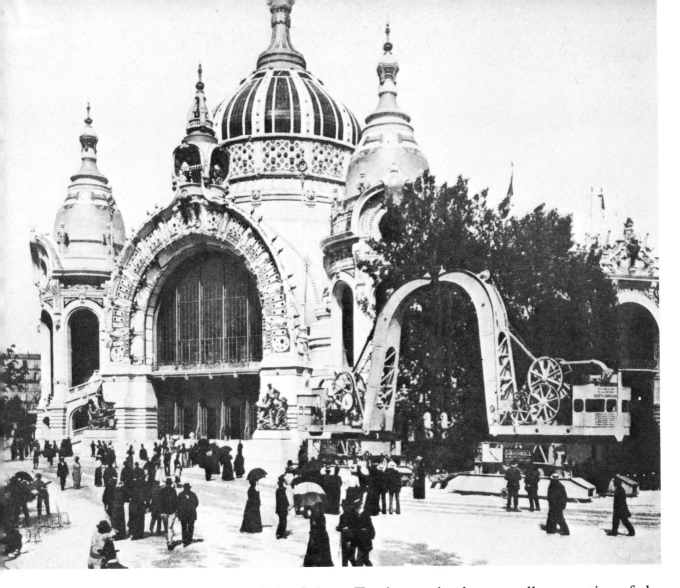

the veiled women of the Sultan. To the south, the marvellous portico of the Palace of Education stands in all its decorative beauty and monumental grandeur; beyond the domes of the Palace of Civil Engineering and the Palace of Chemical Industries, the Great Wheel thrusts its huge spider's web into the clouds; and behind, like some magic mirage, rise the abrupt peaks and pointed rocks of the chain of jagged mountains which gives the delicious Swiss Village its background of Alpine freshness. To the left, above the pylons, spires and pinnacles of the palaces of the Champ de Mars, one can see shining the great golden helmet of the Invalides.

It is true that the pavilions on the Champ de Mars gave the detractors of the exhibition some justification; they were a combination of paradoxes—eccentricity

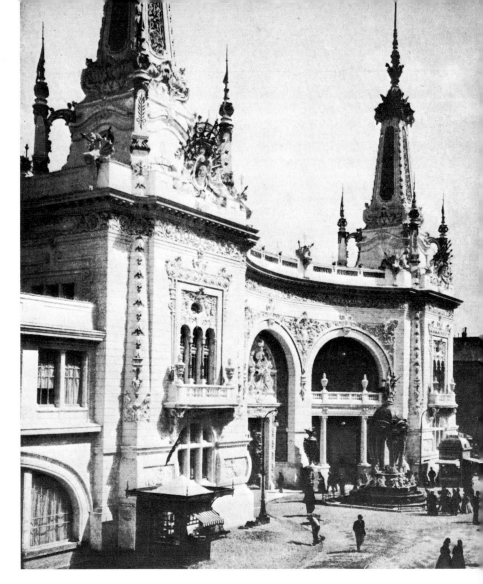

31, 32 (*left*) Palais des Mines et de la Métallurgie. The metal framework is decorated with cast-iron ornaments that give the edifice the appearance of a stage-set for a fairy-play at the Châtelet. The Palace of the Decoration of Public Buildings (*right*) is a blatant imitation of the casino at Monte Carlo built by Garnier twenty-five years earlier, but is cluttered with superfluous detail.

and banality, frivolous affectation and turgidity—and yet they were worth looking at, for their absurdity was a frantic, blind attempt to achieve a style appropriate to the modern world. This world of the fantastic which, if they had restricted themselves to what they had been taught, the architects would have encumbered with a ponderous classicism, inspired them in their designs for the vast pavilions of civil engineering, education, textiles and optics, to create a style that can only be compared with the scenery which, since the Second Empire, had been used in the spectacular fantasies and operettas performed at the Châtelet—a mixture of the Hindu pagoda and the winter garden, a bristling mass of pinnacles and poles where one could imagine the supernumeraries of *Les Pilules du Diable* or *Le Docteur Ox* descending the winding staircases in their outlandish costumes (**31–4**). One of the prototypes for these pavilions was the Magasin du Printemps, built twenty-five

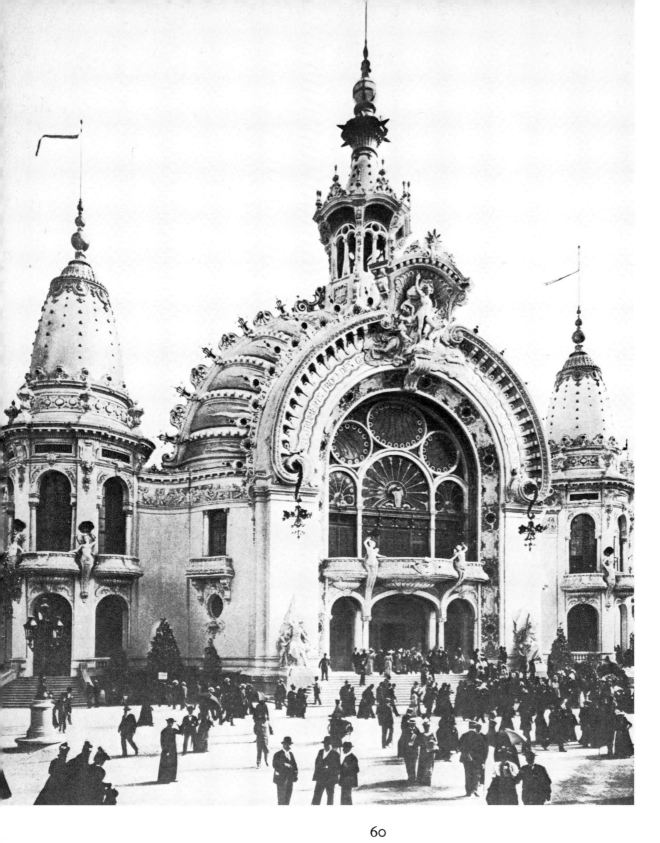

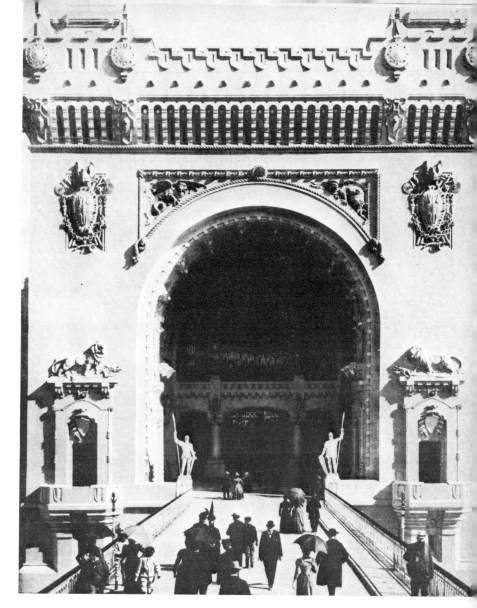

33, 34 One of the most extravagant examples of Neo-Rococo and comparable to the Zwinger in Dresden was the Palace of the Liberal Arts on the Champ de Mars (*left*). It contained only a dull exhibition of *objets d'art*. The Palace of the French army and navy (*right*) was a fortress built like an opera stage-set. It contained weapons and uniforms dating back to the seventeenth century, flags and battle plans. But the German military section was much more impressive.

years earlier by Franz Jourdain, but they also recalled the Casino at Monte Carlo by Garnier. The organizers of the exhibition had given the architects clear instructions: Above all, make things cheerful.

Under their frivolous exteriors these pavilions housed the most serious products of industry, usually arranged in categories, as had been customary since the exhibition of 1855. In the gardens around the Eiffel Tower stood an incongruous medley of smart edifices reminiscent of seaside resorts: the Touring Club Pavilion, the Palais du Costume, publicity kiosks, newspaper kiosks and bandstands, a mass of fretwork wood and wrought iron. The École Militaire was hidden by the machine gallery of 1889 where visitors could admire the locomotives and the different kinds

35 Central dome of the palace on the Champ de Mars. Centre of the Machine Gallery erected for the exhibition of 1889. At this exhibition the engineers greatly overshadowed the decorators, who were content to ornament the metal frameworks with motifs similar to those designed for the Paris Opéra at the end of the Second Empire. There is no hint of Art Nouveau in this building.

of motor car (**52**). Against this structure had been erected the enormous Salle des Fêtes (**III**), with its dome of coloured glass resting on iron pillars, its frescoes glorifying labour and an arena like that of a circus; numerous conferences were held here. To the left of the Salle des Fêtes, under another vast glass roof, stood the Pavillon de l'Alimentation, an international exhibition in itself, dominated by the reconstruction of Louis XIV's ship, the *Triomphant*. In a jumble of picturesque or merely pretentious stands the public found its favourite products, Menier chocolate, Grey Poupon mustard, Olida hams and Amieux preserves. French wines were grouped in regions: Bordeaux in a pavilion with rococo trellis-work; Burgundy in a cardboard imitation of Rabelais' abbey of Thélème; and Champagne in a pavilion of rococo and Art Nouveau style, decorated with gigantic drinking glasses (the rich merchants of Rheims were, apart from a few Nancy industrialists, the only members of the bourgeoisie who commissioned modern architects to build their houses). At the end of the esplanade, concealing the Salle des Fêtes, like a setting sun casting its rays, stood the Pavillon de l'Électricité and the luminous Château d'Eau (**VI**), the water tower which, after the Porte Binet, was the most fantastic building at the exhibition and which was best seen at night (we shall return to it in a later chapter).

The jaded visitor would now make his way back to the Seine, take a boat at the bottom of the Pont de l'Alma and, like Jean Lorrain, forget his weariness in his excitement. Floating up the Seine, he might think to himself (**IV**):

Oh, this journey through the Exhibition at dusk! What sight could equal this mighty avenue of water lined with alhambras, generalifes, pagodas, cathedrals and kremlins? . . . It is an architectural hotchpotch conceived in the dream of an opium-smoker; here, along the banks of the river, eccentric, sumptuous and bizarre monuments of all epochs have been piled one upon the other. What a pity there is no beautiful sunset this evening! . . . All these Hindu, Burmese, Italian and Spanish cities outlined against a sky of gold! The Exhibition of 1900 promises some fine Turners for the end of this summer!

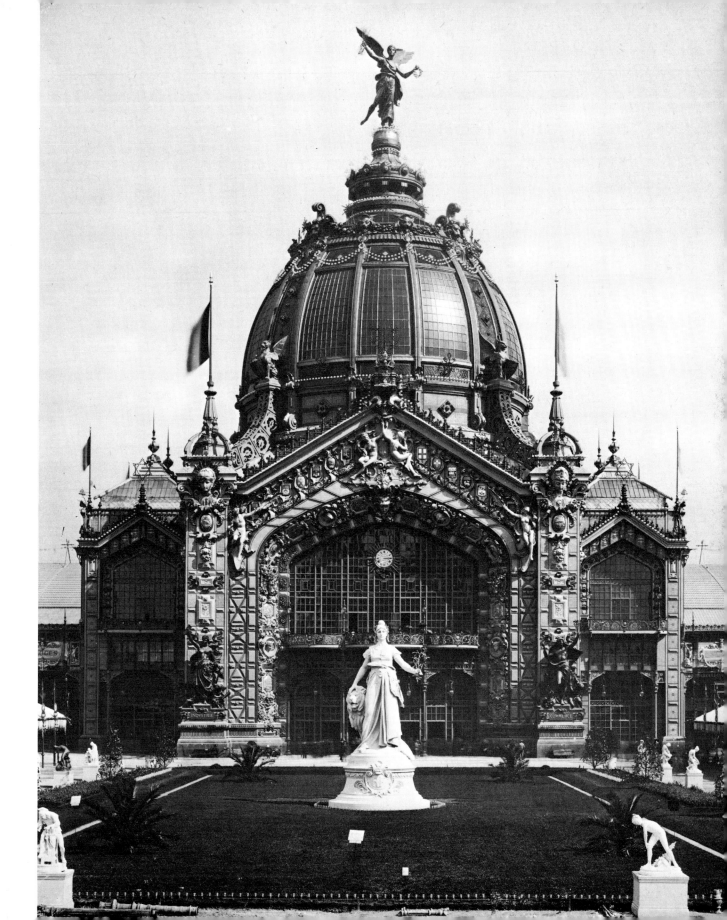

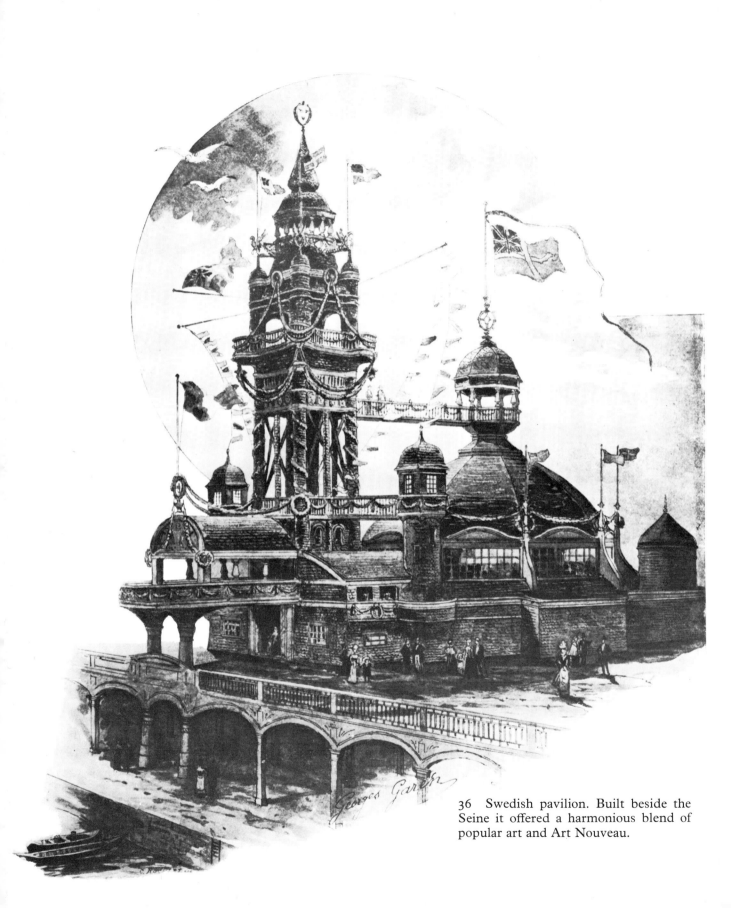

36 Swedish pavilion. Built beside the Seine it offered a harmonious blend of popular art and Art Nouveau.

3

THE FOREIGN PAVILIONS

A GERMAN VICTORY

The pavilions of the foreign powers extended over the left bank, between the Pont des Invalides and the Pont de l'Alma (**II**). This was the most popular part of the exhibition. Jean Lorrain professed his delight in his first articles on the 'great bazaar':

This is what should remain permanently. It is only reconstruction, but it looks quite different from the nougat style. Hungary is a marvel; Italy is blatant in its colours, but has something of the arabesque; Austria is pretty enough to make you go down on your knees; Belgium has produced one of those town halls of

E

37 Hall of the German decorative section. The architect Professor Hoffacker created this Wagnerian beerhouse décor typical of the German imperial style but clearly Art Nouveau in its detail.

which she alone possesses the secret. Oh, the Audenarde style is far better than the Binet style! Monaco has sent us a tower almost as high as the German one, and Germany is painted and gilded like a house in old Basle. Hurrah for Holbein! It really is a picture and, I am sad to say, the most successful décor at the Exhibition.

Although the 'Exhibition of the Century' had eluded him, the Emperor Wilhelm made up for this by the sheer size of his contribution. Not content with having the largest pavilion, he sent part of the collection of Frederick II to furnish it. The catalogue contains these words, undoubtedly dictated by the Kaiser himself: 'Can one contribute more nobly to the great peaceful festival of the Universal Exhibition than by recalling, by this return to the past, the memory of what the German people owes, in the domain of art, to its neighbour, and the memory of the homage rendered by Frederick the Great, one of the greatest minds of all time, to French civilization and art?'

The general public was not admitted to the suite of white and silver rooms where the works of Watteau and Lancret were hung; it was necessary to apply for entrance-tickets.

Surmounted by a high tower, the German pavilion had nothing rococo about it, but suggested the architecture of Nuremberg and Heidelberg. The interior resembled a beer-hall and the stage sets for *Die Meistersinger*; everything was vast

66

and solid (**37**). The wood and stained glass created the atmosphere of sombre opulence typical of Wilhelm II. The artists who were beginning to be active in Munich, were not represented in this pavilion where everything was supervised by the Emperor, and the official art of Germany was no better than that of the École des Beaux-Arts. The difference was that the Germans did everything on a larger scale; in all the sections of the exhibition they occupied most space: . . . 'giving the impression of a commercial invasion in the absence of actual conquest'. The pavilion of the German merchant navy was a scale model of the Rothe Sand lighthouse built at the mouth of the Weser to serve the port of Bremen. Every evening a projector of exceptional power cast its beams over the pavilions and often illuminated the Château d'Eau. Inside, models displayed the comfort of Germany's passenger-liners and the growth of her merchant fleet. The sculptor Ernst Wenck, in a powerful allegory, had represented Day and Night turning round a terrestrial globe furrowed by lines of ships. Thor, the god of thunder, supported the figures with one hand and in the other brandished a hammer, the symbol of unceasing labour. Woe betide any nation that halts as the world moves on! 'Henceforth, the future of Germany lies on the waters', Wilhelm II had said.

The wise M. André Hallays sighed:

This colossal room of German painters, where the heavy drapes and thick carpets deaden the sound of voices, creating an almost religious silence, and which one enters nervously, as if into a crypt with black pillars; the colossal vestibule of the German section on the Esplanade des Invalides, where a huge eagle with wings spread and slaying a dragon stands on a pedestal of rocks, and on to which open, like chapels, the rooms furnished by the upholsterers and cabinet-makers of Berlin and Munich; the colossal pavilion of machines; the colossal installations of the metallurgy and agriculture sections; and the colossal Bremen lighthouse whose powerful projections, when evening comes, make all the other lighthouses at the Exhibition seem like oil-lamps (*L'Exposition du Siècle*).

38 British pavilion. The architect Lutyens was well known for his adaptations of traditional architecture to modern styles, but here he contented himself with reproducing an Elizabethan manor and it proved a failure.

VANITY FAIR

Only the Russian pavilion was larger than Germany's, but it had been included in the 'exotic' section. Great Britain had commissioned an excellent architect, Sir Edwin Lutyens, to build a mock-Elizabethan manor, of modest dimensions, filled with pictures and old furniture (**38**). This pavilion made no impression on the general public. The 'negro visitor' whose observations have been quoted earlier wrote:

> The English, puffed up with pride, are afraid that not many people will visit their pavilion, which is like a middle-class house in Newhaven. They have put an attendant in front of the closed door. The attendant says the door will shortly be opened, the crowd gathers, and there are people naïve enough to queue. This trick is often used by dentists (*Journal d'un nègre à l'Exposition*).

The Studio, which devoted several excellent numbers to the exhibition, lamented such inadequacy, but the author of the articles could write that, if the British pavilion made no contribution to a new art, the sections of decorative art displayed by other countries all betrayed the influence of William Morris and Walter Crane, and that the work of Burne-Jones was reflected in the best of the young painters. The reason for Britain's indifference lay as much in her poor relationship with France at this time as in the suspicion with which aestheticism was regarded in British official circles. On the other hand, the little pavilion of the Boer Republic and the Transvaal farm soon became extremely popular.

According to the visitor quoted above, the United States made no great impact:

> In the United States pavilion, for example, there is nothing. Some tables, chairs, newspapers, letter-boxes, and that's all. Obviously, these people don't waste their time on trivialities. One well-equipped post-office and you have seen America.

Indeed, the pavilion seems to have been designed for the Americans themselves rather than for the general public:

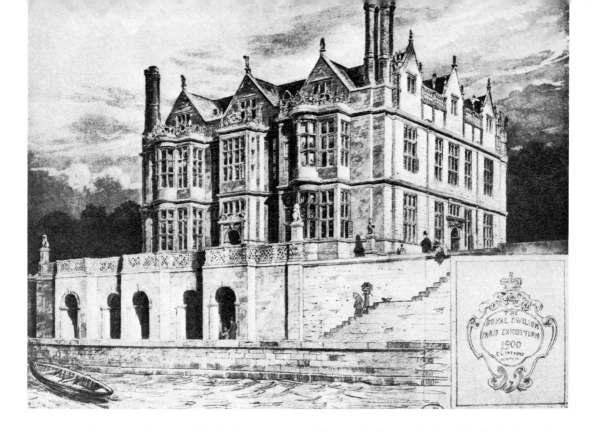

Here the American will find a compendium of the social and administrative organization of his country. It will be a meeting-place where the traveller can see his acquaintances and find all the newspapers; guides will be at his service; secretarial facilities, typewriters and every possible kind of information will be available. He will be able to follow the prices of the Stock Exchanges in New York and Chicago. An office will be set up for commercial information, formulated in as reliable and impartial a manner as possible. Finally, the American citizen on his travels will not have the inconvenience of giving up his normal habits, since iced water will be placed at his disposal.

(The use of ice was at this time restricted to tea-rooms.) The United States Congress had initially voted 650,000 dollars, but eventually the budget was nearly double this figure.

The pavilion (39) was the kind of building common at this period in the capitals of the federal states: a dome adorned with a quadriga and allegories of bronze and surmounted by a gilded eagle; in front of the entrance arch, overlooking the river, stood the statue of Washington that was later to be placed on one of the squares of Paris. In short, this was an official style which gave no idea of the multi-storey buildings that Sullivan had been erecting in Chicago during the past ten years. Beside this senatorial dome rose the Muslim cupola of the Ottoman Empire. The Turkish pavilion looked less like a mosque than a Moorish casino in some second-class spa.

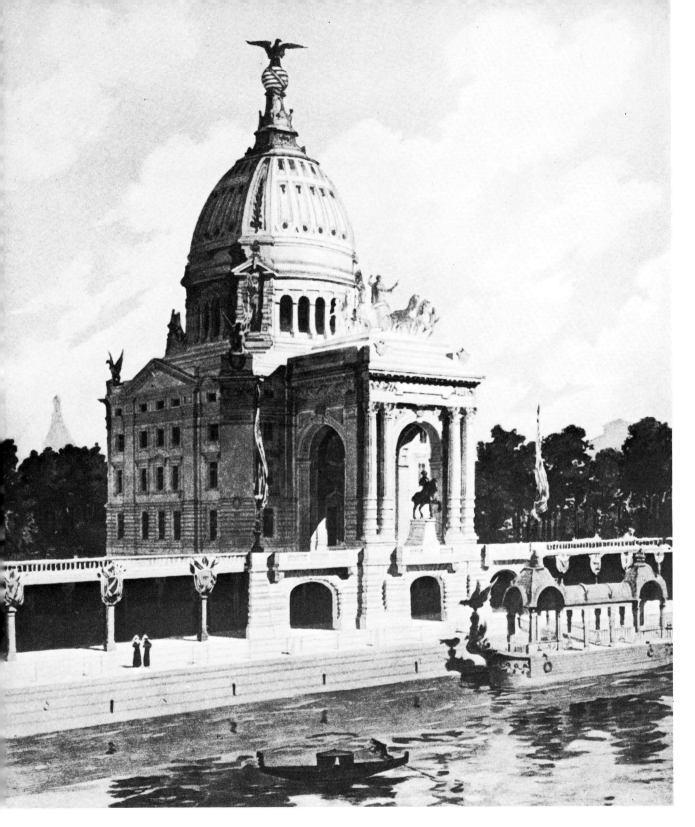

39 An artist's drawing of the United States pavilion.

40　Frescoes in the Bosnia-Herzogovina pavilion by Alfons Mucha.

In the evening, visitors were dazzled by illuminations, but during the daytime they could judge for themselves the decadence of the Sublime Porte:

> The interior of the palace was monopolized by tradesmen. The weapons and fine costumes which the Museum of the Janissaries was to have sent had been replaced by carpets and bric-à-brac, and the undecorated rooms were merely bazaars. A reconstruction of Jerusalem and its environs was a distasteful travesty of the holy places. Although the spectacle of the Karagöz [puppet show] had been prohibited—it would have been a great attraction!—Turkish dramatic art was represented by some dreadful belly-dancing. In an atmosphere of attar of roses and pastilles, Levantines pestered passers-by with a disagreeable familiarity. All restraint was banished from this pavilion where organization was totally lacking, the giant tomb of Islam uprooted and planted amid European civilization.

In contrast, the pavilion of the Austrian dominions in the Balkans, Bosnia and Herzegovina (V), offered a delightful picture of folk traditions: peasants dancing in their fustanellas, pretty weaving-girls, colourful carpets, embroidered table-cloths and a realistic décor by Alfons Mucha (40–2). The highlight of the pavilion was a panorma of Sarajevo.

The elegance of the Austrian pavilion (44) united the partisans of Art Nouveau and Classicism; the latter were pleased by the Neo-Schönbrunn architecture of the pavilion, while the former were captivated by the bright, ultra-modern decoration produced by the same artists who had recently been responsible for the Secession Pavilion in Vienna (43). This mixture of rococo and modernity was very much in the spirit of *Der Rosenkavalier* which Hugo von Hoffmannsthal was

71

41, 42, V The Balkan territories of Bosnia and Herzogovina were under Austrian domination but entitled to a pavilion in an Oriental style. The watercolour (*right*) is by Mucha, who himself decorated the interior (*left*). He was an excellent designer who did not yield to the temptation to indulge in a facile folklore style. There are still frescoes like these in the railway stations and town halls of Central Europe.

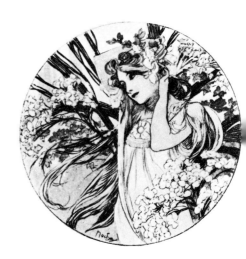

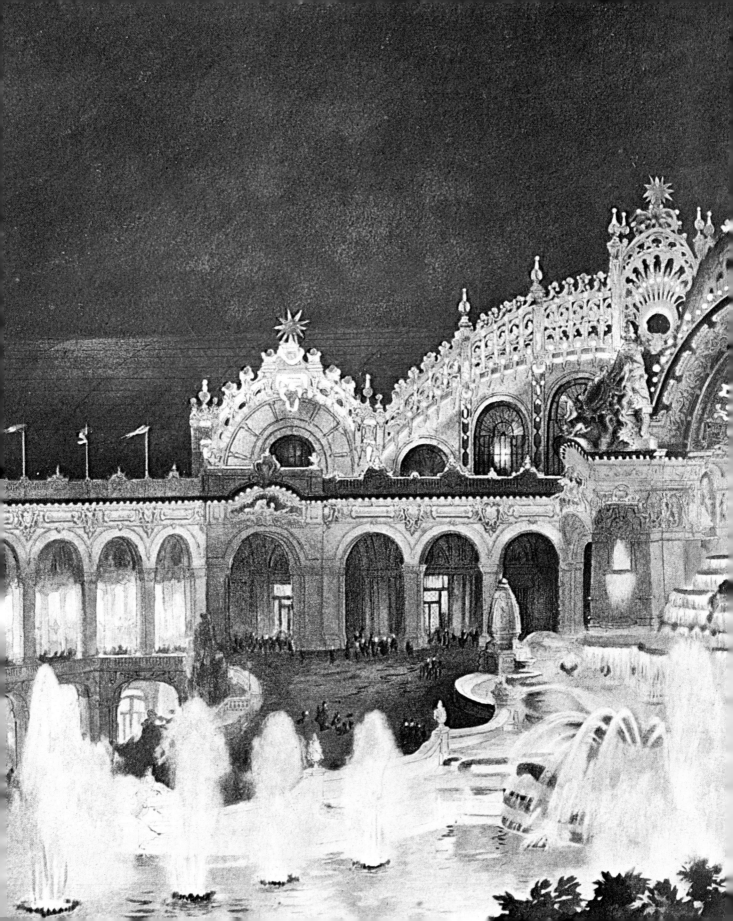

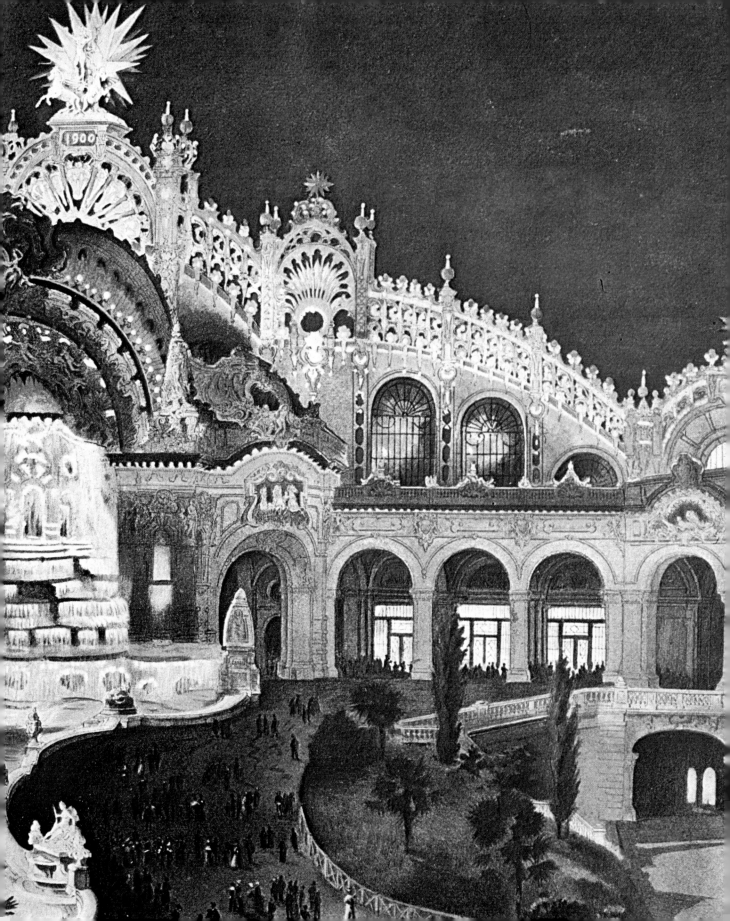

VI (*previous page*) Palais de l'Électricité and Château d'Eau. The apotheosis of the new source of power was given a theatrical fairyland setting.

VII Georges de Feure: *The Visit*. The best and most extreme Art Nouveau decorator had reproduced the atmosphere of the exhibition in his room in the Bing pavilion (**80**).

to write some years later. Major-domos and hall-porters in the imperial livery really gave the pavilion the aspect of a palace.

The same good taste, adapted to a medieval building, was to be found in the huge Hungarian pavilion evoking the splendours of the crown of St Stephen. Attendants dressed in close-fitting hussars' costumes (furs and frogging) helped to give the pavilion a grand air. Agricultural produce and hunting equipment were exhibited. Clearly, an important place was being given to Franz-Josef's various peoples, with the exception of Bohemia.

Italy had at great expense erected an imitation of St Mark's in Venice. The interior was imposing but cluttered with objects of all sorts, like a vast store selling nothing but tourist souvenirs. Equally disappointing was the medieval town hall erected by Belgium. Admittedly, there were some beautiful tapestries, but the official authorities had commissioned nothing from either Victor Horta or Henry Van de Velde, and visitors therefore could have no idea that this country was the centre of Art Nouveau.

The Swedish pavilion (**36**) offered a complete contrast:

> The Swedish pavilion is certainly the most original of all the edifices on the Rue des Nations. First of all, it does not belong to any known style of architecture and does not attempt to revive any of the forms of the past. Built for a festival season, it has the gay and cheerful appearance appropriate to its purpose. Nothing could be more whimsical than its pepper-box turrets, its tiered footbridges, its garlands and ropes, its crown-shaped buoys and bowsprits offering to the breeze a mass of pennants. The edifice is entirely of wood, red deal, but the wood is not disguised under a deceptive covering of plaster or staff; it is bare everywhere. From top to bottom, including the roofing, all the surfaces are dressed with pine shingle-boards, similar to our slates, and nailed so that they overlap, resembling fish-scales. Some parts are painted in a brilliant red, some in yellow, and others retain the natural tone of the wood (*L'Exposition du Siècle*).

Two artists were particularly admired in the Swedish pavilion: the engraver

Anders Zorn and the illustrator Carl Larsoon. Ravishing young women in picturesque costumes were to be seen occupied in traditional folk activities and dioramas showed the midnight sun. In short, it was all a great success.

The young Norway, with a very simple wooden pavilion, earned the goodwill of the public.

Almost as high as the Belgian and German towers, the tower of the principality of Monaco overshadowed the Spanish pavilion and the little brick churches that served as the Greek and Serbian pavilions. Inside the Monaco pavilion were exhibited Prince Albert's oceanographic collections, but roulette was obviously out of the question. The Spanish pavilion, in the Charles V style, was mainly a tapestry museum, but hanging in a corner was the work of a young Catalan named Picasso. As for the Balkan countries, folklore seemed to take the place of art and industry.

An avenue running parallel to the embankment was lined with the smaller pavilions. The South American republics had chosen the *stile floreale*, a sort of Louis XV style which was flourishing in the tropics and which thus flattered the pride of visitors from these exotic lands. Most of the pavilions had been built with the aid of French funds and many of them were reconstructed in their own countries after the exhibition. The Ecuador Pavilion, which looked like a sweet-box, was to be 'transported to Guayaquil where it will serve as a municipal library. On the façade a large stained-glass window represents an allegorical landscape; to the right and left of the entrance are the busts of the poet Olmedo and the prose-

74

43, 44 Austrian pavilion. The exterior (*right*), in a Viennese Rococo style similar to that of the new wing of the Hofburg, gives no idea of the refinement of the interior decoration. The architect Max Fabiani designed one of the rooms (*left*), and the embroideries were by Charles Giani. This elegant style developed around the review *Ver Sacrum*. The Austrian pavilion was a great success.

writer Montalvo.' The Peruvian pavilion was in the same style but on a larger scale and decorated with miradors.

Beside these extravaganzas, imitations of which can still be seen in the wealthy suburbs of Mexico City or Buenos Aires, the Finnish pavilion seemed very different.

FINLAND AND RUSSIA

The Finnish pavilion was by far the most modern at the exhibition, in advance even of the Modern Style and Art Nouveau (**45–7**). In Finland, where political freedom did not exist but where the Russians allowed artistic independence, the architectural originality that had developed in Scandinavia was taken even further by Eliel Saarinen. The railway station in Helsinki, designed by Saarinen on the same principles as the Finnish pavilion and completed in 1910, was to serve as a model for the most advanced architects in Europe for the next twenty years and, when he emigrated to the United States, his constructions were the only ones to rival those of Frank Lloyd Wright. Since Horta, Gaudí, Guimard and Olbrich had not built anything for the exhibition, Saarinen was the only important architect to be represented. The connoisseurs were not mistaken. The most advanced review of the time, *Art et Décoration*, said:

For the quiet, thoughtful visitor who tries to judge works of architecture not

by the flattering attention which they receive from picture post-cards, nor even by the accumulation of gilded domes, scalloped friezes or tumultuous sculptures with which they catch the eye at a first view, the Finnish Pavilion is certainly one of the most alluring and profoundly interesting structures of the whole Exhibition. . . . Here we are in the presence of a genuine national art, and yet it is clearly something new. The architects have not confined themselves to seeking inspiration from local architectural elements. . . . Denmark and Norway, for example, have attempted to give such an impression in their pavilions. The Finns can recognize themselves in the completed work, but there is an individual stamp in the choice and arrangement of the various parts. . . . In their art the Finns seek inspiration in everything surrounding them, in their own natural environment, and it is this that gives an extremely vivid quality to what they produce. There is no attempt to use classical formulas, ready-made columns or capitals from which a cast is simply made, but instead a continual and direct return to the animal and vegetable worlds to find original forms of decoration. First of all it must be said that the Finnish Pavilion has been built by a young

45-7 Finnish pavilion designed by Eliel Saarinen (*left*). This style was to be much imitated twenty-five years later throughout Scandinavia and also in the seaside towns of Normandy. Inspired by an old Finnish church, this ensemble at first suggests a simplified folk style, but one soon perceives its great novelty. The stylization of the motifs and the form of the doorway seem to have been inspired by a Romanesque porch (*below left*). The bell-tower shows the skill of the Finnish carpenters and the fir-cone motif on the turrets (*below right*) shows the use of natural forms.

architect from Helsingfors, M. Eliel Saarinen, who has drawn up all the plans, designs and various details of ornamentation, and who has been assisted in the execution of the building-work by MM. H. Gesellius and A. Lindgren. The broadly arched doorways, the pointed roof resting on half-turrets, the distinctive form of the rounded bell-tower which dominates the whole with its delightfully curving arrises—all this is irresistible, and the pleasure of the eye is in unison with the logical satisfaction of the mind. The lines are simple, felicitous, and new. Even the arrangement of the colours, discreetly employed in the decoration of the roof of the bell-tower, adds a very pleasing impression which is enhanced by the beautiful varnished red wood of the doors. From the main lines and the general forms, the eye ventures to consider the details of the decoration. One observes, each time with renewed surprise, the ingenious ornamental inventions: the serpents descending from the roof of the bell-tower and the four bears placed at its base, in a simplified, solid style well adapted to the architectural sculpture of stone hewn in simple planes, and asserting their composite character. As we move downwards, the decoration becomes even

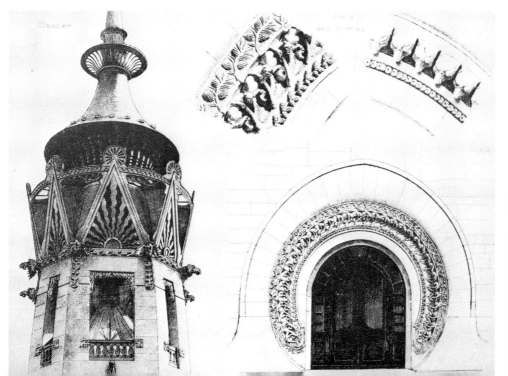

more attractive. First one notes the turrets which seem to enhance the entire perimeter of the roof and which take the form of fir-cones, with the overlapping of the scales soberly and accurately interpreted. The observation of everyday nature enlivens and enriches the construction; figures of plants and animals inherited from traditional styles could not possibly be introduced here. Around the doorway of the main façade there are bears' heads, again very simply modelled, and arranged in alignment; on the other façade the doorway is surmounted by a delicious frieze of squirrels playing in pine-branches. The same can be said of the frogs perched under the wings of the roof, as if they were coming out of their swamp to breathe in the air, and below them a light, fan-shaped pattern of water-lily leaves carved in delicate relief.

An artist inspired by sombre Nordic sagas, Axel Gallen-Kallela, painted some simple, melancholy frescoes (**48**). The furniture, designed by Gallen-Kallela, also seemed of the utmost novelty, although borrowing too heavily from folklore (**49**). The decoration of the interior included stoneware by Vallgren, who was well known in France.

While artists dallied in the Finnish pavilion, patriots queued to enter the enclosure of the Kremlin, in the gardens of the Trocadéro, which housed the exhibits of European Russia and her Asiatic possessions, the Russian section being far too large for the Rue des Nations (**100**). There was a complete village and the various Russian regiments were represented; the Emir of Bokhara had a pavilion adorned with fabulous carpets which foreshadowed the stage sets for *Schéhérazade*. A style

The Foreign Pavilions

48, 49 Axel Gallen-Kallela. The several episodes of a sombre saga decorated the hall of the Finnish pavilion (*left*). The painter, who was well known in Scandinavia, resembles certain Russian illustrators, such as Bilibin. His small armchair (*right*) in the same pavilion was twenty-five years ahead of its time.

emerges from this ensemble which one could call the 'Ivan the Terrible style', a galaxy of jewels and daggers, compact and gilded like a boyar in his ceremonial cloak. This brilliant ensemble of disparate elements was dominated by the golden eagles of the bell-towers. The French bourgeoisie felt greatly reassured and subscribed cheerfully to the loan floated by this empire of boundless riches. Paul Morand, who was a small boy at the time of the exhibition and who was particularly fond of the Russian pavilion, wrote in 1930:

> This Russia which is loved today for its poverty and which was loved then for its luxury: tables of crystal from the Urals, onyx dinner services, slabs of marbles never seen previously; the Kremlin bands played *Boje Tsara Krani*. Furs from all parts, from Amur to Finland, were exhibited: beavers from Kamchatka, otters from the Society of Otters, seals, red foxes and the skins of those great northern tigers with almost white fur, by comparison with which the tigers of the tropics are mere alley-cats. Everyone sat down and immediately the train moved off. What I really mean to say is that the painted scenery began to unfold before the window of the motionless carriage; we crossed great rivers scattered with driftwood, forests of pines and larch-trees, and deserts where Mongol tombs loomed up. The Russian government had put plenty of gold-mines and precious metals into this painted scenery, to bolster the confidence of French capitalists. We ate all sorts of *zakuski* as these desolate plains followed one after the other, plains traversed in bygone times by the Tartar warriors and the sable-merchants of Novgorod. Suddenly (I only had to close my eyes for a moment to rediscover my astonishment) the *muzhik* servant had vanished and was replaced by a Chinese boy in a robe of blue silk who brought tea perfumed with jasmin, in a little porcelain cup. —'Peking, all change!'

China, despite the total decadence of its administration, had managed to build an enormous and beautiful pavilion (**108**). Visitors were courteously received there in spite of disturbing news of missionaries being tortured and legations besieged, and of the imperial city being sacked in retaliation.

79

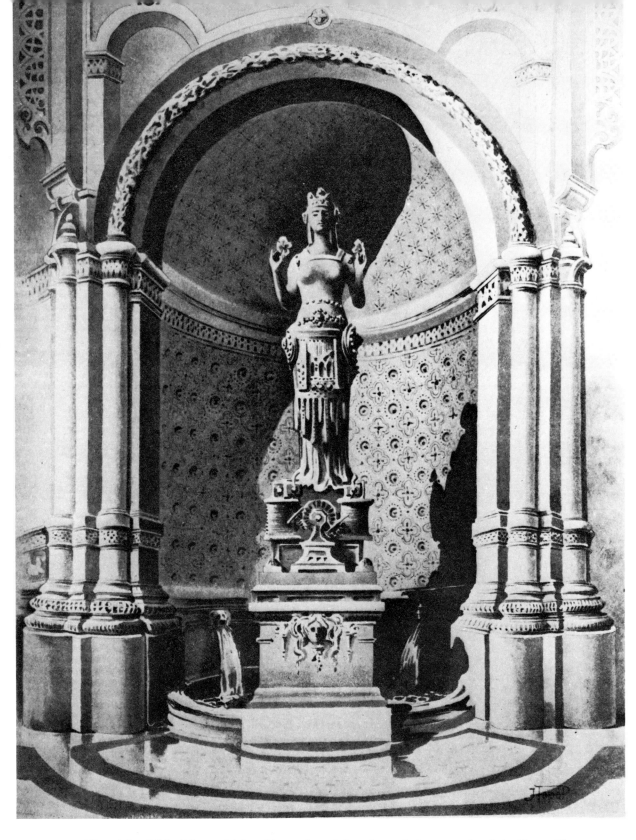

50 *Electricity*. This Salammbô in a Byzantine niche adorned the rotunda of the Porte Binet.

4

THE FAIRY ELECTRICITY

THE WORLD OF THE FUTURE
If Jules Verne provided the inspiration of the 1889 exhibition, a less serious person, Robida, should be awarded a similar role in the conception of the exhibition of 1900, for two reasons: as a draughtsman with a gift for the picturesque, he was responsible for 'Old Paris'; and, as a writer of futuristic novels, he had predicted the new world whose advent the exhibition proclaimed. The illustrations in his *XXème Siècle,* published in 1890, show how architects, consciously or unconsciously, imitate the fantasies of imaginative writers and artists. Today it is obvious how much the aspect of our modern world owes to the strip-cartoons of science fiction.

81

F

51 Decoration of the Palais de l'Électricité and niche of the Château d'Eau built over the Machine Gallery of 1889. This Neo-Rococo plasterwork recalls the interior decoration of certain German palaces of the eighteenth century. It is also the style of the Paris Opéra, the plaster lending itself to every kind of extravagance.

Robida's novel *La Vie Électrique*, published in 1895 and with the action set in 1955, predicted the visual telephone, the broadcast of news by television, air transport and even—an idea owing nothing to scientific innovation—a National Park of Armorica (ancient Brittany) which people entered by stagecoach (the Breton village built near the Trocadéro was a tremendous success in 1900). Robida could almost have designed the fabulous buildings (reminiscent of the spectacular fantasies performed at the Châtelet) erected on the Champ de Mars and dominated by the Palais de l'Électricité, a gigantic fan-shaped structure which towered above tiers of fountains, concealing the Salle des Fêtes and the Château d'Eau (**51, VI**). In spite of its extravagance, this group of fountains dedicated to the energy of the modern world remained very much in the tradition of the fountains at the Villa d'Este, Versailles and Peterhof; but they were designed on a vaster scale for the amusement of great crowds. More recent examples of cascades adorned with allegories were to be seen at the Palais de Longchamps, built in Marseilles during the reign of Napoleon III, and at the Trocadéro of 1878. This palace of the Thousand and One Nights is described thus in the Hachette Guide:

The Palace of Electricity, its imposing front facing the Trocadéro, joins the two wings of the constructions on the Champ de Mars, like a gigantic backcloth. Its façade has nine bays, covered with stained glass and transparent ceramic decoration of incomparable lightness and boldness. The total length is 130 metres and the height 70 metres. The centre is decorated with a scroll bearing the unforgettable date 1900. At night the whole façade is illuminated with the changing lights of its 5,000 multicoloured incandescent lamps, its eight monumental lamps of coloured glass, the lanterns of its sparkling pinnacles and its phosphorescent ramps. At the top the Spirit of Electricity, driving a chariot drawn by hippogryphs, projects showers of multicoloured flames. At night the openwork frieze forms a luminous embroidery of changing colours. The Palace of Electricity is designed not only to delight the eye. This enchanted palace contains the living, active soul of the Exhibition, providing the whole of this colossal organism

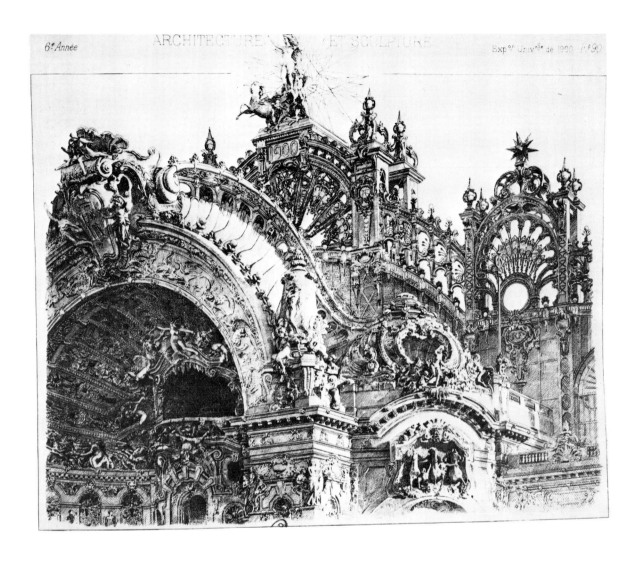

with movement and light. If, for one reason or another, the Palace of Electricity happens to come to a halt, then the entire Exhibition also comes to a halt; the thousands of machines stop working, the myriads of lamps in the buildings and gardens remain unlit. Without electricity the Exhibition is merely an inert mass devoid of the slightest breath of life. In the Palace of Electricity, indeed, is manufactured all the energy necessary for the lighting of the Exhibition and the operation of its various parts. From the basement of the Palace, leading in all directions, run miles and miles of wire transmitting power and light, along the walls, winding underground and crossing the Seine. A single touch of the finger on a switch and the magic fluid pours forth: everything is immediately illuminated, everything moves. The 16,000 incandescent lamps and the 300 arc-lamps

52 The automobiles. A whole gallery of the Palais de l'Industrie was devoted to automobiles. The variety of models is extraordinary when one realizes that the invention was barely five years old.

light up at the same time, at the Porte Monumentale, at the Pont Alexandre III, in the Champs-Élysées, at the Invalides, on the Champ de Mars and at the Trocadéro; the Château d'Eau sets its cascades of fire streaming. Everywhere the soul of the Palace of Electricity brings Light and Life.

Transformers utilized the energy produced by steam. In *L'Encyclopédie du Siècle* a journalist observed the anguish of the engineers responsible for producing the power on which the brilliance of the exhibition depended:

Leaning over the first-floor balcony of the Palace of Electricity, I witnessed the birth of the machines on the ground floor which constitute the mighty power-station of the Exhibition. . . . An easily recognizable signal gave warning of the imminent birth: the enormous chimneys, not normally used at this period, emitted great puffs of smoke. . . . I assure you, it was indeed a solemn moment when the foreman, his hand on the crank, opened the inlet valve. Certainly, all the components, carefully polished and oiled, were in their proper positions. But what if this marvellous anatomy were not to come to life when its burning soul of steam entered into it? Some men set the heavy fly-wheel going and suddenly the machine was independent of this artificial impetus; the steel components, small and large, turned, oscillated and vibrated: the beast had come to life. Of course, everyone was sure it would. But, all the same, this birth spread a proud happiness around it. A bouquet of fresh flowers was placed on the back of the cylinder and, believe me, they will certainly be watered. But all was not over with the starting of the engine. You should have seen those hands, some smooth, others rough with calluses, placed on every part of the machinery, feeling its pulse and trembling to see it heating up. It was feared that one of the parts might have a fever, in which case it would have to be treated at once.

One of the consequences of the widespread use of electricity was that the public lost interest in the machinery that had drawn so many people to previous exhibitions. Locomotives, boilers and blast-furnaces belonged to the nineteenth century;

they were relics of the Industrial Revolution, already out of date in spite of improvements. Only the automobiles really interested the visitors to the Machine Gallery and drew a few people to Vincennes to see an industrial and agricultural annexe of the exhibition (52–3).

Near the École Militaire stood some huge chimneys which had to provide sufficient power to operate the escalator that went round the Champ de Mars and the Invalides.

A NEW BEAUTY

At first the Palais de l'Électricité was a disappointment:

Will it work or won't it work? For two days all the newspapers have been announcing that this evening, at last, this eighth wonder of the world will be in full operation. Cries of anticipated admiration can be heard everywhere. When is it going to start? All around, the illumination of the pavilions lit *a giorno* intensifies the blackness of the great hole of darkness where the doubtful apotheosis of the Water Tower still lies dormant. The Water Tower is not working prop-

85

L. Sabattier

53 Automobile gymkhana in the Parc de Vincennes.

erly, or rather it is not working at all. Admittedly, the red and green friezes light up well enough, the details of their ornamentation teeming with mottled serpents; but the jets of water and the cascades of the tiers of basins at the bottom obstinately remain in darkness; they are lit up only by the intermittent beams of the Eiffel Tower. Sometimes, green glimmers can be seen flickering at ground-level and misty, livid hues rise a few feet above the crowd; but the central motif remains black. And then, suddenly, all the friezes are plunged into darkness (Jean Lorrain).

Two weeks later, however, everything had been put right and the aesthete Lorrain, captivated by this new beauty that had just been born, wrote:

The Water Tower is working at last and in a sparkling of stained glass, under its multicoloured pediment, can be seen the jets and cascades of liquid sapphires and rubies, then topazes and sards. At night the Trocadéro, tacked with large stitches of gold in every detail of its architecture, offers an Orient of the Ramadan and the bazaar: a mass of minarets haloed with fairy-lights, domes and terraces illuminated *a giorno* to the great joy of the eyes, which are amused by these interplays of electricity and shadows. But the main spectacle is in the dark, shimmering span of the river, the Seine suddenly constricted by the palaces of the Rue des Nations and the glass-houses of the Rue de Paris and carrying reflections and flames along its waters, the Seine transformed into an expanse of incandescent lava between the stones of the embankments and the pillars of the bridges. Oh, the magic of the night, the many-sided and changing night! The Porte Binet and its grotesque pylons become like translucent enamel and assume a certain grandeur. A symbol of the times, it is a gateway of Byzantium, the dome of some entrance into Tiflis or Samarkand dominated by the 'Parisienne'. Paris, the city of the Orient, Paris conquered by the Levant—this is what the crowds who throng the bridges and the Champs-Élysées are taught by the daily conflagration of the monstrous fair which is now in full swing.

Under the Porte Binet stood the statue of Electricity (**50**), like the priestess of Tanit, death-like in its stiffness and laden with ornaments which may have been electric batteries or coils. This effigy could well have been the Future Eve imagined by Villiers de l'Isle-Adam in his story of that title (1886), a futuristic novel which was certainly less popular than the works of Robida or Jules Verne, but which initiated a whole generation of writers and dreamers into the new world of fantasy. With the help of electricity, the temporary festival structures of the exhibition were transformed into the fairyland palaces imagined by the Symbolists. The Château d'Eau, with its changing colours, was for the crowds what the electric grotto of Ludwig II of Bavaria had been for the poets. For a time people were dazzled, then they grew accustomed to these marvels.

Loïe Fuller

An American woman, Loïe Fuller (**1**), who was neither pretty nor young, expressed the splendour of electric lighting so effectively that she came to be regarded as the embodiment of this new beauty. She had her own theatre at the exhibition (**54**). Her statue, with its mass of floating draperies, stood above the low, cavern-like entrance of the theatre. Inside there were enormous butterflies everywhere, recalling her most famous dance. In front of the entrance, statues of her by Pierre Roche which could be used as lamps were on sale. Of course, Jean Lorrain had to explain to Parisians what was new in this dancer's art:

The Fairy Electricity

54, 55 The Loïe Fuller theatre (*left*) was designed by
Henri Sauvage. It is typical of the vulgarities of the
'Modern Style'; a statue of Loïe Fuller crowns the entrance.
The performances which she gave here enraptured the
artistic public, who bought bronzes of the dancer, in the
form of lamps or ash-trays, as they came out. The bronze
grille (*below*) was by Lalique who transformed the most
commonplace objects into jewelled designs. The butterfly-
women are a tribute to Loïe Fuller.

Modelled in glowing embers, Loïe Fuller does not burn; she oozes brightness,
she is flame itself. Standing in a fire of coals, she smiles and her smile is like a
grinning mask under the red veil in which she wraps herself, the veil which
she waves and causes to ripple like the smoke of a fire over her lava-like nudity:
she is Herculaneum buried beneath ashes, she is the Styx and the shores of Hades,
she is Vesuvius with its gaping jaws spitting the fire of the earth, and she is Lot's
wife transfixed in a statue of salt amid the avenging conflagration of the five
accursed cities, this motionless and yet smiling nakedness among the coals with
the fire of heaven and hell for a veil. I have already talked elsewhere of the morbid
voluptuousness of the Dance of the Lily—La Loïe, wrapped in wreaths of frost
and opal shimmerings, herself becoming a huge flower, a sort of giant calyx with
her bust as the pistil. But what I have been unable to tell you and could never
convey properly (of this I am aware), although I long to do so, is the sublimity,
the deathly terror of La Fuller's entrance in the Dance of the Lily. In a sea of
shadows a grey, indistinct form floats like a phantom and then, suddenly, under a

56 Palais Lumineux, erected in the gardens of the Champ de Mars. The last example of chinoiserie in the tradition of the Rococo pavilions, covered with ceramics and cabochons that sparkled in the evening under projectors of different colours. To the left, the turrets of the 'Tour of the World'.

a beam of light, a spectral whiteness, a terrifying apparition. Is this a dead woman who has been crucified, hovering above a charnel-house, her arms still held out under the folds of her shroud, some huge, pale bird of the polar seas, an albatross or a gull, or perhaps a spirit of the dead on its way to the sabbath, a martyr of ancient times or a ghoul of the cemeteries? But how poignant, how superb, how overwhelming and frightening, like a nightmare induced by morphine or ether.

Instead of the 'Parisienne', stiff as a dressmaker's dummy, an effigy of Loïe Fuller swirling under the projectors should have crowned the Porte Binet. Her image, or rather her quality of movement, could be found reflected in all the truly modern parts of the exhibition, in bronze, in glass, in fresco or in terracotta. Her fluttering veils inspired the glass tulips enclosing the electric bulbs and also the precious ornaments of Lalique (**55, 58**). In the Decorative Art section great attention was paid to the processes of the new technique of lighting. The corollas of the flowers were mostly modelled in the style of the 'biological Romanticism' that dominated Art Nouveau decoration. The other tenet of that movement, 'abstract dynamism' (both phrases were coined by Schmutzler), was not represented in these magical but frivolous pavilions.

Another woman, this time a classical dancer, Cléo de Mérode, imposed her countenance on the exhibition's decorators: a perfect oval, with the smile of the Mona Lisa and the hair bound with ribbons, her face could be seen on keystones and consoles, and on countless mermaids and fairies which seemed to come to life, emerging from the realm of legend.

Alas, Loïe Fuller did not perform in the electric pavilion of Poncin (**56**), a structure covered with coloured vitreous enamel and bristling with dragons of wired glass, a sort of Chinese kiosk situated on an island of rockery in the little lake below the Eiffel Tower. The pavilion, an extreme example of the *chinoiserie* fashionable in the eighteenth century, was illuminated by extraordinary light effects on curtains of coloured beads and through glass flowers. A restaurant beside the lake made it possible to enjoy the spectacle without being bothered by the crowds.

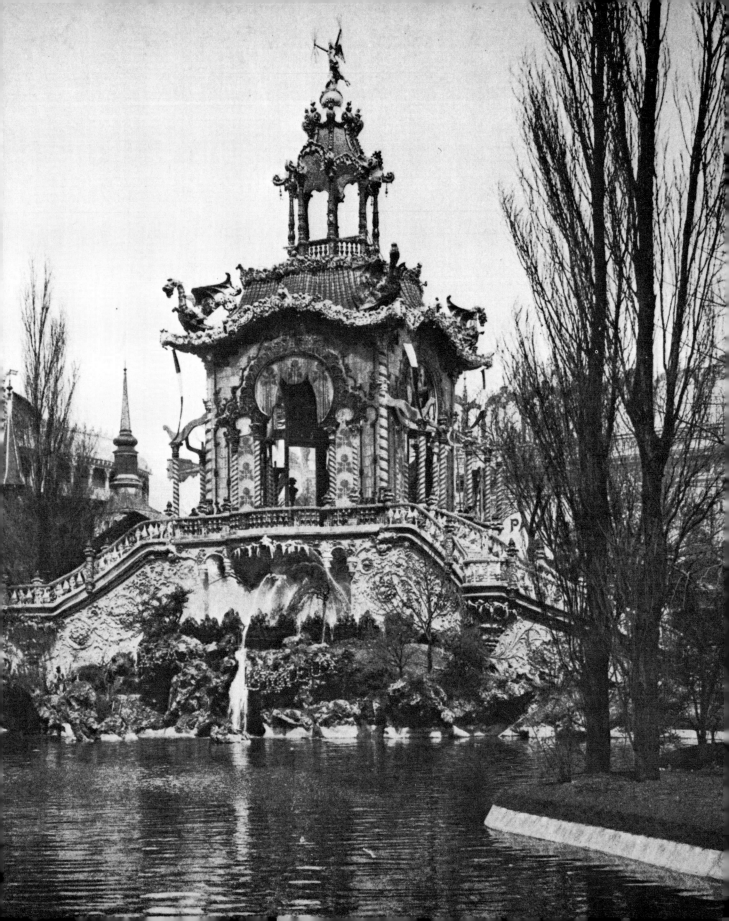

57 *Electricity* by Eugène Cormon in the Salle des Fêtes.
One of the paintings glorifying the workers. But observe
the elegance of the telephone-girls. The automobile is
one of the first to have been represented in a painting.

The Loïe Fuller vogue lasted as long as electricity was regarded as a miracle.
When people became sated with nocturnal illuminations and nearly everyone had
electric current in their homes, the woman who had embodied the new energy and
the new beauty returned to obscurity and the public turned its back on Art Nouveau.
Soon electricity became a household spirit rather than a magician. But it seems that
even this had been foreseen, if one is to judge by Fernand Cormon's fresco *Electricity*
(**57**) in the Salle des Fêtes:

Electricity forms a group arranged with a rare felicity. In the light of the
incandescent lamps suspended from gigantic poles at the very top of the composi-
tion, an automobile carrying an elegant group can be seen flashing over the ground.
In front of it a workman in shirtsleeves raises the lever of a powerful dynamo and,
on the opposite side, an appetizing group of young beauties indulges in the joys
of sending telegrams and of telephonic communication. Two of them, sitting at a
table, tap furiously on the keyboard of a transmitting machine, or unwind the
long blue ribbon punched with cabbalistic signs by the receiving apparatus. In
the foreground a telephonist, standing by her switchboard, holds to her ear the
rubber disc encircled with metal in which the subscriber's voice can be heard
(*Le Figaro Illustré*).

OPTIMISM

Electricity owed its triumph largely to the fine weather. In fact, everything went
badly for the first month after the opening: there were delays, mishaps, and not
many visitors. A bitterly cold spring had transformed the promenades into a freez-
ing building-site. But around 15 May, at the moment when the Château d'Eau
began to operate, the weather changed and there followed four months of sun, with
an extraordinary heat-wave in July (38°C—100°F—in the shade). The fine
evenings lured all of Paris to the exhibition. From the café pavements and the river-
steamers people could enjoy the nocturnal festivities, crowding in front of the

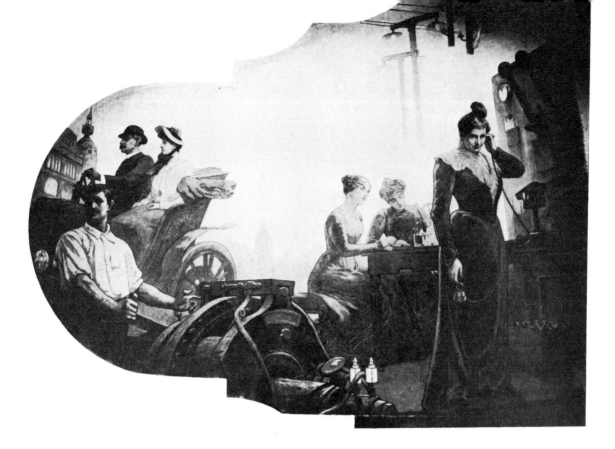

Château d'Eau to watch the illuminated fountains. Pessimism made way for euphoria. Undoubtedly, if the bad weather had continued, serious-minded people would have found the exhibition extremely interesting, but no one would have talked of its magic.

Two quotations, quite different in spirit, will help to show how the exhibition gave Frenchmen the feeling of entering an age of miracles. The first quotation is from an excellent art critic, Gustave Geffroy, describing a night scene on the Seine in the *Gazette des Beaux-Arts*:

It is an avalanche of diamonds, a shimmering of jewels. Electricity returns what it is lent a hundredfold, and even to infinity, sending flashes and glimmers rippling in waves into the farthest and most hidden corners of the darkness. The Exhibition, illuminated and reflected in the water, thus has a special charm. The river is transformed into a fantastic street of light and shade, traversed by dazzling gilt and multicoloured bridges. All along it one sees the inverted image of a dream-city, as in certain Japanese landscapes, night-blue and lit with lanterns. In the depths of the water the arches form caverns straight out of the Thousand and One Nights, where the invisible hands of fairies and goblins unceasingly stir liquid riches, gold, silver, molten metals, torrents of stars, brilliant clouds of Milky Ways. Hidden under the banks are the borders of strange forests,

93

bright and quivering foliage laden with resplendent fruits. Between the banks, in this inverted city, pass the boats adorned with many-hued fairy-lights and festoons of coloured glass.

The second passage is from Charles Simond, the conscientious historian of the City of Paris who has already been quoted in the Introduction:

If the organizers had succeeded in spreading the magic of life over its vast surface, this was because a new force, electricity, had given them the assistance of a mysterious power; in a kind of dawning apotheosis, they had been able to offer us the spectacle of electricity transforming and recreating everything— movement, light and sound—by means of invisible wires, without the odious inconvenience of the clumsy transmission machinery which steam needs. With electricity, power becomes lighter as it increases tenfold—and in Paris itself, quite apart from the Exhibition, had it not already triumphed with the opening of the Métropolitain? In this victorious affirmation of an unrivalled power, the year 1900, though bringing one century to a close, was really ushering in another, the twentieth, which will be the age of physics, far superior in strength to the nineteenth century, the age of chemistry.

Thus electricity was immediately regarded as a beneficent force. The manner in which it was used at the exhibition made people think that humanity was finally entering upon the age of light; everything seemed possible and happiness was within the reach of all—soon one would only need to press a button. Alas, the optimism of 1900 seems naïve in our atomic age, but for a time it swept away the political quarrels, the social restlessness and the military rivalries that had poisoned the preceding decade. In his book *1900*, which is admirable except when he writes about Art Nouveau, Paul Morand recalls this euphoria:

It was then that a strange, crackling, condensed laughter resounded, the laughter of the Fairy Electricity. She triumphed at the Exhibition; she was born of the heavens, like true kings. The public laughed at the words 'Danger of

Death' written on the pylons; it knew that Electricity cured everything, even the 'neuroses' fashionable at the time. It was progress, the poetry of both rich and poor; it bestowed light in abundance; it was the great Signal; as soon as it was born, it swept acetylene aside. At the Exhibition it was used with gay abandon. Women were like the flowers enclosing the electric bulbs, which in turn were like women. It was electricity that enabled the espaliers of fire to climb over the monumental gateway. At night, projectors swept across the Champ de Mars and the Château d'Eau sparkled with cyclamen colours; it was a tumbling mass of greens, orchid-coloured flashes, flaming lilies, orchestrations of liquid fire, a riot of volts and ampères. The Seine was violet, dove-coloured, blood-red. Electricity was accumulated, condensed, transformed, put in jars, stretched along wires, rolled round coils, and then discharged into the water, over the fountains, over the roofs and into the trees. It was the scourge, the religion, of 1900.

58 René Lalique: Electric lamp-bracket of gilt bronze.

59 Art Nouveau elegance in an interior by Georges de Feure.

5

DECORATIVE ARTS

THE TRIUMPH OF PRECIOSITY While the most important edifices, those built to last, marked a return to Baroque bombast, the temporary structures showed a Neo-Rococo tendency, an attempt to recapture the delicate extravagance of the pleasure pavilions of the eighteenth century. This style was to be found in the parallel rows of pavilions, beyond the Pont Alexandre, which were devoted to wood, fabrics and iron-work—that is, to all those industries which might serve the purposes of decorative art. The art critic André Hallays expresses exactly the reactions of persons of taste:

G

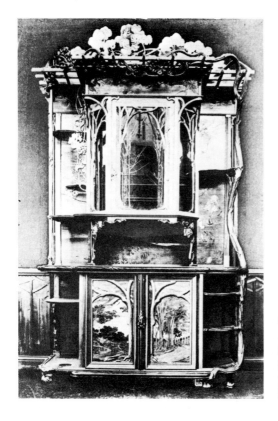

60 Emile Gallé: Dining-room sideboard entitled *La Blanche Vigne*. This kind of wood-mosaic furniture was very expensive. But nests of tables and trays in the same style, without the slightest pretensions to good taste, were soon to be found in every home.

The 'palaces' that have been erected on the Esplanade des Invalides are masterpieces of ugliness. Viewed as a whole, as one leaves the Pont Alexandre III, they inspire terror. If one examines the crazy decoration on each façade, they leave one dumbfounded. Architects, sculptors, ornamentalists and painters seem to have been trying to outdo one another in incoherence. It is a hotchpotch of horrors. At first, one ascribes it simply to an attack of general madness. An exaggerated German Rococo is intermingled with the most depressing and vapid echoes of the 'school style': it is as if the students of the Rue Bonaparte had amused themselves by caricaturing their own ponderous concoctions; they have stuck cockerels on the classical cassolettes [incense-burners]; they have crowned the pavilions with domes ribbed like melons or with Wallace fountains. At first, one has the impression that a horde of artists has been let loose on the esplanade with the instructions: 'Build, carve and paint'. And they have all built, carved and painted as the fancy took them. . . . But if one looks more closely, one is not fooled for long by this deceptive appearance. One soon realizes that, underlying all this extravagant decoration, there is a definite purpose—what shall I say, a certain unity. Yes, a single idea has dominated this ensemble: Make things cheerful.

Behind these palaces stood pavilions where a more imaginative, less official style was permitted. Here, rather than in the official sections, flowered the Art Nouveau movement which for the past ten years had been striving to change traditional decorative styles, and even the whole aesthetic creed. Art Nouveau had left its mark on both the most precious and the most commonplace objects exhibited in the pavilions of the decorative arts, whereas it was hardly to be seen in the buildings designed by the pupils of the École des Beaux-Arts. Thanks to artists like Eugène Grasset, who had published books in which botany was treated artistically, and Georges de Feure, the designer of fabrics, and thanks to the posters of Mucha and the vases of Gallé, the sinuous lines of Art Nouveau found expression in iron and wood, while its delicate colours shimmered on glassware and pottery. Artists stylized everything with gay abandon, even in the most modest studios, and lilies, irises or swans adorned lace-work, blotting-pads and baths.

The need for artistic creation was so great that the young people who had hitherto been content to express themselves in watercolour took to poker-work, embossed leather or stencilling. This new enthusiasm was accompanied by the idea that the art of the future would be an art for all, not only replacing the clutter of furniture in the apartments of the bourgeoisie, but bringing gaiety into the homes of the workers. And so the pavilions on the Esplanade des Invalides which proclaimed the supremacy of art were visited and discussed much more than the industrial pavilions on the Champ de Mars, where the machinery belonged essentially to the nineteenth century. The Fairy Electricity was allowing the arts to flourish, while steam, utilitarian and dirty, represented the materialism of the closing century. Many Frenchmen, however, turned up their noses at this prodigious renaissance of the decorative arts and, as always, patriotism came to the assistance of their humdrum mentality. André Hallays, though a discerning critic of earlier art wrote:

The most original feature of this decorative parody is its universality. The Modern Style is European. Visit the exhibition of furniture. Everything is contorted, attenuated and unbalanced according to the new fashion. From the north

61, 62 As in their national pavilion, the Germans did things on a grand scale in the gallery of decorative arts (*left*). A mosaic representing Parsifal dominates this hall, cluttered with bronzes which are more '*Wilhelminich*' than *Jugendstil*. The décor (*right*) was highly characteristic of the *Jugendstil*, showing how this style preferred straight lines and circles to the convolutions of Art Nouveau. There are traces of a Scandinavian archaism, comparable with the Cologne railway station which was one of the most advanced buildings in Imperial Germany.

to the south of Europe are to be found the same thin, unsteady shapes, the same vague and puerile decoration. The Germans streak the draperies of their most Gothic interiors with weird designs and produce an extraordinary mixture of the medieval and the new. The Viennese have adopted the decorative zigzag with an alarming enthusiasm. Furniture in the Modern Style is made in Barcelona. And in their admirable pavilion, a masterpiece of architecture, the Finns have exhibited furniture which, though made of Finnish pine, is none the less Belgian, indeed Belgian three times over. . . . For it was from Belgium that the new fashion came and spread across the world. A few Belgian artists—painters, ceramists and architects—have attempted a renaissance of decoration and furniture, and they have succeeded. Instead of each making a similar attempt in their own countries, other peoples have set about borrowing from the Belgians what was either most eccentric or most peculiarly national in their works. And Europe has been Belgified. Obviously, at the origin of this Belgian movement one finds the influence of English art. But today, in everything called Modern Style, in France, in Germany, or elsewhere, one finds only a slavish imitation of Belgian art.

THE FOREIGN SECTIONS

In spite of its influence on other countries, Belgium did not achieve any greater distinction on the Esplanade des Invalides than in its medieval pavilion. Once again, Germany occupied the most space and Austria sent the prettiest exhibits. The German hall (**61**) was Wagnerian in its frescoes and sculptures (in the centre a gigantic eagle slaying a dragon) and modernist in its general lines, which were straight and massive—in short, it showed little evidence of Art Nouveau. In the minor rooms, however, admirers of the covers of the *Jugend* magazines could find the same refined style (**62**), sometimes spoilt by a heavy humour (the bathrooms looked like Fafner's cave).

If Berlin had imposed official art in the main pavilion, Munich, the artistic capital of Germany, dominated the decorative section. There were draperies em-

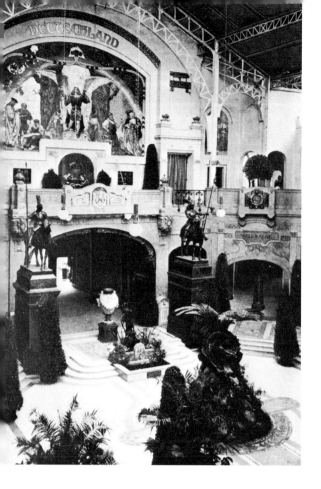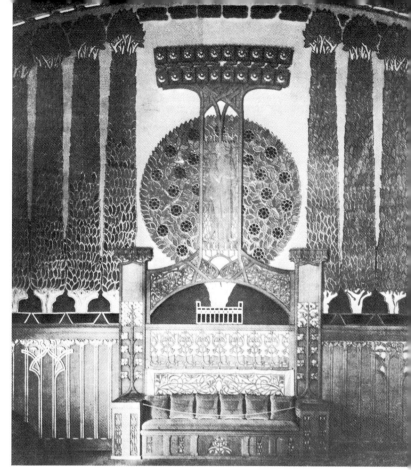

broidered by Obrist and a room 'for an art-lover' with a plaster frieze by Riemer-schmid. The pottery and the hangings, often inspired by the art of Archaic Greece, foreshadowed the simplicity that was to blossom twenty-five years later at the Exhibition of Decorative Arts. In the formation of this Neo-Neo-Classicism, which was to produce excellent results under the Weimar Republic, no one proved more influential than the painter Franz von Stuck. This artist was at the time embarking on the plans for a vast villa in the ancient style (now the Von Stuck Museum in Munich) and working with Heissnanseder on furniture far removed from the *Jugendstil*, which was already considered vulgar. The cabinet-maker Heissnanseder received a gold medal for his furniture.

In a museum quite different from the Musée des Arts Décoratifs are still to be found not only individual objects but also some complete ensembles that were to be seen at the 1900 exhibition. This is the Hamburg Museum für Kunst und Gewerbe (Arts and Crafts). The city of Hamburg in fact accorded a considerable sum (more than a million marks) to its director Justus Brinckmann, who bought enough at the exhibition to fill a huge display room, known as the Pariser Zimmer (the Paris Room) (**63**). Here one can see the best examples of furniture, tapestries,

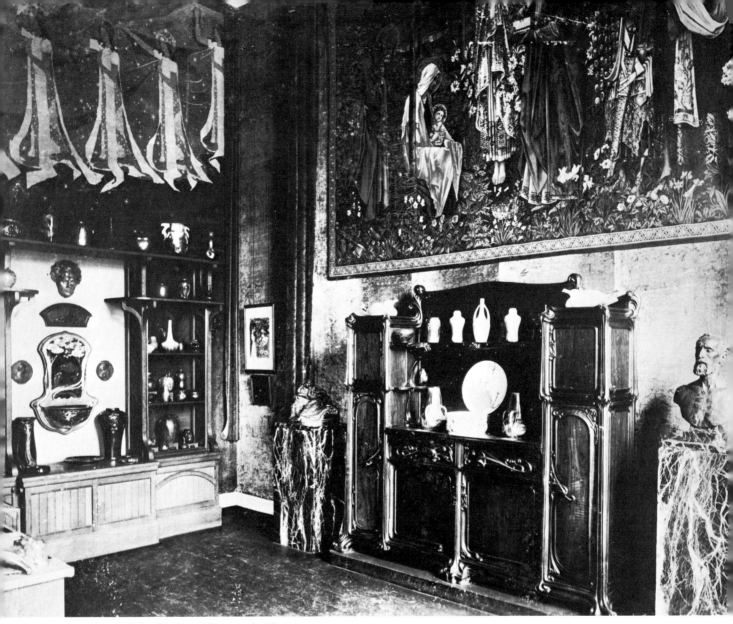

63　The Pariser Zimmer in Hamburg.

and ceramics brought from the various pavilions. The sums that had been paid out for all this led to strong attacks in the more nationalistic German newspapers 'for spreading degenerate art in our healthy Germany'. The Darmstadt museum also bought a number of items in Paris. The Germans particularly liked tapestries, a type of object which had little success in France but which was to flower in Germany with Otto Eckmann and even more in Scandinavia with Munthe (**69**) and Hansen (**XVI**).

The two greatest architects of the Secession movement, Josef Olbrich and Josef Hoffman, had each designed an enormous room. Olbrich's room (**65**) presented an uneasy mixture of William Morris, echoes of the Rococo and a sprinkling of

64 Carpet by Alfons Mucha in the Austrian section with all the sources of Art Nouveau: Celtic interlacings, Japanese stylized flowers, Byzantine haloes and wheels from India.

65 J. M. Olbrich: A drawing-room in the Austrian section. One of the successes of the Secession style, closely resembling the décors of Klimt.

66 (*opposite*) Josef Hoffmann: Interior of the School of Decorative Art in Vienna, or boudoir for a lady painted by Klimt.

furniture twenty years ahead of its time. An extremely simplified floral decoration also helped to launch the Decorative Arts movement. In Hoffmann's room (**66**) one can imagine the bankers' wives who posed for Klimt in hieratic, sophisticated attitudes. The linear mural decoration, and some extremely simple pieces of furniture, were taken straight from Beardsley's designs for *Salomé*: no one had ever seen such audacity. Austria enjoyed another success, though more predictably, in the works of Alfons Mucha which were scattered here and there: a beautiful carpet in the textiles section (**64**); in the typography section, illustrations to the Lord's Prayer (the intricate interlacings, the peacock plumes and the dishevelled hair also featured in the design of the carpet); and the much simpler frescoes in the Bosnia–Herzegovina pavilion, where the misty expressions on the faces of the peasants recalled the painter's favourite model, Sarah Bernhardt (**40–2**).

Hungary exhibited the Mitteleuropa style (**67**), in which heraldic motifs were linked by the creepers of the *Jugendstil*, but with a touch of *turquerie*, and with echoes of Byzantium in jewelled copper objects. In the Hungarian and Bohemian sections visitors were delighted by some pretty furniture in a rustic, or, more precisely, a folk style. In France, this return to the land and the vogue for sea-bath-

104

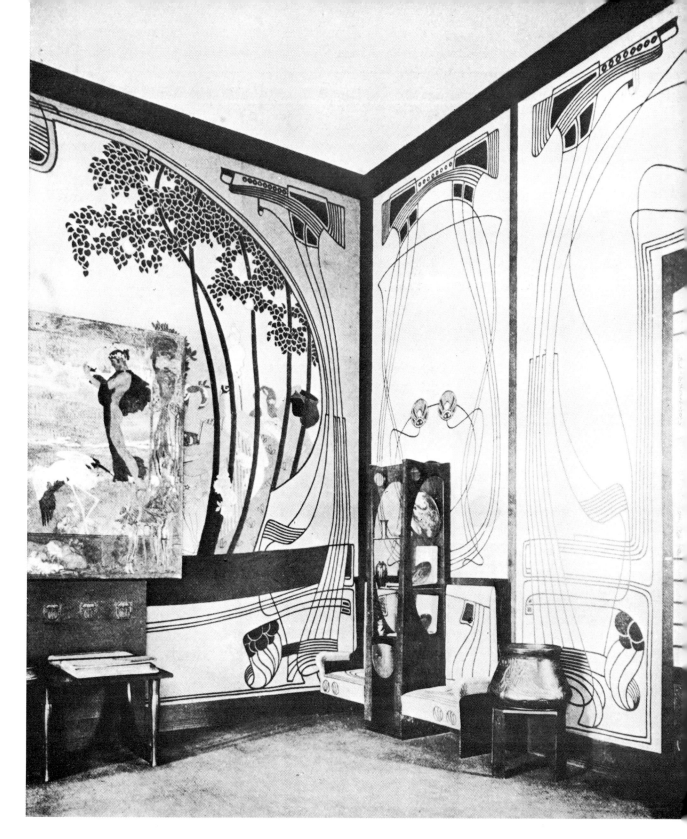

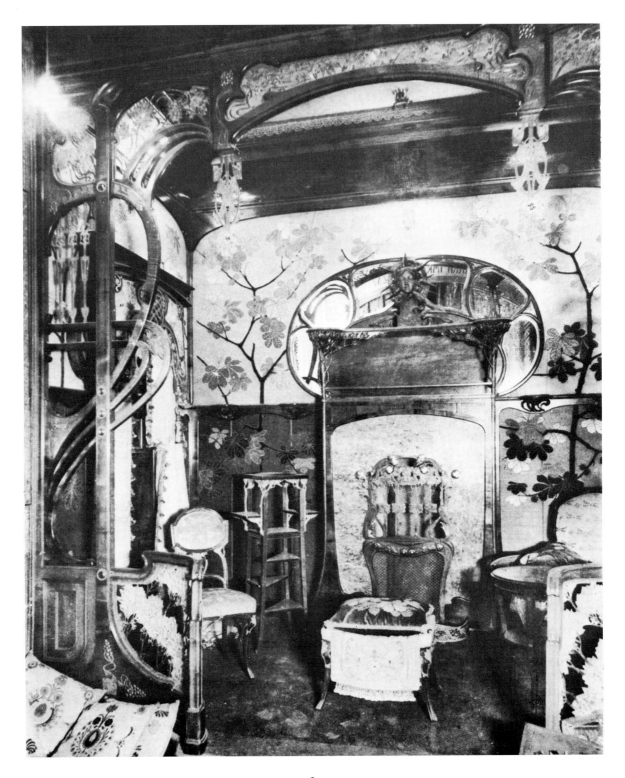

67 (*opposite*) Fork: Drawing-room in the Hungarian section. An example of the Modern Style run riot (often called the 'Munich' style in France).

68 Wash-basins by Mamontoff. Russian decorative section. This brightly coloured ceramic work has a clumsiness characteristic of folk-art; the mythical birds recall the designs of Bilibin and foreshadow the décor for *The Firebird*.

ing were later to lead to the Breton, Basque and Provençal styles of furniture. Examples were already to be found in the Maison du Poitou, in the Provençal farm-house and in the Arlesian house (carved wood stained with walnut and cretonne printed with simple designs).

It was folklore, once again, that enabled Russian decorative art to escape from the European imitations in which it seemed to have been trapped for the past two hundred years (**68**). An article by Miss Netta Peacock (what a typically 1900 name!) in *The Studio* shows clearly the influence of Tolstoy on the organizers of this section:

> The future of this decoration, which appeals both to the eye and to the fancy, lies in the fact that it deals more with colour than it does with line, and, with rare exceptions, deals with simple subjects simply treated. It seeks its inspiration in the very heart of life—in nature as seen through the eyes of the peasant, who is free from all the conventionalities of civilization, and whose eye is unspoilt by the constant contemplation of the ugliness which is so unsparingly distributed around us. The real poetry of life is the peasant's birthright—he is in ceaseless intercourse with the splendour and mystery of ever-changing nature. Therefore this art is spontaneous, sane, vigorous and serene.

In workshops such as those of Princess Marie Tenicheff and Hélène Polenoff, craftsmen worked under intelligent supervision, but the results of their efforts were to be seen not so much in the decorative arts—few people, apart from a handful of rich Muscovite merchants, wanted to live in an *izba* or peasant hut, however sumptuous—as in designs for stage scenery. (About twelve years later, Larionov and Gontcharova were to work in this same spirit for Diaghilev.) The carved and painted wood, and the fabrics with appliqué ornamentation, were inspired by Slav legends; but the furniture was so crudely coloured and so uncomfortable that even admiring visitors were hardly encouraged to place orders.

In Scandinavia, similarly, the sagas inspired craftsmen no less than painters. The simplicity and the geometrical motifs of the tapestries of Gerhard Munthe (**69, 70**) also foreshadowed the Decorative Arts movement, while the legendary

69 Gerhard Munthe: Tapestry inspired by Norwegian
popular art but distinctly Decadent in its theme.

character of their themes created a pleasing effect. In other words, in all the
Germanic and Slav countries the spirit of William Morris was triumphant.

Great Britain, however, which had advanced beyond this stage, could offer little
more than comfort in its furnishings. Unfortunately, the young Glasgow school
was not represented, but there were some wallpapers by Voysey. The United States
had nothing of real interest, except for some attempts to imitate the style of *The
Chap-Book* and some glassware from Tiffany's.

The Japanese pavilion, on the other hand, thrilled the visitors. It was oddly
situated between 'Old Auvergne' and the Viennese restaurant. Admittedly, Japan's
first lessons in good taste dated from the exhibition of 1878, but in 1900 the influence

70 Mural drapes designed by
Gerhard Munthe. Norwegian
section of the Palais des Arts
Décoratifs. The armchair re-
mains Victorian in its lines,
despite attempts at stylization.

71 (*right*) Pleyel piano, model by Tassu. Such objects brought the Modern Style into disrepute, earning it the nickname '*style nouille*' (noodle style).

72 (*far right*) Armchair of Algerian plane-wood, designed by Georges Hoentschell for the Pavillon des Arts Décoratifs. The exuberant vegetation is typically Art Nouveau, but it is not sufficiently stylized.

of Art Nouveau—the porcelain of Copenhagen, for instance, with its misty hues—was to be seen in the most recent Japanese products.

Italy's exhibits, and particularly its furniture, baffled those who considered themselves up-to-date:

> Wooden negroes and negresses in tinsel clothing, holding a halberd or a tray in their hands; looking-glasses shaped like violins and mirrors like harps; garlands of cupids in light wood; consoles like corkscrews and unsteady pedestals; seats on which one cannot sit—all the most bizarre objects the imagination could possibly conceive had been assembled there. The Gothic, the Renaissance and the eighteenth century had been enlisted to create a nameless style, contorted in volutes, astragals and coils, and the carved wood, a good and honest wood, thus became an angry, spiteful substance eager to catch the eye and tear people's clothes (*Revue des Arts Décoratifs*).

THE MODERN STYLE

It would be almost as exhausting for the reader as it must have been for conscientious visitors to dally long in the huge French palace on the east side of the Esplanade des Invalides, where goldsmith's work, bronze, furniture and tapestries were arranged in categories. Each section had its own room. Only the section of the Manufacture Nationale of Sèvres was of any real interest, for here visitors could observe the clash between the heavy Neo-Rococo style of official art (mainly articles produced for the embassies and vases presented to visiting monarchs) and Art Nouveau, which was represented by a whole series of vases inspired by the *grisaille* designs of the porcelain factory of Copenhagen. The vitreous enamel bas-reliefs of Henri Cross were enormously successful among connoisseurs, while the series of scarf-dancers captivated society people. A number of private firms had more daring stands, for all up-to-date architects at this time wanted to cover the façades of large buildings with faience designs and bathrooms were becoming more common (the

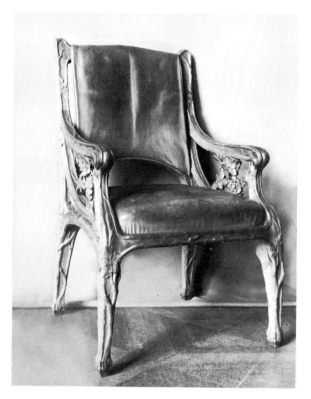

tiles were decorated with lilies and swans). The lavatories of the Casino at Monte Carlo are the best surviving example of the Modern Style put to the service of plumbing. The stands displaying leather and lace goods, wildly Modern Style and showing little evidence of Art Nouveau, represented what soon came to be known as the '*nouille*' (noodle) style (**71**), of which Maxim's restaurant remains the supreme example. Within three or four years the expression 'Modern Style' came to designate all the Art Nouveau inventions that had been reduced to vulgarity through mass production. Some of the showcases contained very ugly objects sent by routine industries; the religious art section was quite atrocious, until Maurice Denis and his friends decided to drive the tradesmen from the temple and to create a religious art in the spirit of Symbolism.

The most poetic and least commercialized Art Nouveau was to be found not in the official palace, but in some of the pavilions. The great Parisian shops Le Printemps, Le Louvre and Le Bon Marché were accommodated under the same roof. One of the surest signs of the role which art was assuming in commerce was this group of shops in which elegant décor replaced the frugality described by Zola twenty years earlier in *Au Bonheur des Dames*. Grasset, for example, had designed some delightful almanacs for La Samaritaine.

VIII Pavilion of the Union of Decorative Arts reconstructed in the Musée des Arts Décoratifs around Besnard's painting *L'Ile Heureuse*. Furnishings by Majorelle.

Fortunately, one of the rooms of the pavilion built by the Union Centrale des Arts Décoratifs, under the direction of Hoentschell, has been almost exactly reconstructed in the Musée des Arts Décoratifs in Paris (**VIII**). Today, in the same showcases, carved like branches, and under the same wall-panelling, one can see the objects which attracted so many visitors. This is the only interior ensemble of the exhibition that still exists in its original form. In fact, the photographs of the pavilion are a little disappointing. The collectors who controlled the Union Centrale des Arts Décoratifs had instructed Hoentschell to design a 'folly', a small eighteenth-century pavilion of the kind built to house the collections of art-lovers. In this Louis XVI style, Art Nouveau is to be found only in some naturalistic plant motifs surrounding the windows or in the wrought ironwork. Here one can discern the influence of Robert de Montesquiou, a close friend of the decorator. The aesthete was a votary of the classical tradition, only really enjoying the modern in furniture or trinkets.

The interior of the pavilion was arranged rather like a jeweller's shop. There were only three rooms. The first, the one reconstructed in the Musée des Arts Décoratifs and entirely the work of Hoentschell, rested on wooden pillars carved like trees which suggested a Wagnerian nature-mysticism—in fact, it was all rather like a stage set for Klingsor's garden, with Lalique's jewellery (**74–6, XI**) and Gallé's glassware (**73, X**) for flowers. In these showcases, among the carved branch-work, visitors could admire Art Nouveau's most accomplished products, those most highly esteemed today and which were responsible for this movement's emergence from oblivion some ten or fifteen years ago. In the centre, a large composition by Albert Besnard, *L'Ile Heureuse*, which has nothing Wagnerian about it, conveys the poetic optimism of the period. Besnard was regarded as the Rubens of 1900 and his incredible fluency made this a not unreasonable comparison. He had also provided a decoration of nymphs for the stand of the perfume-manufacturer Pivert. Drapes in various shades of pink blended with Besnard's warm harmonies.

Then there was a room constructed of iron, in the style of an underground station entrance, designed by Robert and accommodating the ceramics section. Hoentschell

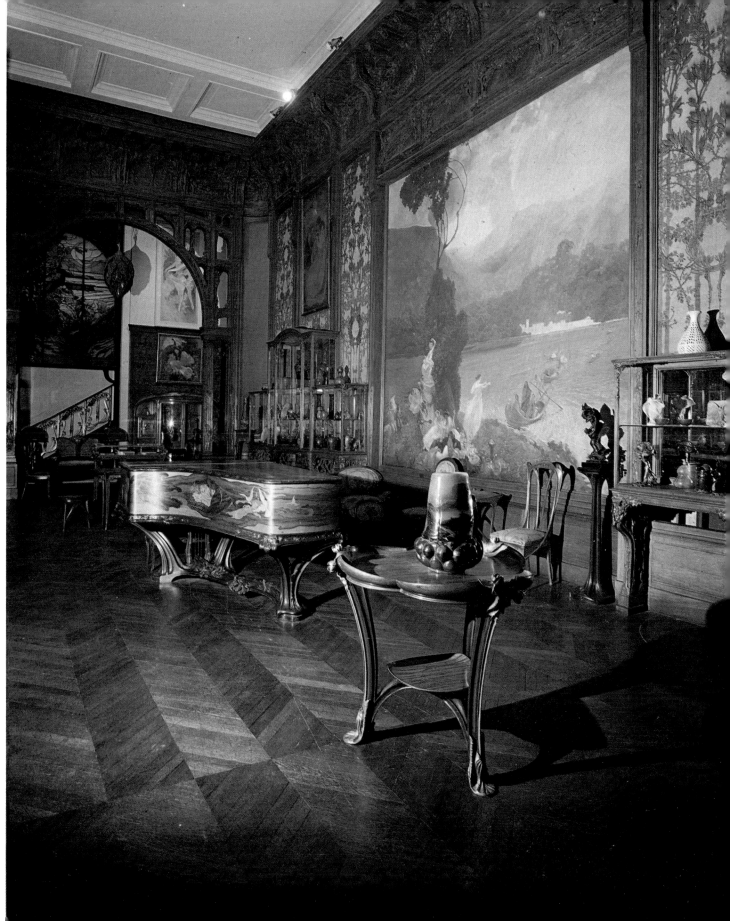

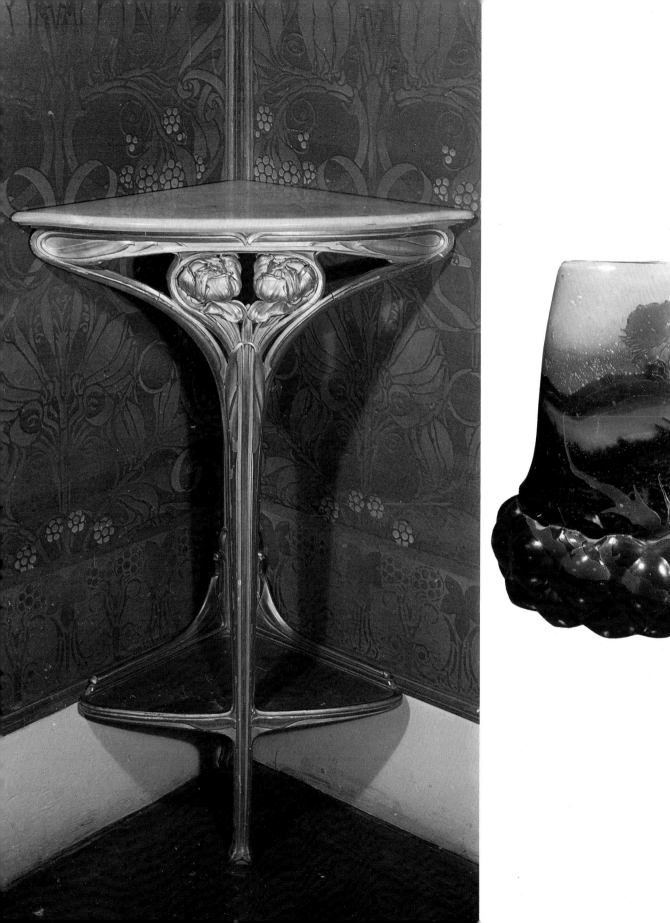

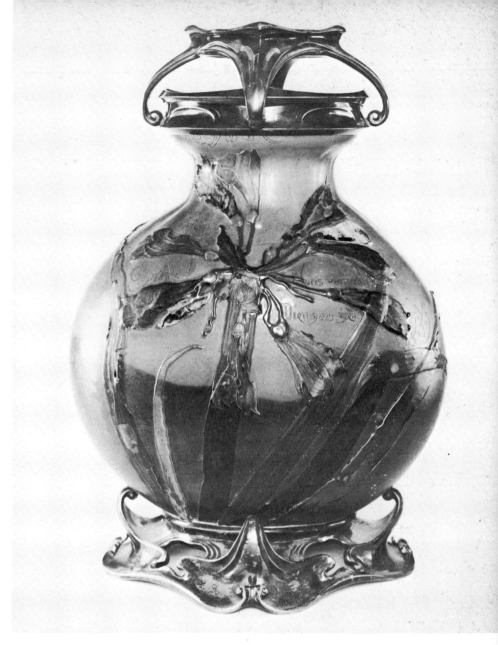

IX (*far left*) Gilded wood console table after a design by de Feure.

73, X Glass vases by Émile Gallé. The inscription 'We shall win, God is leading us. Emile Zola' (*right*), is proof of Gallé's faith in the innocence of Dreyfus. This vase or a similar one, had been presented by the artist to Sarah Bernhardt, who shared his convictions. It was mounted in silver by Bonvallet.

had received his artistic training from the potter Carriès, who had died two years earlier, and consequently he had a fondness for enamels of sombre hues, a vegetation animated by faun-like figures in the style of the Renaissance grottoes. Carriès exhibited the best example of this style, a bath designed for the Marquise de Ganay (**XII**); Bracquemond, who had enjoyed great success at the previous exhibitions, showed vases by Lachenal, the painter Georges Cazin (very melancholy) and Damoye (some of the prettiest). There were also works by Sandier, at the time director of the Manufacture Nationale at Sèvres, and who in 1889 had had the idea of

H

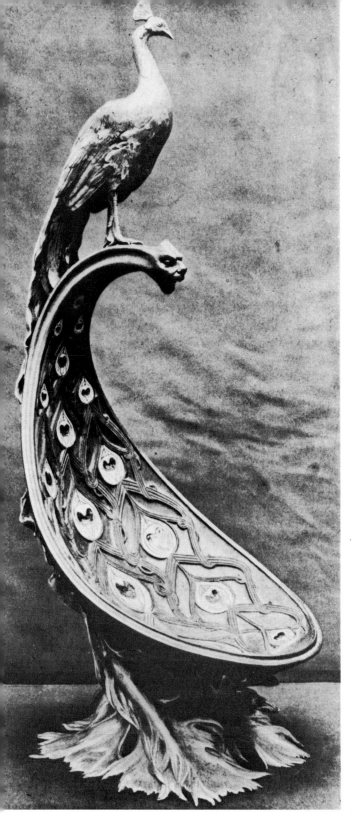

74–7 Jewellery by Lalique and Grasset. The jewel-casket by Lalique (*left*) was adorned with the Symbolists' favourite creature, the peacock, whose plumes provided such a variety of decorative motifs. Sarah Bernhardt, who launched the jeweller's career, inspired him to fashion such gems as the diadem in the form of a mermaid (*below*) and the pendant (*far right*). The pendant (*right*) executed by the firm of Vever is from a design by Grasset, the best of the Symbolist illustrators. He was strongly influenced by the Aesthetic Movement.

introducing plant motifs into the decoration of a showcase. The third room, arranged like a boudoir and cluttered with frills and furbelows, was devoted to ladies' fancy-work.

THE BING PAVILION

The most elegant and *avant-garde* specimens of Art Nouveau furniture and hangings were exhibited in a pavilion erected by Samuel Bing, a figure of great importance in the diffusion of this art. Bing, a native of Hamburg, had begun by importing Japanese art and in 1885 had published his *Artistic Japan* which exercised such a powerful influence on young decorative artists; his gallery in the Rue de Provence reflected the most advanced trends in both Impressionist and Symbolist painting. He specialized in an ultra-modern décor and attracted a modish clientele. The pavilion, curiously adorned with volutes like those on the entrances of Parisian underground stations, resembled a small mansion. On the façade a panel by de Feure showed two young women (or were they fairies?) on each side of a fantastic dwelling set in the heart of a forest (**78**). This kind of painted decoration on the outside of a house was another idea that was much imitated during the next twenty years. But let us now enter the Bing pavilion, with Jean Lorrain and his ecstatic female followers. Imagine him pointing out every detail of its studied elegance with a heavily ringed finger:

78 Georges de Feure: Decorative fresco
on the façade of the Bing pavilion. These
two peacock-women are the last word in
aestheticism and represent an effort to
integrate modern personages in a modern
décor, as was customary up to the Renais-
sance, instead of the nudes or draped figures
that has been common since that time.

And so Germany, Switzerland and even Japan come to seek inspiration in
the New Art, and this homage from abroad is to be found at every step, in the
rooms and in the furnishings of the model dwelling [this time it was Copenhagen
that decided to buy] designed by M. Bing. And in the dining-room of E. Gaillard,
with a walnut sideboard and dresser ornamented with copper, the minutely
wrought metal follows almost voluptuously the mouldings and panels of furniture
of a solid elegance; their lines suggest, without actually imitating, the finest
models of the eighteenth century; chairs covered with stained leather by Madame
Taulow are inviting in their comfort and the simplicity of their curves; on the
walls a strange tapestry by J.-M. Sert, an almost Jordaensesque orgy of nymphs
and fauns carrying quarters of venison with full pitchers and fat bunches of
grapes, proclaims the triumph of Abundance. The yellow and green room by
Colonna appeals to me less; but it is exquisitely tinted and has a fine boldness in
the choice of shades. It is the furniture of mottled citrus-wood with inlaid
coloured woods that fascinates me. This furniture is soft to the touch, like silk,
and has the shimmering hues of sumptuous damasks; the finish of the details,
the simple preciosity of the chased copper, like so many jewels, make each item a
collector's piece, a rare object, and—a delightful thing—it all blends into a whole.
I must confess that I prefer Colonna's style to that of Gaillard. One can say of

Colonna that his furniture is elegant and fragile with solidity, but for me the grace and charm of the dwelling are in the dressing-room by de Feure. I know of nothing more soft and soothing to the eye than his seats covered with blue-grey cloth embroidered with roses of white silk, nothing more delicate to the touch or to the eye than his furniture of mottled Hungarian ash, lightly decorated with motifs of silvery copper, as if the whole room were eternally bathed in moonlight; on the walls a marvellous silk tapestry, woven according to the directions of Bing on sketches by de Feure, presents endless blue and grey floral designs on a woof of silver. In the unfinished bedroom, on a bed by Gaillard, is spread a magnificent counterpane such as I had hitherto believed only the Japanese capable of embroidering; it would be impossible to carry the gradation of shades of colour further; the curtains and bed-ends designed by de Feure make the room a 'rosarium' of silk and silver threads. But so far all the rooms have been lit from the ceiling, a luminous ceiling hung with an awning of a tender shade and from which the daylight falls as if it has been sifted and melted. De Feure's boudoir illuminates its golds from a bay window, but how discreetly, for the golds are soft and subdued like lacquer, and this return of gilding in the 'New Art', from which it seemed to have been banished, is a revelation: corner cupboards, a fire-screen, light chairs and an adorable little settee whose slenderness and simple severity recall the end of the reign of Louis XVI; a silk cross-stitch tapestry with a decoration of bouquets of flowers fits the shape of the seats perfectly. On the walls, in dream-like rosettes, the same dawn and twilight shades, of which de Feure seems to have discovered the secret, adorn the shimmering waters of a lake. (**79, 80**)

De Feure and Grasset were the two most gifted decorative artists of their time. Much influenced by Japan, which explains the high regard Bing had for him, de Feure provided the inspiration for French fashions, both in his highly poetic drawings of ladies in settings which were the ultimate in Art Nouveau (**59, VII**), and in his fabrics on which peacocks and peonies blended in unusual shades. De Feure longed to design scenery for the theatre; in *Arts et Décoration* he wrote:

117

80 Dressing-room by de Feure. One of the most elegant ensembles of the Bing pavilion, in lime-blossom and lilac tones. Light wood. The dressing-table and carpets are among the finest achievements of Art Nouveau. Georges de Feure was the movement's most fertile inventor of forms.

In the theatre, likewise, the scenery should resemble as closely as possible the nature of the things represented. The artist should paint it to conform with the leading idea of the poet, inserting the unexpressed motifs, the muted colours, the revealing secondary planes, and should be content to introduce of his own accord only that measure of individuality which is necessary to transform the whole. Here again, M. de Feure is in agreement with the Wagnerian theory: the stage-designer must be the poet's collaborator. It is his role to develop the main idea, to embroider all around the themes which are the muffled echoes of the principal planes, the shaded and delicately tempered reflections of the leading idea. The poet is the prince Prospero who weaves in beautiful verses the whole legendary thread of the story; the stage-designer is the more discreet Puck who is content to flitter around and to heighten the illusion of those who watch in admiration, by adorning the principal theme with the accompanying melodies of his palette.

Beside the refinements of de Feure, among whose fragile furnishings, as the saying went at the time, 'a geisha Marie-Antoinette could dream', the furniture exhibited

79 Screen designed by Georges de Feure and brocaded by Anaïs Faure. This silk screen attracted much attention in the Pavillon des Arts Décoratifs. The Far-Eastern influence is evident in the use of the lotus and the association of drawing and sculpture.

in the main gallery seems distinctly cumbersome, but it enjoyed the approval of the public, which was recommended by the publication *Panorama* to see 'the dining-room of MM. Plumet and Selmersheim where the fashionable style is not over-loaded with those complicated ornaments which give the furniture and hangings the appearance of tentacled monsters'. Equally undistinguished was the furniture of Alexandre Charpentier, which to M. Brisson looked like 'the Pompadour style adapted by William Morris'.

And so, side by side with objects that were often to become the bric-à-brac of the future, all the sections devoted to the decorative arts included articles of admirable workmanship made from beautiful and novel designs, pieces which the museums show today with the proud words: 'Displayed at the exhibition of 1900'. As has been seen, this need for art in all things could have ludicrous results, but it seems that the new fashion mostly affected the ephemeral. If it is true that, in the art which flowered at the exhibition, one finds a mixture of Japan and Versailles, Valhalla and Byzantium, some of these works revealed an extraordinary originality, especially after a century of pastiche and industrial production.

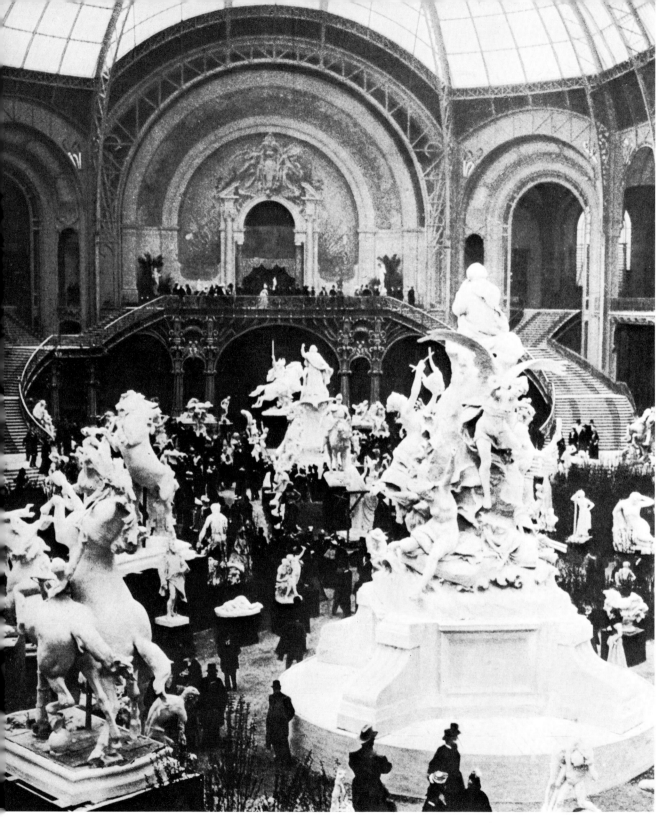

81　Central hall of the Grand Palais where the plaster casts of the 'Décennale' exhibition, mostly allegorical and grandiloquent, were assembled.

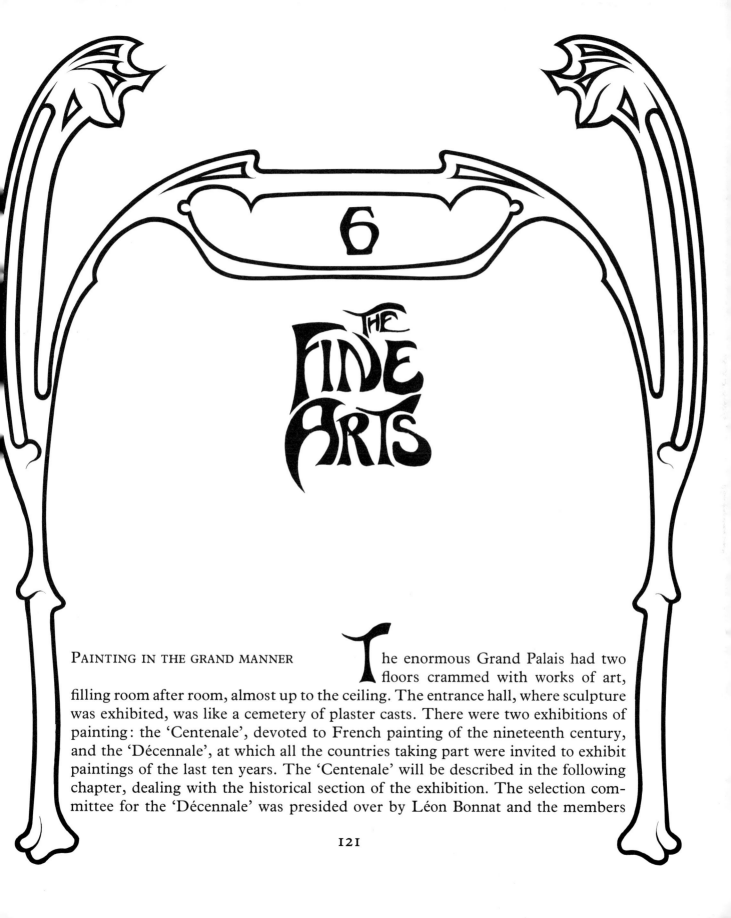

6

THE FINE ARTS

PAINTING IN THE GRAND MANNER The enormous Grand Palais had two floors crammed with works of art, filling room after room, almost up to the ceiling. The entrance hall, where sculpture was exhibited, was like a cemetery of plaster casts. There were two exhibitions of painting: the 'Centenale', devoted to French painting of the nineteenth century, and the 'Décennale', at which all the countries taking part were invited to exhibit paintings of the last ten years. The 'Centenale' will be described in the following chapter, dealing with the historical section of the exhibition. The selection committee for the 'Décennale' was presided over by Léon Bonnat and the members

82 Henri Martin: *Towards the Abyss*. This painter was
an excellent Symbolist and a disciple of Puvis de
Chavannes. Here he depicted an allegory that is difficult
to understand today (perhaps witchcraft dragging human-
ity to its doom, or perhaps the eternal feminine).

of the Académie des Beaux-Arts. Their choice merely accelerated the Institute's
growing disrepute. The French section, which occupied the north half of the Grand
Palais, comprised 1,546 paintings, 190 drawings, 144 watercolours, 123 pastels and
76 miniatures.

The catalogue makes heavy reading. *The return from the Circumcision* by Barias
is next to *Evening penetrating the Mist* by Beauversi. Though the names of Béraud,
Madeleine Lemaire and Antonio de la Gandara may still mean something to
disciples of Proust, who on earth was Pharaon de Winter? Are Benjamin Constant,
Jules Breton and Fernand Cormon, all famous at the time, really worth exhuming
from the dust of storerooms and provincial museums? Ten years ago one would not
even have thought of asking such a question, but exhibitions such as the 'Salon
Imaginaire' in Berlin in 1968, 'Equivoques' at the Musée des Arts Décoratifs,
Paris, in 1973, and the vogue for the pictures of academic artists (Bouguereau,
Gérôme) in the United States, only show that in the history of art there is no bottom-
less abyss and that, sooner or later, everything will be disinterred. Bouguereau,
whose *Madonna with Lily* proved a great success at the 'Décennale', would enjoy an
almost equally great success if the Metropolitan Museum in New York were to
exhibit it today. Even in 1900, however, this 'Super Salon' aroused misgivings.
The critic of *Le Figaro Illustré* wrote:

Enormous canvases, innumerable personages, décors, costumes, the scenery
for a theatre of the boulevards and all the bric-à-brac used at the shows in Rome
[the French Academy]; at the bottom of most of the pictures, on a cartouche,
one finds prose or verse explaining to the public the subject which has been
borrowed from history, from legend or from the news columns of the daily
papers; plenty of murders and plenty of dramas; attitudes and grand gestures;
nearly everywhere the search for effect. It appears that nowadays the majority of
artists, mistrustful of the public or of their own powers, rely solely on the literary
interest of their subject to lift them out of obscurity, to bring their works and
their names to the attention of art-lovers and critics. . . . Among the contemporary

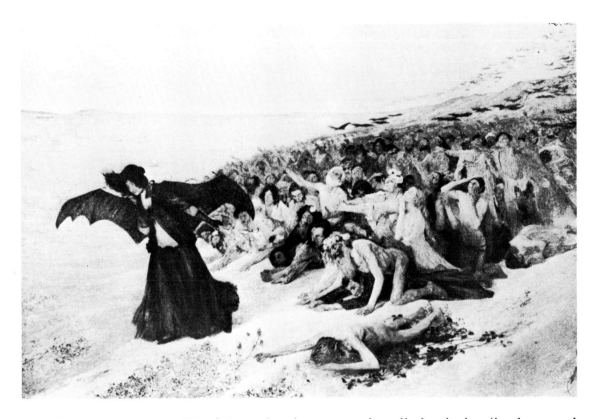

artists who are most faithful to what is commonly called painting 'in the grand style', M. Henri Martin deserves a special mention. If he is one of those who have sacrificed most to the literary art whose tendencies we have just been deploring, and if one may regret that he should sometimes seek from Baudelaire an inspiration which he finds much more happily when he turns to nature in all its simplicity, one must be grateful to him for having revived a genre and for having introduced into decoration some of the techniques which, before him, the Impressionists applied only to easel-paintings. One of the first major works in which he risked this interesting experiment is the *Chacun sa Chimère*, taken from a prose poem by Baudelaire. (**82**)

The themes that inspired the canvases of these official artists are of little interest today. The same phenomenon had occurred with the numerous painters of the Counter-Reformation who illustrated theological propositions and miracles which today simply seem absurd. Their pictures had been gathering dirt in the chapels of Bavaria and Sicily for a long time before they attracted the attention of art historians. As in the case of the French artists of 1900, the preparatory drawings for their grand tableaux were far superior to the finished paintings; and they, too, worked for patrons with conventional ideas. The painters of the Counter-Reformation served

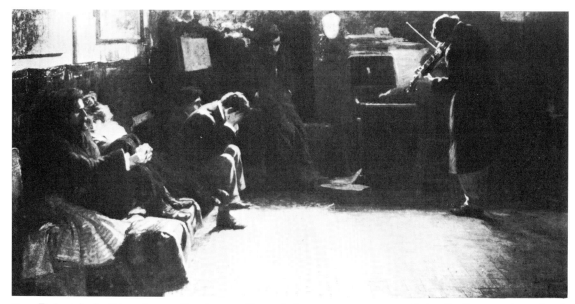

83 Balestrieri: *Listening to Beethoven*. One of the great successes of the Italian section, for it recalled the atmosphere of the Opéra and *La Bohème*.

84 (*right*) Georges Rochegrosse: *The Race for Happiness*. The painter of a highly-coloured antiquity brought a social message to the 'Décennale'. The rich obviously have the advantage in this 'struggle for life', the protagonists of which appear to derive from Zola.

the Church and the princes; those of the Third Republic served the museums and the municipalities; consequently, all were primarily 'theatrical'.

Of the now-forgotten celebrities of 1900, which are most likely to regain the favour of the public? Let us proceed by genres. It would appear that the cows painted by the innumerable imitators of Rosa Bonheur have the least chance of survival; not much can be said for the scenes of rustic life, even when skilfully painted by the realist Jules Breton; the military paintings are too cumbersome, though Edouard Detaille and Alphonse de Neuville have a certain verve. The huge republican canvases of Roll are also too difficult to hang, and who would want his *Ragard the Beggar-woman*? Nevertheless, historical painting will return to favour, and especially the bloody scenes of Jean Paul Laurens, which were based on Augustin Thierry's *Récits des Temps Mérovingiens*. One of the most admired compositions in the Grand Palais was his enormous *Entry of Pope Urban II into Toulouse*. Hugo's *La Légende des Siècles* seems to have inspired Cormon, the painter of *The Caveman*. But the most bizarre of these artists, and therefore the one most likely to regain favour, was Georges Rochegrosse. A distant relative of Flaubert, this artist began by illustrating *Salammbô* and painting other visions of barbarous luxury; then Roman history enabled him to give grave warnings to the politicians of France in

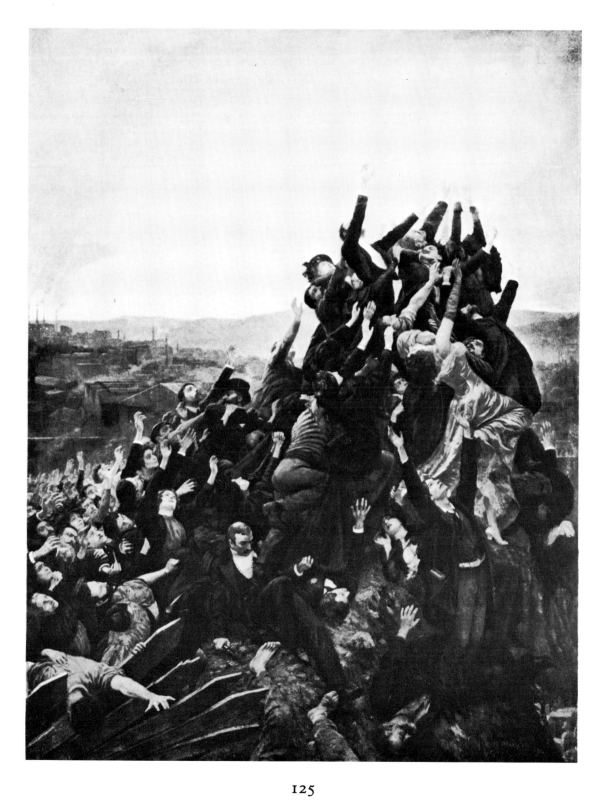

pictures such as *The Death of Caesar* and *The Assassination of Geta* (the latter was greatly admired at the 'Décennale'). Finally, he adopted the social message and in his *Race for Happiness* (**84**) stigmatized the capitalist system. Rochegrosse provided a link between official painting and poetic painting. While the Symbolists had a weakness for his highly Wagnerian *Knight of the Flowers* and his *Fall of Babylon*, the State commissioned him to design a huge tapestry for the Pavillon des Colonies and also part of the decoration of the Salle des Fêtes. In addition to history and social messages, Rochegrosse painted voluminous bottoms which delighted the men, and virile centurions who set the ladies' hearts a-fluttering. The eroticism which had long been suggested in countless allegorical paintings now ran riot. Never had there been so many swooning postures, so much bared flesh and so many smouldering looks in paintings which, ostensibly, were meant to appeal to the mind, to sentiments of duty, rather than to the senses. This intrusion of realism into academicism contributed in a large degree to the vogue which these official French painters enjoyed abroad.

In the foreign sections, which also had their official artists, a greater decorum was to be observed. Germany had sent works by its leading painters, all of whom were distinctly inferior to Böcklin. The only one who approached Böcklin, though with a greater heaviness and less mystery, was the young Von Stuck, who had been given generous wall-space for his *Paradise Lost*. Hans Thomas Trubner, Wilhelm Leibl and even the charming Adolph Menzel, who was far superior to Meissonier, aroused little interest. Serious people admired Wilhelm Uhde's *Birth of Christ*, a dreary lesson in evangelical realism.

In the British section, on the other hand, the general public liked Alma-Tadema and his Greece of Oxonian athletes, the aesthetic young ladies of Lord Leighton and Albert Moore, and *The Old Garden* by Millais. We shall see later what the artists liked. The United States section was well chosen, with pictures by Winslow Homer, Louis Eakins and Whistler. Sargent had sent his pink and grey portrait of Lady Mayer and her children. It is a pity that the catalogue contains no reproduction of the painting by William Glackens entitled '*Silence, pigs' she cried!*

Those fond of sentimental subjects treated in a realistic manner were enchanted by the Italian section and the works of Michetti and Balestrieri; the former reminded them of *I Pagliacci*, and the latter, of *La Bohème* (**83**). Alas, the Russians had not sent the extraordinary canvasses of Ilya Repin and Vasili Vereshchagin which are still drawing thousands of visitors to the museum in Moscow.

In all the sections the portraits displayed the satisfaction of persons wealthy enough to commission their likenesses from artists such as Benjamin Constant, Léopold Flameng or Bonnat in France, Lenbach in Germany, or Millais in England. Two incontestable masters dominated this vast and monotonous output: Sargent, who could have been better represented, and Boldini, to whom Italy had given an entire panel in the middle of which was hung his portrait of Count Robert de Montesquiou (**90**). Serov in Russia, Zorn in Sweden, Zuloaga in Spain and Cecilia Beaux in the United States all showed more originality than their academic colleagues. Jacques Émile Blanche attempted to establish a bridge between the official painting of Carolus-Duran and the Impressionists.

Thus all countries had, like France, their portraitists (with or without ribbons), their landscapists (with or without cows), their painters of seascapes (with or without foam), their orientalists (with or without dancing-girls), their religious artists (with or without haloes) and their painters of nudes (with or without fig-leaves—men were usually shown from behind). But France remained without rivals in genre-painting. The other countries could not imitate the gallant 'Musketeers' of Roybet, the 'Marquises fleuries' of Madeleine Lemaire, or the 'Kitchen-boys' of Chocarne Moreau. Yet these painters, showered with gold medals, won the approval only of the provincial bourgeoisie or of rich South Americans. They were frivolous and belonged in spirit to the Second Empire; in 1900 this drawing-room art had less appeal. Even painters of anecdotal subjects did not hesitate to include a message. Béraud, who specialized in courtesans and men-about-town, had sent to the 'Décennale' the painting of which he himself was most proud, *Saint Mary Magdalen prostrate before Christ* (**85**), completed five years earlier. Around a well-stocked table various celebrities of the time could be recognized, with Ernest

85 Jean Beraud: *Saint Mary Magdalen prostrate before Christ*. This was one of the many successes at the 'Décennale' by the painter of the *demies-mondaines*. Renan and Clemenceau can be identified amongst the Pharisees.

XI Necklace by Lalique.

XII (*overleaf*) Bathroom designed by Carriès for the Marquise de Ganay.

Renan, the historian, representing scepticism. Liane de Pougy had posed for the figure of the Magdalen (in a gown by Redfern) at the feet of a Tolstoyan Christ.

Another greatly applauded painting at the 'Décennale' was Jean Weber's *The Puppets* (**86**). In a studio, ignoring a model sprawled over a divan, a man, a thinker and a true artist, is seen playing with silky dolls, preferring dreams to reality. This picture was intended as a warning of the dangers facing the young generation of poetic painters, whose work did not bear the stamp of the École des Beaux-Arts.

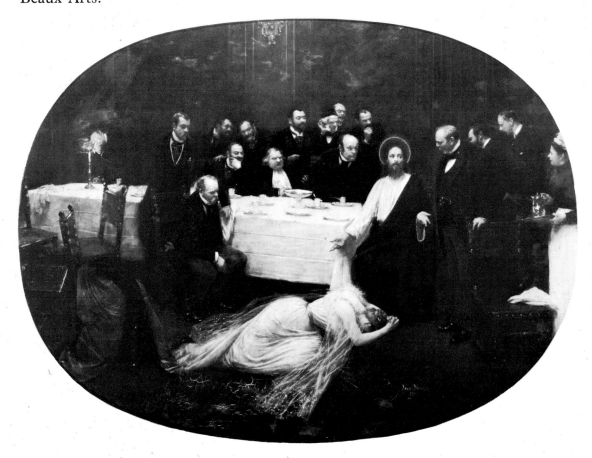

86 Jean Weber: *The Puppets*, 1900.

POETIC PAINTING

These young painters, who above all admired Gustave Moreau and Puvis de Chavannes, were Edmond Aman-Jean, Lucien Lévy-Dhurmer, Edgar Maxence, Eugène Grasset and Henri Le Sidaner, and their work was quite generously represented at the 'Décennale'. Anything rather than Impressionism, thought the selection committee, who did not care much, however, for these hazy lines, dull tones and disturbing metaphysical subjects. The painting most characteristic of the group was Aman-Jean's *The Girl with the Peacock* (**88**). Nearly all of them had begun exhibiting at the Salons of the French Rosicrucians. Their works were hung side by side with those of two very popular and widely represented artists, Eugène Carrière and Albert Besnard (**87**). Inspired by the movement that had given birth to Art Nouveau, these painters were called Symbolists, for sometimes they seemed

J

87 (*left*) Albert Besnard: *Portrait of Réjane*. Exhibited at the 'Décennale'. In the eyes of the public, the great actress, in a pale green dress pleated in the Modern Style, represented Parisian woman much better than the statue on the Porte Binet.

88 (*right*) *Aman Jean: Girl with Peacock*. One of the best known paintings of the Symbolist school, chosen for the 'Décennale'. One recognizes the themes of the poetry of Verlaine, who was a friend of the artist.

to be illustrating the works of Maeterlinck or Verlaine. Their contribution to Art Nouveau was, however, less important than that of Gallé or Lalique. The Impressionists and Post-Impressionists were not represented at all. The critic Alfred Mellerio protested at this dictatorship of the École des Beaux-Arts and the Prix de Rome. He thought that the Impressionists, like Rodin, should have had their own pavilion. In contrast, the 'Centenale', the paintings for which were chosen by a highly intelligent man, Roger Marx, exhibited a whole panel of Manet's pictures around *Le Déjeuner sur l'Herbe*. Degas was represented by the *Cotton Counter at New Orleans* and by some *Danseuses*, Renoir by a *Danseuse* and Monet by a *View of Argenteuil*.

The painters who, at this vast 'Décennale', were considered the masters of a modern art were to be sought outside France. The two greatest were Sir Edward Burne-Jones (**89**), who had died two years earlier and whose *Dream of Lancelot* was exhibited, and the young Gustav Klimt whom Austria, decidedly the most daring of the exhibiting countries, represented with the portrait of the *Lady in Pink, Pallas Athene* and *Philosophy*, an extraordinary composition which was to be destroyed by the S.S. As they went from one foreign section to another, up-to-date art-lovers could see a succession of canvases which, if they were to be assembled today, would form a complete exhibition of Symbolist painting. In the Belgian section,

they would find a painting by Jean Delville, *L'Amour des Ames*; Baron Frédéric's terrifying triptych, *The Lake*, dedicated to Beethoven and full of dead children; Fernand Khnopff's *A Blue Wing* (**91**) and *Incense*; some Ensors; and Constantin Meunier's sculptures of miners. But they would leave to bourgeois admirers two delightful anecdotal artists, Alfred Stevens and Van Beer. Holland, on the other hand, confined itself to Mengs and Israels, ignoring Jan Toorop and, of course, Van Gogh. Modern Italian art was quite well represented by Giovanni Segantini and by Aristide Sartorio's *Diana Generatrice* (**92**), an equivocal jumble of nudes which captivated d'Annunzio.

Switzerland achieved a certain distinction with the three most famous paintings by Ferdinand Hodler, *Night* (**93**), *Eurhythmy* and *Day*, and the bizarre water-colours of Carlos Schwabe. In the United States section people stopped to look at the Whistlers, perhaps attracted more by the artist's personality than by his works. The drawings of Maxfield Parrish were also admired. The exhibits of the Scandinavian countries were considered interesting, but Munch was not represented. The entry in the catalogue concerning the *Ultima Thule* by the Dane, J. F. Willumsen, is worth reproducing: 'The figures in relief represent those who, with a firm

89 Burne-Jones: *Adoration of the Magi*. Justus Brinck-
mann bought this tapestry for the Hamburg Kunst-
gewerbemuseum from the British pavilion.

90 The Boldini room in the Italian section of the Grand
Palais.

will, seek by science and reason to find a link between the infinitely great and the
infinitely small.' Modern art in Russia was represented by a large painting by the
Finn, Gallen-Kallela. In the British section visitors lingered in front of the pictures
of Burne-Jones and went into ecstasies over the drawings of Beardsley and Walter
Crane. Society women dreamed of being painted by Sir William Orchardson. Among
the visitors Oscar Wilde would often stop in front of a portrait that reminded him
of the evenings spent in Chelsea in the studio of two young friends, the illustrator
Ricketts and the painter Shannon. The latter's self-portrait, painted in 1897 and now
in the National Portrait Gallery, was described by Wilde in a letter to Robert Ross
as 'the most beautiful modern picture' (**94**). A stimulating example of a different kind
came from Austria, but many painters were led astray either by Klimt, or by
Olbrich's projects for the artists' colony at Darmstadt and by Frantisek Kupka's
'Madmen'. The Secession style, far in advance of that which prevailed at the
exhibition, bore fruit twenty-five years later at the Exhibition of Decorative Arts.
It was the writers who most admired Klimt's *Philosophy*. The poets were less interes-
ted in the *avant-garde* than in the elaborate compositions which Mucha designed
around the text of the Lord's Prayer, though their admiration was not unqualified,
for posters had vulgarized this art. Émile Verhaeren, writing in *Le Mercure de
France*, underlined the differences between the two styles of painting: 'Official

92 (*right*) Sartorio: *Diana Generatrice* (detail).
Eroticism and death were combined in this
painting.

91 (*left*) Khnopff: *A Blue Wing*. The tail-end
of Symbolism was better represented in the
Belgian section than elsewhere.

painting borrowed its browns from the old masters; modern painting, on the other hand, lives on blues and violets. It breaks up dark or brilliant light according to the hour of day; it has a fondness for the workmanship itself and for vibrancy.' But this modern painting could also become a stereotyped formula, from New York to Tokyo: 'And really, as one walks along the carpet which goes round the Grand Palais and which, apart from a few changes in its design and colouring, seems always the same from one room to another and from country to country, one finds here the symbolic representation of the monotonous art of our time' (July 1900). In other words, anyone who wanted to see some modern paintings in this spring of 1900

93 (*below*) Ferdinand Hodler: *Night*, 1890. One of the most important Symbolist paintings outside France. It was the Swiss section's greatest revelation.

94 (*right*) Charles Shannon: *Self-Portrait*, 1897. Oscar Wilde was delighted to find the portrait of one of his greatest friends in the British section.

would have to go to the galleries. At the one sponsored by the *Revue Blanche*, there was a Seurat exhibition which included the *Grande Jatte*. At Bernheim's, the works of Maurice Denis, Paul Serusier, Paul Ranson, Ker-Xavier Roussel and Vuillard could be seen. Van Gogh was exhibiting in the 'Esoteric Group' at 9 Rue de Londres, with Émile Bernard and Charles Filiger.

SCULPTURE

The 'Décennale' was dreadfully tiring for the visitor, for exhibits had been sent from all over the world—even Ecuador submitted twenty-six paintings and fifteen pencil portraits of successive presidents by the Society of the Children of Labour. Visitors could rest among the sculptures under the central dome; seats had been arranged under a rearing horse or between a Victory and a Venus (**81**). The republican nudes of Alexandre Falguière were greatly appreciated by the general public before being dispatched to decorate various monuments in Toulouse or Béziers; persons of taste, however, preferred Paul-Albert Bartholomé's very simple monument to the dead which was to be placed in the Père-Lachaise cemetery. Now that the

136

yews have grown around the doorway, this monument has assumed the mysterious quality of a Böcklin painting.

Less discerning visitors, shrugging their shoulders, left the Grand Palais and headed for the Porte de l'Alma, outside the exhibition proper, to see the pavilion which the City of Paris had erected for Rodin. The pavilion was not intended as a token of protest, like those of Courbet and Manet at previous exhibitions, but it was nonetheless a challenge to official art after the controversy that had arisen with regard to Rodin's statue of Balzac. Paris had resolved to honour Rodin and not to leave to Vienna the privilege of having accorded the sculptor a large room in the

Secession building two years earlier (a bare room had been hung with pictures by Segantini). It is only fair to say that the Third Republic was not always blind, for it paid homage to some great artists: Gustave Moreau, Puvis de Chavannes and, rather more cautiously, Rodin himself. Oscar Wilde made more than one visit to the Rodin pavilion: 'Rodin has a pavilion to himself and showed me anew all his great dreams in marble. He is by far the greatest poet in France, and has, as I was glad to tell myself, completely outshone Victor Hugo' (letter to Robert Ross, 7 July 1900).

Rodin now became the 'Great Frenchman'; there had been no one who could claim this title since the death of Victor Hugo, and Wilde was not mistaken. Jules Renard, who was also delighted, noted in his diary: 'In the *Balzac* there is admiration for his work, the sculptor's anger with the clay which he is moulding and a challenge to men.' Of a nude, Renard observed: 'There are breasts which seem to melt in the lover's hand.' To those who spoke highly of other parts of the exhibition, aesthetes replied: 'Rodin, there is only Rodin.' And for these Rodinists, says Jean Lorrain, it was improper even to mention Burne-Jones or Gustave Moreau. The *fin-de-siècle* Michelangelo had not the slightest doubt about his own genius. The ex-Empress Eugénie, who happened to be in Paris at the time, was also anxious to visit the Rodin pavilion: 'It's wonderful', she said to Rodin, in front of *The Kiss* (**95**).—'Wonderful, Madame', repeated the sculptor.—'Truly sublime', added the Empress.—'Sublime, Madame', Rodin calmly repeated. When they came to the next sculpture, the Empress began with 'Sublime' and gave up trying to find the word that might prompt a more modest reply.

In the rotunda of the Rodin pavilion visitors found assembled nearly all the sculptor's work, which was much more closely linked with Art Nouveau than is commonly supposed. The bodies emerging from the marble with their sinuous lines, the soft, nebulous quality unique in sculpture, the Baudelairean eroticism, belong wholly to their time (**97**). *The Burghers of Calais* are an exception. In the preface to the catalogue Carrière could write: 'The art of Rodin comes from the earth and returns to the earth, like those giant blocks, rocks or dolmens, which proclaim

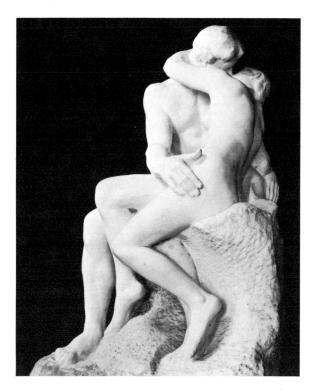

95 Rodin: *The Kiss.*

the wilderness and in whose heroic grandeur man recognized himself. The transmission of thought by art, like the transmission of life, is an act of passion and love. . . . The forms seek one another, and come together in voluptuous yearnings of violence and submission.' Claude Monet, Besnard and Jean Paul Laurens had also written ecstatic introductions for the catalogue. The official world decided to lay claim to Rodin; at all costs, it must not make him an *artiste maudit.* The art critic Gustave Geffroy said very rightly: 'He has accomplished, in the domain of plastic art, what Wagner has achieved in the domain of music.' Of the *Gates of Hell* (**96**), a work much closer to Victor Hugo than to Dante, the same critic wrote in these rapturous terms: 'Mouths open as if to bite, women run with swelling breasts and impatient buttocks; equivocal desires and tormented passions quiver under the invisible whip-lashes of animal rutting.'

Octave Mirbeau, the friend of the Impressionists and of Van Gogh, had organized a great movement of opinion in favour of Rodin. This enemy of the Symbolists and of the arts of the imagination, who wanted his feet firmly on the ground and even, when necessary, in the muck-heap (his books are full of the sadistic and the sordid), went wild with joy on seeing Rodin's sculptures:

I do not want to vilify the Universal Exhibition and the architectural horrors which it has caused to erupt like a dreadful disease, from the old soil of Paris;

96, 97 Details of *The Gates of Hell* by
Rodin and (*right*) *Danaide*, 1885.
There is more of Art Nouveau in these
sculptures than is generally thought.

I do not want to vilify it because it has also been the pretext for a manifestation
of art of a magnificence never before seen in this century. I am speaking of the
exhibition of the works of M. Auguste Rodin. Amid all the incoherence without
boldness, the folly without verve and the decadence without joy in the depressing
décors which we see before us, in this frenzy of ugliness where all the nations
are trying to emulate one another with increasingly disastrous effects, it comes
just at the right moment to proclaim to the universe the truth that human genius
is not dead and that never, in any country or at any time, has it appeared with greater
power and creative abundance.

This panegyric published by the literary magazine *La Plume* was endorsed by the
eulogies of Stuart Merrill, Arthur Symons and Frank Harris.

The Rodin pavilion included some of *The Burghers of Calais*, the statue of General
Lynch which was to be sent to America, and the eternal *Spring*, as typically 1900
as a piece of furniture by Majorelle or a curtain by de Feure. The walls were hung
with numerous drawings highly praised by Mirbeau. Clearly, this was the most
advanced art to be seen at the exhibition. (In the end, however, there were to be far
too many of Rodin's drawings, just as, fifty years later, there were to be too many of

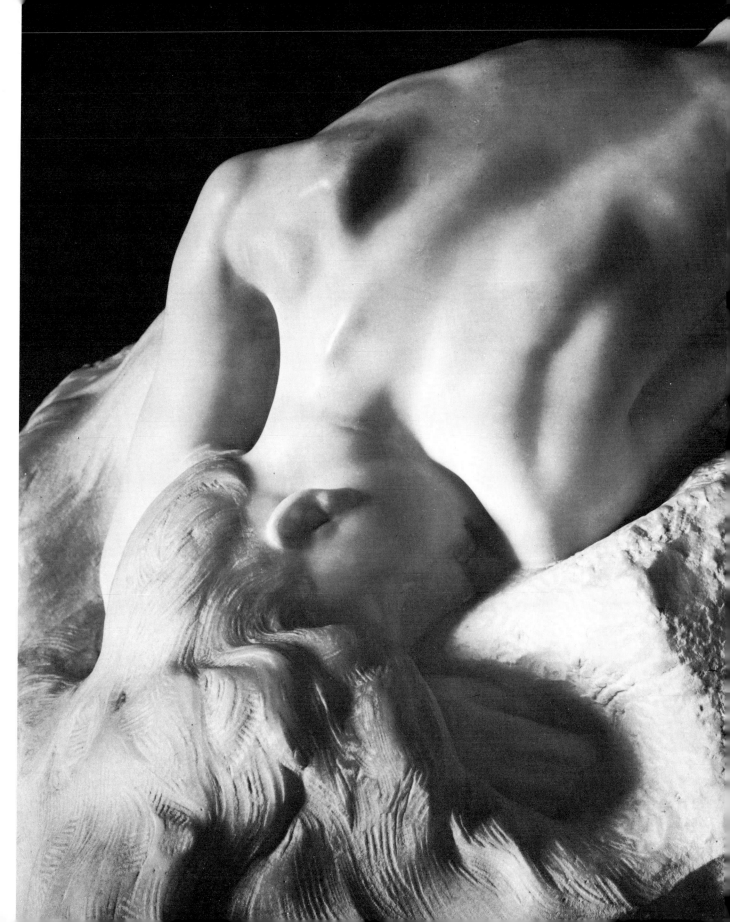

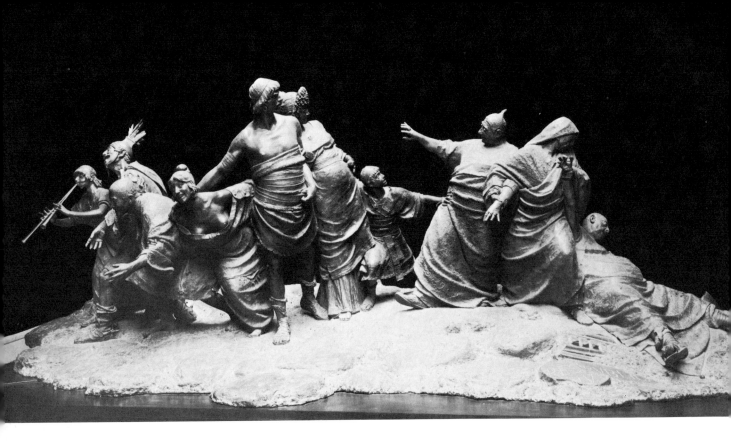

Matisse's drawings—which indeed owe something to those of Rodin.) The pavilion proclaimed Rodin the genius of modern times. Here, visitors found sculptures which recalled both the temples of Greece and Asia, and the cathedrals of Christendom. Today Rodin is recognized as the greatest of the artists of 1900.

MUSIC

Music was the least honoured of all the arts at the exhibition. The official musicians, the members of the Institute whose works were comparable with the canvases of the most boring painters of allegories, found themselves being commissioned to compose cantatas, marches and symphonies for the occasion. The programme performed at the prize-giving ceremony, despite the inclusion of Massenet and Widor, was of rare tedium: 'The performance of *Ars et Labor,* the second part of M. Fernand Le Borne's lyrical poem *Patria,* Massenet's *Incantation of the King of Lahore* and finally Widor's *Toccata,* a voluntary for organ, brought the ceremony to a close.'

The concerts took place in the Trocadéro of 1878, either in the main hall, famous for its deplorable acoustics, or, in the case of chamber music, in a room which was dark and difficult to find. Attendances were thin, except for the big occasions such as Gustave Mahler conducting the Vienna Philharmonic in the symphonies of

98 Ernesto Biondini: *Roman Orgy*. Typical of the taste
for eroticism disguised in historical terms.

Beethoven. The Scandinavian choruses also enjoyed a great success. The pro-
grammes, arranged in rather the same manner as the exhibition rooms, included
excellent composers side by side with the boring winners of the Prix de Rome. But
one can always walk past a bad painting, whereas one must sit through a sonata
from the first note to the last. There were, however, two new works of major im-
portance: Lalo's *Symphonie Espagnole* and Fauré's *Requiem*. An obscure but dis-
tinguished musician, Pierre de Bréville, describes Fauré's *Requiem* thus: 'This white
Mass evocative of wreaths and sheaves of virginal scents and whose epitaph should
be the line of Jean Lahor: "Exquisite death, fragrant death . . .".' In the recital
room visitors could hear quartets by Debussy and *Le Chant de la Cloche* by Vincent
d'Indy.

It was not in traditional or even in modern music that the exhibition was to mark
an important date in the history of music—not in the official programmes, but in
those to be heard in the exotic pavilions. Debussy learnt much by listening to 'the
liquid music of crystal-clear sonorities and contrasting rhythms underlined by the
tiny gestures of the precious Japanese puppets' (Pierre de Bréville).

In the Egyptian, Indonesian and Japanese pavilions Judith Gautier, followed by
her faithful friend, the musician Bénédictus, could be seen taking notes for a
series of remarkable studies on the exotic music performed at the exhibition, in
which she gave a minutely detailed description of the dances and the instruments
and transcriptions of the melodies. When they were published, these studies were
to prove almost as important as the discovery of jazz twenty years later.

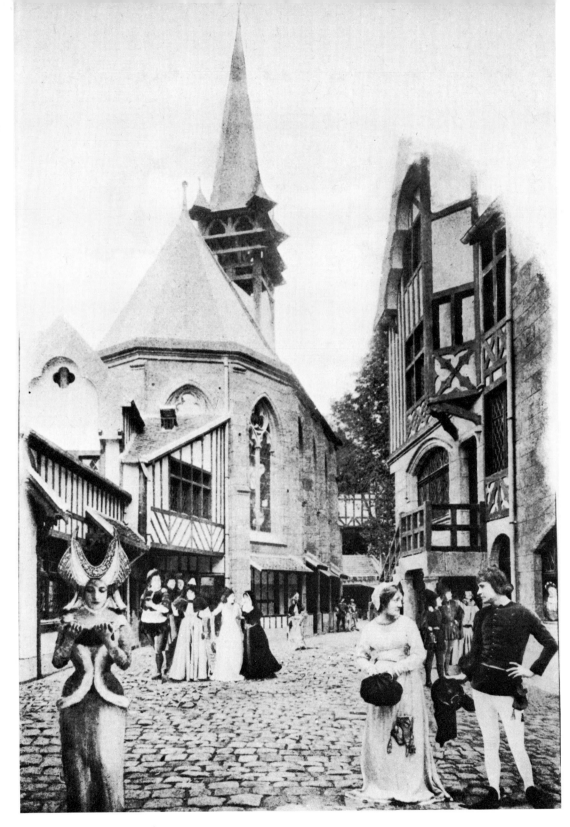

99 Old Paris. People in costume served in the taverns and shops.

7

HISTORY

HISTORICISM

One of the most surprising things about the illustrated publications devoted to the exhibition is the number of pastiches, of so-called 'old' monuments built either by France herself or by her guests; similarly, as one turns over the pages of the catalogues for the various sections, one is struck by the importance given to retrospective displays. Thus, while belonging to the future in its dependence on electricity and in the flowering of the Modern Style, the exhibition of 1900 was also a vast museum, a repository of all the styles of all the arts of the past. Faithful to its programme, it thereby demonstrated that History had occupied just as import-

K

100 Siberian pavilion. In fact the pavilion of Russia, which had made a tremendous effort in this edifice reminiscent of the Kremlin. In the foreground, the fountains of the Trocadéro dating from the exhibition of 1878.

ant a position as Science in the nineteenth century. From the romantic history of Michelet to the more scrupulous Fustel de Coulanges, recent French literature boasted a large proportion of historical works: Augustin Thierry, Renan, Guizot, de Tocqueville and Taine. In England there had been Carlyle, Froude, Macaulay, among many others, and in Germany Ranke, Pastor, Burckhardt and Mommsen. Historical painting had assumed enormous importance with the advent of the Romantic era. Rochegrosse and Jean Paul Laurens were its latest representatives. Finally, architects were also turning to the past (though it must be said that they had been doing nothing else for the past hundred years), adapting old formulas to new requirements. Great Britain had acquired its Houses of Parliament, its marvellous Gothic railway stations, Austria its Renaissance opera-houses. Viollet-le-Duc was the most illustrious continental exponent of Historicism, a term invented by art historians to designate this eclectic return to a past which was endowed with all the virtues of idealism and the picturesque which the age of steam so lacked. Yet the Gothic style, traditionally associated with churches and feudalism, could hardly endear itself to the Third Republic. At first, in erecting town halls, official architects attempted to revive the style of the castle of Chambord. When Frenchmen wish to suggest glory, they usually turn to Versailles. The style of the Grand Palais and, to an even greater degree, that of the Petit Palais served for all the large buildings erected in the 16th arrondissement; the same pastiches are to be found and, inside, the same mock-Trianon wainscoting and Louis XVI fireplaces. There was more originality in the Second Empire buildings on the Plaine Monceau. But Versailles represented both power and good taste and so on the Pont Alexandre, in cartouches surmounted by a cockerel, the initials R.F. balanced the fleurs-de-lys surmounted by the crown—the two symbols of the greatness of France reconciled for the first time on the monuments of the exhibition.

In the foreign pavilions the influence of the English Gothic revival and Viollet-le-Duc was much more in evidence than in the French sections, either in an intelligent adaptation of a medieval style to the new spirit, as in the Hungarian and Rumanian pavilions, or in constructions that looked like opera scenery, as in the

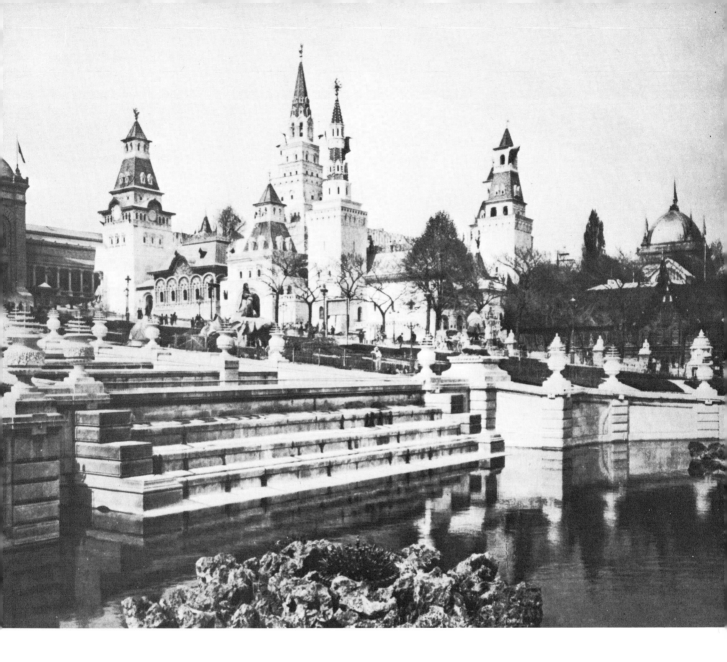

pavilions of Spain, Belgium and even Italy. Steeped in the cult of History, the ruling classes were immersed in a nostalgia for glorious epochs, closing their eyes to the present. This fervour for the past, moreover, exacerbated patriotism and nationalism. The official committees which chose the architects for the national pavilions always preferred a style that would recall the edifices of the great ages of their history rather than a modern, living style. Thus Austria, dreaming of the time of Maria Theresa, was Neo-Rococo, Rumania Neo-Byzantine, Russia Neo-Kremlin (**100**), Great Britain Neo-Elizabethan (**38**). The British manor-house,

designed by Sir Edwin Lutyens who was to transform Delhi into an imperial city, contained paintings by the English masters. It was an oasis for weary spirits, for there were never many visitors. Jules Renard would relax there with the actor Lucien Guitry, who was enraptured by the pictures by Sir Joshua Reynolds: 'It is utterly beautiful, the painting of a lover. Children, little girls, women, leave us feeling sad that we are not loved by them.'

The German pavilion was Neo-Nuremberg, a masterpiece of the 'patina style' that reached its zenith in Munich in the Bavarian National Museum designed by Gabriel von Siedl. Museums were plundered to fill all these pavilions: portraits for Great Britain, tapestries for Spain and Belgium, goldsmith's work for Hungary. We have seen that the Emperor of Germany stripped the palaces of Potsdam to furnish the Imperial Pavilion.

MUSEOMANIA

France did not lag behind in this display of national treasures. If all the old objects scattered around the exhibition had been gathered together, the Louvre would not have been large enough to accommodate them. Simultaneously with the passion for history and pastiche there had developed a taste for acquiring and labelling mementoes of the past; interest in curios had grown considerably during the past century and every year new categories of objects were judged worthy of the museum. The history of art, which had always been a long way behind history proper, was at last beginning to assert itself as a science. After visiting the innumerable retrospective displays, Gustave Geffroy wrote, rather naïvely, in the *Gazette des Beaux Arts*: 'Henceforth, the history of art will not be possible without a knowledge of the artist's whole environment, without a confrontation of the various orders of knowledge.'

A large part of the Grand Palais was devoted, as has already been seen, to French painting of the nineteenth century. Allegories on the exterior made it abundantly evident that the huge building was dedicated to art.

The Grand Palais, where the international 'Décennale' was held, also housed the 'Centenale'. The selection of French paintings for the 'Centenale' included some Impressionists. There were also some enormous canvases such as *The Distribution of the Eagles* by David, *The Vow of Louis XIII* by Ingres, and *The Embarkation of the Duchess of Angoulême* by Gros. Delacroix, Courbet and Chassériau were well represented, but so were such academic painters as Delaroche, Vernet and Cabanel. Carrière had a panel to himself—after all, he was seen as the Rodin of painting.

Contemporary accounts of the 'Centenale' betray a certain weariness; in spite of its quality, it interested visitors much less than the exhibition of decorative arts in the Petit Palais. If the first European galleries of painting and sculpture were barely a hundred years old, the museums of decorative art were even more recent. The Victoria and Albert was the first big one; the Musée des Arts Décoratifs in the Pavillon de Marsan dates from 1875 and the Kaiser Friedrich Museum in Berlin was even later. The earliest such museum in France had been the Hôtel de Cluny (the medieval and Renaissance periods), followed by the Hôtel Carnavalet. Nothing had been borrowed from the Parisian museums so that they should not lose any of their prestige in the eyes of visitors. The real interest of the exhibition in the Petit Palais lay in the objects sent by the provincial churches and museums and from the large private collections. The total number of exhibits was larger than Cluny, Carnavalet and the Musée des Arts Décoratifs put together. The churches sent 'the tapestries which, with goldsmith's work, were the largest contribution, and I cannot believe that two such remarkable ensembles have ever been seen before. The famous gold tapestry, *The Coronation of Esther by Ahasuerus*, considered the pearl of Gothic tapestries, has been taken from the treasury of the cathedral of Sens. . . . The extraordinary image from Conques in Aveyron, the statue of Saint-Foy, will be taken from the old basilica and will make the journey to Paris, despite the fanatical jealousy of its faithful worshippers. Lovers of old French painting of the fifteenth century will be able to study the celebrated triptych from the cathedral of Aix, *The Burning Bush*, which recent archive discoveries have attributed definitively to Nicolas Froment, official painter to King René' (Gaston Migeon).

101 *Fitting of the Wedding Gown.* In the Pavillon de la Mode, wax figures represented scenes of 'high society'; here, a fitting session at Worth's.

This painting and the *Pietà* from Villeneuve-les-Avignon awakened interest in French painting of the Middle Ages, a famous exhibition of which took place in the same galleries three years later. For the first time the Rothschilds allowed their Limoges enamels, Oiron faience and Sèvres dinner services to leave their houses. The finest pieces of the eighteenth century (now to be seen at the Cammondo Museum) were on show together with hundreds of objects which, if just one of them were to appear at a public auction today, would bring antiquarians rushing from all parts of the world.

The only interesting thing in the City of Paris pavilion was its museum, arranged like the Carnavalet Museum. It consisted of objects borrowed from private collections. The Emperor of Austria had lent the cradle and carriage of Napoleon II, King of Rome; the Tsar of Russia, the fifteen volumes of the watercolour views of Paris by Percier and Fontaine; the dramatist Sardou, the portfolio of the revolutionary Fabre d'Églantine; and the Marquis de Lasteyrie, the armchair of his grandfather La Fayette.

This taste for the past was satisfied in every section, for, side by side with the rooms displaying the last word in technology, a retrospective exhibition was to be found. For instance, in the Pavillon de la Librairie there was an admirable exhibition of manuscripts, incunabula, illustrated editions and bindings. The perfumery section had asked Count Robert de Montesquiou to write a preface for the catalogue of cassolettes, perfume-pans and various bottles assembled by the firm of Klotz. The preface was entitled 'Au Pays des Aromates' ('In the Land of Spices') and, between quotations ranging from Ovid to Anna de Noailles, the visitor could find extravagant sentences like the following: 'Could one not see in the sad cruelty of Louis XIII the product of the perfumeless soul of a sovereign branded with the heinous crime of having detested roses?'

The retrospective room of the Palais de l'Électricité was particularly interesting, with apparatus dating back to the seventeenth century and including the first telegraph sent by Pouillet in 1845, Mercadier's radiophone of 1841, and Froment's cumbersome epicycloidal electromotor of 1847. The table which Ampère used in

1820 to demonstrate the laws of electrodynamics would pass today for a masterpiece by Alexander Calder with its delicate assemblage of scales, metal plates and copper wires. Images of Loïe Fuller were to be seen in the designs obtained by the oxidation of gold wire on paper with Van Marum's electric machine of 1784. Visitors could see the rapid progress that had been made in lighting, from Jablokoff's first electric candles of 1876 to the incandescent lamp of 500 candle-power. They could also observe the notebooks which Faraday kept for his experiments, old books, and mementoes of the Abbé Nollet, the eighteenth-century physicist.

In the Pavillon de la Métallurgie visitors could marvel at the fact that a certain Monsieur Domergue had been able to assemble 1,400 old bells, and in the Pavillon de l'Armée they could relax in a beautiful room decorated with portraits of marshals. Rabid militarists could see the panorama of the battle of Jena outside the enclosure. 1900, it should be remembered, was the year of Edmond Rostand's play *L'Aiglon*, based on the life of Napoleon's son, the Duke of Reichstadt.

Side by side with dry history, labelled in showcases, the exhibition offered its visitors a more colourful history of period reconstructions in the manner of the

151

XIII Grun: *A Private View in the Grand Palais.* This painting dates from 1911 but shows the inside of the Grand Palais as it looked on this social occasion for 'official art'. All the academic painters are there, some writers and a number of actresses.

XIV (*overleaf*) Stained glass window by Grasset. A number of artists, de Feure included, worked in this medium.

Grévin Museum, with wax figures dressed as accurately as possible in theatrical attitudes. In the Palais de la Mode, the history of costume was summarized in thirty or so tableaux of this kind. Visitors could admire the Empress Theodora on her throne, Queen Isabeau of Bavaria watching a tournament, the Field of the Cloth of Gold, and Marie-Antoinette at the Trianon. Modern fashion was represented by scenes of society life with dummies dressed by leading couturiers such as Worth and Doucet. Provincial women went into raptures on seeing the 'Fitting of the Wedding-gown' (**101**) or the 'Departure for the Opera', visions of high life which they could dream about long afterwards in their small-town existence.

Old Paris

On the right bank of the Seine, between the Pont de l'Alma and the Trocadéro, lay the 'Old Paris' whose reconstruction had been entrusted to Robida (**99, 102**), the illustrator of Rabelais, who showed no less a facility for picturesque medieval designs than for ingenious futuristic novels. Robida himself explains his intentions in the pseudo Old French made fashionable seventy years earlier by Balzac's *Contes drolatiques :*

'O good Pantagruel who, crossing and recrossing the Séquane [Seine], loved to stroll through the quarters of the city in the company of Panurge, a boon companion accustomed to making joyous visits to the worthy taverns and playing tricks on the constables of the watch—and you, Master François Villon, the good poet and lover of free repasts—O Cyrano de Bergerac, who used to parade your long carcass, your plumed felt hat and your rapier along the banks of the Seine enlivened by infamous quacks and mountebanks—and you too, Boileau, son of the city, child of Sainte-Chapelle—Molière, child of the Halles, it is your old Paris, the old Paris of your time which we are striving to restore to you and to resuscitate for the amusement of your grand-nephews who, alas, are obliged to live in an orderly Paris, straight as a bowstring and raked in squares;

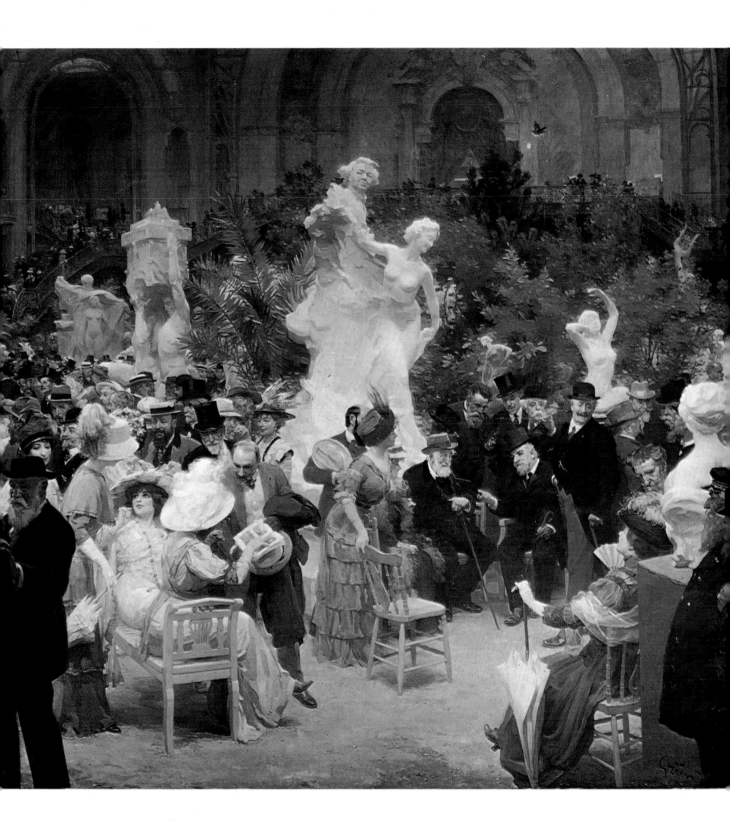

XV (*previous page*) Pendant designed by Bing. Copper and enamelled gold. This kind of 'Melusina' is to be found on numerous Modern Style objects popular today among collectors of *kitsch*.

XVI *The Milky Way* by Frida Hansen. This tapestry from the Norwegian room was one of the objects bought by Justus Brinckmann and now to be seen in the Pariser Zimmer in Hamburg (**63**).

it is your old Paris with its uneven streets, its houses washed by the noble river, and its bustling squares—with all the delicate outlines of the olden days against the sky, with towers, turrets and bartizans, notched pinnacles, gables of every shape, little houses nestling against high masses, chiming bells, street stalls between the buttresses of buildings, soldiers at the gates, tradesmen in the shops, minstrels on the squares, craftsmen working, forging, illuminating, glazing and enamelling, and delicious nooks and corners where, amid the smoke and aroma of the eating-houses, near the taverns with their gleaming signs, rise the music and the songs of bygone times mingled with the laughter of today.

The style of this passage is in itself enough to give an idea of the errors which exasperated learned persons, the excessive picturesqueness which was further exaggerated by costumed players who looked as if they were performing *Faust* in some provincial theatre, ladies in hennins, students in breeches, matrons at their windows and craftsmen at their benches. To understand the success of such a a carnival—and nothing is more dreary than a carnival that lasts five months—one must remember that opera at this time was enjoying the same kind of vogue as history. Visitors had the impression of living amid the scenery of *Rigoletto* or of other popular operas such as Hérold's *Le Pré aux Clercs* or Meyerbeer's *Les Huguenots*. But let us follow Robida as he guides us round his Old Paris:

Another street, lined on one side by houses and on the other by stalls, leads to the Place du Pré-aux-Clercs, after a short flight of steps, and runs at a slightly higher level under the greenery of the trees, above the displays of handicrafts. This Rue des Remparts leads, like the Rue des Vieilles Écoles, to a transversal building where there is a room, the Poets' Garret, in which Master François Villon would have felt at home, and in which gay or satirical ballads and songs will be recited and sung, to the clinking of bottles, of course. This end of the Rue des Remparts is enclosed by a postern-gate, while the Rue des Vieilles Écoles passes under a large gateway which, except for a few inevitable modifications, is a copy of a gateway of the Jacobin friary on the Rue Saint-Jacques from

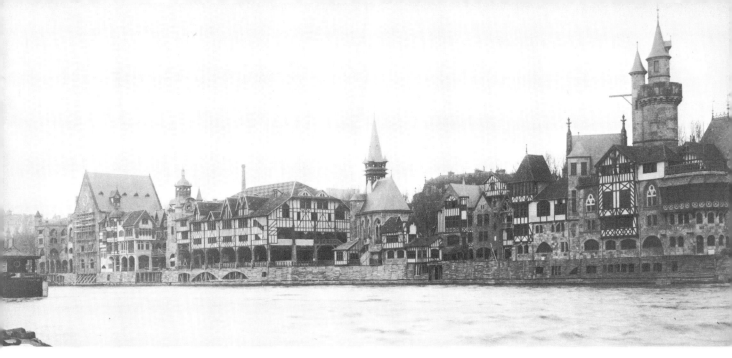

which there emerged on many an occasion, to the cheers of the Guisard populace, battalions of friars who were led to the barricades or to the armed processions by the most rabid preachers of the League. Above the gateway the building is surmounted by a pinnacle from this same Jacobin friary, whose last remnants disappeared only forty years ago. Going through the gateway, we come into the corner of the great Place Saint-Julien, where there are various things to see: first, on the other side of the poets' building, the balconied window is the lectern of the refectory of the abbey of Saint-Germain-des-Prés, an architectural marvel almost comparable with the Sainte-Chapelle and which unfortunately was destroyed by the explosion of a powder magazine in 1793; then some arches of the cloister of the college of Cluny, one of the beautiful Gothic cloisters that Paris once possessed in its numerous colleges and monasteries, and which have all vanished. . . . Finally, beside the cloister, there is a very different memento of the old Parisian abbeys, terminating the district of the Old Schools: the pillory of the abbey of Saint-Germain-des-Prés, a little turret with a stone base, on the upper level of which turns the great circle of wood pierced with holes for the head and hands of the delinquent exposed to the mockery of passers-by. How many students, for misdemeanours committed in the abbey grounds or in the famous Pré-aux-Clercs, had to come here to grimace for several hours on the old pillory, which in olden days stood at the place today traversed by the Boulevard Saint-Germain? Old Paris has revived one of the most curious of all the innumerable churches of bygone times: Saint-Julien-des-Ménétriers, the church of the brotherhood of the minstrels and itinerant musicians of Paris, built in the thirteenth century on Rue Saint-Martin by 'the *jongleurs* and the masters of the art

154

102 Old Paris. Robida had produced a décor resembling
a stage-set from *Faust* along the Seine. The inhabitants
were represented by a montage of photographs.

of minstrelsy, which belongs to the science and art of music, who at that time
dwelt in this city of Paris', at the suggestion of and with the funds provided by
two charitable minstrels. . . . The Old Paris will strive to bring back to life all
that joyous and colourful world, so as to restore to the old church its picturesque
aspect and its bustling surroundings of the olden days. On leaving the church the
visitor will find himself in front of one of the largest restorations of Old Paris:
the whole of the far end of the square is occupied by the façade of the sixteenth-
century Chamber of Commerce, one of the masterpieces of French architecture
of the Renaissance, unfortunately destroyed by fire in 1737.

'Old Paris' was divided into three districts: the Schools, the Halles and the Tour de
Nesle; visitors entered through the reconstruction of the Grand Châtelet fortress.
There was a theatre in the old Halles; the Cour des Comptes resembled the Palais
de Justice in Rouen, while Molière's house was more like Shakespeare's. In the
church some hideous stained glass was dedicated to 'St Cecilia, Lady and mistress
of all music and of the minstrelsy of the angels of Paradise'. There was also an organ
which was played by Merovak, the cathedral organist, an outlandish, bearded figure
dressed like Charlemagne. In his costume of gold and purple he attended all the
official receptions as 'ambassador' of the Gothic collegiate church. Quite a cele-
brated figure in Rosicrucian circles, Merovak left behind him some interesting
architectural fantasies.

The décor of 'Old Paris', much closer to Gustave Doré than to Viollet-le-Duc,
established the inn style once and for all: bare beams, imitation brickwork, wrought-
iron signs, pinnacles and Dutch ovens; it was also the precursor of the historical
section of Disneyland. It was called the 'Chat Noir' style, for that famous night-
club in Montmartre, perpetuating the tradition of the Romantic ateliers, was
decorated with stained glass, coats of arms, ensigns and armour. This sort of period
reconstruction has always enjoyed great success in Belgium; at the exhibition of
1958 'Old Brussels' with its beer-saloons provided a glimpse of what 'Old Paris'
must have been like.

103 The souks. Algerian pavilion at the Trocadéro. Here the public could buy all kinds of exotic articles.

8

Exoticism

THE COLONIES

After a fourth or fifth visit to the exhibition, having admired the foreign pavilions, lingered in the interminable galleries crammed with machines or pictures, taken a few lessons in taste in the sections of decorative art, and recharged his patriotism in the army and navy pavilions, the tourist must have felt that old Europe had nothing more to teach him. Longing for adventures and unknown lands, he would decide, perhaps, to visit the exotic section. But before embarking on this adventure, he would go to the top of the Eiffel Tower, the Hachette Guide in his hand, and look towards the west:

157

104 Georges Rochegrosse: *France in Africa*. Design for a tapestry executed at the Gobelins. France represents Progress and the 'good negroes' are dazzled, as if the Fairy Electricity had appeared before them. Observe in the border the mingling of scientific instruments and creepers.

The Trocadéro, with its symmetrical fan-shape, envelops the mass of pavilions. To the left, recalling the Byzantium of the Empresses and the Moscow of Ivan the Terrible, rise the gilded ridges of the Siberian Pavilion. At the top a large heraldic bird begins its flight of conquest over Asia, which lies out at its feet like a tame leopard. . . . Lower down, the sculptured structures of the Dutch Indies display their red and blue masses. Sumatra, Borneo and Java, luxuriant islands of palm-trees, forests, glades and torrents, are admirably symbolized here in their carnivorous fauna and their inextricable flora. Roofs, curved at the corners in the form of ships' prows, cover the sanctuary with elaborate friezes where Buddha, with eight arms and eight legs, rests on the immortal lotus. Near by, to the right, rises the graceful spire of the Pavilion of the Transvaal and in the background, beyond the masses of greenery, the inextricable entanglement of the Chinese roofs bears witness to the active presence of the children of the Celestial Empire.

Thirty-one years later Paul Morand, who as a small boy already had a passion for travelling (or did he acquire it at the exhibition?), recalled some soul-stirring journeys in the exotic section:

I made a thousand extraordinary journeys almost without moving; under the Eiffel Tower, near the little lake, was hidden the Tonkinese village with its junks and its women chewing betel; sometimes I watched the old Cambodian elephant sent by Doumer and called 'Chérie' drinking there. The Indo-Chinese theatre adjoined the reproduction of the strange temple which had just been discovered and which was called Angkor. Twice a week I went to refresh myself at the Ceylon tea-room; the Ceylonese pavilion was situated, if I remember rightly, on the heights of the Trocadéro, to the right going up, near the paulownias which bear mauve flowers before they have leaves. I can still feel in my mouth the fire of the ginger, the sharp taste of the iced tea which one drank there with lemon, served by slender natives in white robes, their very black hair gleaming with coconut oil, and whose sex I could not ascertain. In the Ceylonese pavilion there were also the Dancers of the Devil, wearing terrifying masks with bulging

wooden eyes. The entire hill was nothing but perfumes, incense, vanilla, the aromatic fumes of the seraglio; one could hear the scraping of the Chinese violins, the sounds of the castanets, the wailing flutes of the Arab bands, the mystical howling of the Aissawas more heavily painted than De Max, the cries of the Ouled Naïl with their mobile bellies; I followed this opiate mixture, this perfume of Javanese dancing girls, sherbets and rahat-lakoum, as far as the Dahomean village. Among the mosques and straw huts, near the Tower of Sacrifices, tall negroes walked about barefoot, with a proud and graceful bearing, still savages, the subjects of former kings, old and recent enemies who had become our liegemen.

The word 'liegemen', and the tendency to associate adventure with aestheticism, were still prevalent when these lines were written, at the time of the great colonial exhibition organized by Marshal Liautey in the Bois de Vincennes in 1929. Illusions about the colonizing mission of Europe were admirably symbolized by Rochegrosse's tapestry in the Pavillon des Colonies (104). A luminous France with a laurel in her hand, but followed by her soldiers, appeared between the baobabs; negresses in picturesque costumes and warriors holding their spears greeted her with respectful admiration; monkeys, caymans and pineapples decorated the

borders. In the shadow of the colonial palace stood the little pavilion of the Berlitz language schools.

The conscientious visitor would not miss any of the colonial pavilions. The smaller ones resembled the house of Alphonse Daudet's hero Tartarin; they were surrounded by trees, usually of enormous height but standing in pots, and they were filled with stuffed animals, trophies taken from the vanquished tribes, javelins, musical instruments, fetishes and dioramas. In the foreground of one tableau, wax figures of natives were shown ready to receive the word of God from the missionary. These reconstructions were sometimes enlivened with music, as in the pavilion of Martinique: 'The bamboula, a famous dance of that island, is reproduced by wax groups, and a phonograph plays the creole tunes, full of zest and movement or of melancholy and languor.'

Saint-Pierre and Miquelon displayed their cod-fishing industry and sensitive souls would think of Pierre Loti's novel, *Pêcheur d'Islande*. Indeed, visitors were reminded of the celebrated writer at every step: Senegal suggested *Le Roman d'un Spahi*; Japan, *Madame Chrysanthème*; the pavilions of Oceania, *Rarahue*; and the Indian sections, *L'Inde sans les Anglais*. Statistics, alas, often took the place of flowers. This emotional view of the civilizing role of France and of her 'children', the natives, the glow of patriotic enthusiasm (a patriotism which would, however, willingly have surrendered all these lands in Africa and Asia in exchange for Alsace and Lorraine), were tempered by more critical judgements. André Hallays, an eminently sensible visitor, wrote:

Madagascar is exhibiting a grand panorama, the capture of Tananarivo. The panorama is almost a masterpiece of its kind. Rarely has optical illusion been carried so far. The groups are lifelike and the view of the capital of the Hovas is picturesque. But perhaps it was not really necessary to scatter the ground with horribly blood-stained Malagasy corpses. This spectacle is in rather bad taste. Unless I am mistaken, we are here in Group XVII, Class 113: Methods of colonization.

AFRICA

The expeditions of Marchand and Savorgnan de Brazza, and many other such ventures, had recently given France vast territories in Africa which had to be made known to the French public. Whole villages, with their craftsmen and witch-doctors (but no women), were therefore reconstructed around the Trocadéro. There were also contingents of Senegalese infantrymen. Their childish French created the myth of the 'good negro': 'Y a bon la France' or, for the purposes of later advertising, 'Y a bon Banania'. When they returned home, these reluctant tourists talked of all the marvellous things to be seen at the exhibition and became utterly devoted to the French administration.

The most curious of these reconstructions was inspired by the colony of Dahomey where, only a few years earlier, the native king, Behanzin, had violently resisted the colonizers. The latter, less cruel than the Romans, who used to make the barbarian chieftains appear in chains in their triumphal processions, were content to exhibit the African kings' thrones (Behanzin's was 'made in Germany') and the spoils from their palaces, such as the treasure of Ahmadou, ex-sultan of Segou. When they saw the fetishes, people realized for the first time that such a thing as a negro art could exist. An extract from the Hachette Guide shows that ethnography as we know it today had already begun at the exhibition of 1900:

In this picturesque corner of the Trocadéro, where there are already the huts of the Sudan and Senegal, the mole-hills of Guinea and of the Ivory Coast, the buildings of the Dahomey exhibition stand out even more by the barbaric extravagance of their construction. First of all is the Tata, which forms the main pavilion, with a high porch serving as an entrance, and surmounted by a mirador tower which is a reconstruction of the Tower of Sacrifices of Abomey. The thatch roof bristles grotesquely with pikes bearing the actual skulls of the slaves behead-ed under Behanzin's eyes. . . . Particularly worth mentioning, at the end of the building, linked by a staircase with the preceding galleries, is a room accommod-ating the Museum of Fetishist Religions, which are so strange and so numerous

L

in Dahomey. The chief curiosities are: the thrones of the former kings of Abomey, the symbolic fetishes with their weird shapes, the royal vestments, the weapons, the instruments of torture, etc. From time to time, lectures on the colony are given here. On certain days one can also see fetishist meetings enacted by real *griots* [itinerant musicians], witchdoctors and priests dressed in their costumes and accessories. All around, the straw huts of land-dwellers and lake-dwellers (faithful reproductions of the habitations of the different regions of Dahomey), the lake plied by canoes, the enclosure made of a belt of bamboos dotted with stakes (strange fetishes), and the reddish colour of the mud of these constructions, succeed in giving the Dahomey section much originality and local colour.

And this was the impression made by the Sudan pavilion on Robert de Souza, the poetic chronicler of *La Plume*: 'The horizon of Africa, in all its monstrous density . . . the mud of centuries . . . it seems to be made of a black slime that has boiled and solidified in the leaden sun. It is like the upthrust of a gigantic rampart, wild and mysterious.'

To this black Africa, which seemed to them both disturbing and childish, Parisians preferred displays more familiar to their own culture. Egypt had installed a theatre in a Pharaoh's temple with more than two hundred musicians and actors, the highlight of which was the representation of an Arab wedding. A constant visitor at all these performances was Judith Gautier, the daughter of the poet and Wagner's last love, now a very fat lady with wonderful eyes, who was the first to make Eastern literature known in France, in some beautiful novels set in China and the Indies. Her achievement can be compared with that of Lascadio Hern in England.

Here is Jean Lorrain's impression of these Arab quarters where dubious adventures added a little spice to the historical displays:

Thick walls rise into the sky like a fortress; here and there, on the façade, mushrabiyyahs jut out, reminding us that in Egypt the harems of Cairo have now replaced the court of the Ptolemies, Thebes with its hundred gates and the

distant Memphis. In the Egyptian theatre the derboukhas purr; reed-flutes whine, the harsh and strident flute of the Arabs already heard in the Sahara, on the fringe of oases, mingled with cries, guttural and rhythmic, in a chant which tries to be gay and which hums sadly, so sadly and monotonously, so desperately. . . . At the Cairo café where we are seated in front of steaming cups, a delicate, frail Egyptian girl, barely fourteen years old, with a finely modelled face of light amber, smiles at us with all her enamel teeth and her large, green eyes; she is sheathed in reddish-brown silk which makes her look like a gleaming serpent. She stands beside us, immobile and silent, having been brought by a negro at our request. She is called Fatima, naturally, just as her elephant-boy is called Mohammed—one feels that the names must surely have been borrowed specially for the Exhibition! Hieratic and smiling under her chestnut hair arranged in little plaits, the exotic Fatima makes one think of a heroine of Pierre Louÿs or Pierre Loti. A horrible matron, of a thoroughly Levantine puffiness, with swarthy eyes and sunken cheeks, watches her from the counter, wrapped in an ill-fitting coat of sapphire-blue plush of a vulgar modernity.

A few tables away, visitors might see a large Englishman in a slightly rumpled white suit, mopping his brow with a silk handkerchief. The torrid heat of the summer of 1900 enhanced the illusion that one was in Cairo. Oscar Wilde (**125**) was writing to his friend Smithers: 'A slim brown Egyptian, rather like a handsome bamboo walking stick, occasionally serves me drinks at the Café d'Égypte.' One wonders if this Egyptian was as closely guarded as the young waiter at the Café Algérien who used to come to pose with Gide for Jacques Émile Blanche, to add a touch of red to his austere painting. A policeman would bring the young man to the studio for each sitting and then accompany him back to his place of work.

The reconstruction of the Kasbah of Algiers (**103**) had no aesthetic pretensions: 'Nothing is as curious and picturesque as this winding, climbing street overhung by the mushrabiyyahs and the yauleps, and which becomes increasingly narrow towards the top, presenting a most original effect. All along this narrow lane little

105 The gipsies. A band of gipsy-women had been brought from seville to enliven the pavilion representing Andalusia in the time of the Moors. To fastidious visitors they seemed more like a provincial production of *Carmen* or the inmates of a brothel in Toulouse.

shops accommodate natives at work and tradesmen trying to outdo one another in mercantile zeal. This corner of old Algiers is certainly one of the most successful attractions at the Trocadéro Exhibition.' According to Jean Lorrain, however, it was a den of haggling carpet-sellers and 'Fatimas' recruited from the prostitutes of Montmartre. The 'negro' whose amusing journal has already been quoted was hardly more favourably disposed towards the Algerians: 'The Algerians have built a whole district for themselves, where they can feel at home. They make things under the gaze of the public, they sometimes even manage to sell some very ugly products of their country, and they are astonishingly familiar with the women, giving them affectionate names, addressing them as *tu* and holding them by the arm or leg.'

Also slightly dubious, but endowed with the prestige of history and gipsy-dancing, was the large pavilion of 'Andalusia in the time of the Moors', one of the most popular attractions of the exhibition, rivalling 'Old Paris'; tickets cost one-and-a-half or three francs, for which visitors could enter the world of *Carmen*, with serenades, gipsies (**105**) and boleros. In addition to the Lion Court of the Alhambra and the Giralda tower of Seville, which people could climb on a mule, the Andalusian pavilion included,

rising in tiers towards the slopes of the Trocadéro, a gourbi, one of those Arab villages as they existed in the Middle Ages, in the very heart of Andalusia. The little village stands out all in white with its mosque and its whitewashed buildings and, in contrast, the rich products of the industry of its inhabitants: carpets, leathers, fabrics and weapons of unparalleled opulence. Bearing to the left, you go through Granada's Gate of Justice, where the Moorish kings used to deliver their judgements, and suddenly you come into a picturesque old street of a Spanish village in the province of Toledo, near the city of Toledo, with the jarring façades of its Romanesque and Renaissance houses and its shops occupied by an infinity of curious crafts: here the mantillas, the jewels encrusted with gold, the tambourines and guitars are made; in the background the illusion is completed

by part of a 'sierra', harsh and jagged, in violet and peach-coloured tones. Amusements are not lacking in Andalusia: a Spanish theatre where beautiful gipsy-women dance the 'bolero', the 'manchegas', etc., a large track with a stand where Arab fantasias, races, etc., take place (Hachette Guide).

The gipsy-women had the opportunity to extend their circle of acquaintance considerably. Since no one could sleep within the precincts of the exhibition, the personnel of the exotic pavilions were accommodated in temporary camps on the building-sites of the 16th arrondissement:

At the Trocadéro it is the hour when the amusements come to a halt, the quiet period when derboukhas, tambourines and reed-flutes cease to set the belly-dancers quivering. Almahs, Ouled-Naïls, Bedouins and Moorish dancers return to nearby Passy or to distant Grenelle to eat (the badaboums begin again at nine o'clock, after the evening meal) and, under the chestnut-trees of the Boulevard Delessert, there are processions of veiled women, groups of fellahs, amusing

gatherings of Druses and negroes, all the extras of the Egyptian theatre and of the so-called Algerian harems, strolling up and down, hurrying or loitering, presenting attitudes, profiles and silhouettes for the artistic curiosity of promenaders (Jean Lorrain).

ASIA

The Asiatic pavilions inspired more subtle sentiments. Jean Lorrain, visiting the Japanese section, thought of his old friend Edmond de Goncourt:

The Japanese enclosure, with its high palisades, its green lawns, its pagodas with their curving, panelled roofs, the babbling cascades and, in the close-cropped grass of the slopes, the mauve snow of the blossoming paulownias, the leafless paulownias, a rippling mass of pale violet, perfuming this décor of freshness and stillness. In the background, the airy colours of the lanterns, the big lanterns of painted paper hung in front of the shops of the tradesmen; from the pavilion, where Octave Uzanne, whom I happen to meet there, forces me to sample the famous 'saki' (horrid stuff, this rice-wine praised by all the poets of the Far East), one experiences the joy of observing, in the chiaroscuro of this cool, dark corner, the large splashes of brightness of the enormous clematis and the luxuriant peonies. Wonderful things, these Japanese peonies, which I used to admire at the home of the author of *Fille Elisa,* in the little garden at Auteuil—especially the white ones, a rice-paper white, tousled and silky, as if they had been violently forced open, on pistils of a golden yellow. Others blaze in china rose or blood-orange red, heightened by the proximity of the clematis. Mousmees, their waists raised by the enormous knots of their sashes, serve in silence, the clear lines of their large eyebrows giving them an amusing appearance. In the café opposite, Japanese girls serve; one eats cakes and sugared lily leaves presented on pretty serviettes of decorated paper. The doors of the main exhibition pavilion, closed today, add an air of mystery to all this exotic décor. Here, it seems, one can see priceless lacquer-ware; but the public is not admitted today.

The 'mousmees' or Japanese waitresses, the twelve geishas of the 'Panorama of the Tour of the World', and the Hindu and Sinhalese jugglers were accommodated at Vaugirard, under the supervision of Hypolite Framboise, a retired gendarme who had been decorated with the military and colonial medals, and who watched jealously over their virtue. Indeed, the virtue of the men was in just as much danger as that of the women; Jean Lorrain was tempted more than once when having tea in the Ceylonese pavilion:

> A cool, quiet corner of the Trocadéro where, under the shade of foliage which has miraculously remained intact, one takes tea at little tables around a kiosk of lattice-work of a cleanness gratifying to the eye, with its lacquered pillars and its coloured mats. Great strapping fellows with bronze faces, slim and white in quilted jackets buttoned on to aprons forming a skirt, have a disconcerting effect on one, with their long black hair coiled into buns and their gleaming eyes of enamel; barmaids, fresh and pink, serve with them. This has already become a busy corner, frequented by fashionable ladies and curious women who are hypnotized by the supple gait and the velvety eyes of the Sinhalese men. One has been pointed out to me who has lost count of his conquests.

Another aesthete, Robert de Souza, the author of *Modulations sur la Mer et sur la Nuit*, who looked for beauty not so much in faces as in a sort of architectural metaphysics of ideal lines and golden numbers, described his impressions in *La Plume*: 'The palace of Coloa: one enters what seems to be a scarlet undergrowth; there is no sensation of being in an edifice, so to speak, but everywhere shafts rising up to support the entangled branches of the roofing where guilloches, of gold here and there, form apertures.'

Even more disturbing was the pavilion of Angkor, in the shape of a head with four faces, seen through a veil of creepers which gave a more plausible aspect to the reconstruction of this ruined temple which was just beginning to be cleared from the jungle of Cambodia. Robert de Souza was particularly impressed: 'The underground temple of the Khmers. One penetrates into the sacred night. Little by little,

lights filter through the disjointed slabs of the vaulting and the world of the colossal cavern yawns open, mysterious, enormous, swarming. . . . And the cavern has become a temple, the temple of the giant animal . . . the kingdom risen from the waters where man has followed the motions of the primordial waves in the stone of his infinite sculptures.' The description owes as much to Darwin as to Ruskin.

The delicate forms of the contortionist dancers, arrayed in tiaras and bracelets, captivated artists such as Theodore Rivière and Dampt. Rivière, with his ivory and bronze Salammbôs, had already suggested a similar effect of sumptuous fragility. Shortly after the exhibition of 1900, he went to Indo-China to be nearer to this art, which eventually was to inspire some rather poor sculptures. Rodin preferred the carved wood friezes of the Dutch Indies, and Jules Renard, down to earth as always, was astounded, writing on 15 August: 'They are making us sweat with their hot countries.' The Indo-Chinese theatre enjoyed a measure of success showing slides of the court of King Rerodom. But the greatest triumph belonged to the Japanese actress Sada Yacco, to whom Loïe Fuller had lent her theatre (**106**). Her miming seemed quite extraordinary to Parisians, though the Japanese criticized her for confusing different traditions and, most important of all, for not being a boy. A minor art of striking quality, and which reminds one of something familiar, is always the easiest way of approaching an alien culture; and so Sada Yacco was compared to Eleonora Duse because of her pathetic realism (it was even rumoured that the great Sarah Bernhardt, disguised by a thick veil, would go to study a certain death scene performed by her Japanese rival in order to bring something new to her own death in *L'Aiglon*). Two writers as different as Verhaeren and Jean Lorrain were utterly enraptured by her.

Claude Debussy, enjoying the first flush of his glory, also came to spend evenings in the oriental theatres to study new harmonies and to seek an inspiration that would enable him to escape from the world of Symbolism (the *Jardins sous la Pluie* was composed at this period). The Chinese, in their magnificent pavilion of carved wood (**108**), aroused much curiosity. Visitors were amazed by their courtesy at a time when, in Peking, nuns were being massacred and legations were being besieged.

106 *Sada Yacco* by Cappiello. This drawing by the great caricaturist was published in *Le Rire*, bringing to Frenchmen the revelation of the Japanese theatre, the spectacle most appreciated by the aesthetes amid the vulgarity of the Rue de Paris. For the first time Japan, already familiar through its lacquer-ware and engravings, had come to life.

A great deal of diplomacy had been necessary to persuade these Chinamen to leave their country. Finally, the promise that their bodies would be repatriated in the land of their ancestors if, by chance, they were to die in Paris induced them to make the journey; but they showed less interest in the exhibition than other exotic countries.

Visitors whose taste for the exotic was not satisfied by the pavilions in the gardens of the Trocadéro could seek further stimulation in the huge rotunda of the 'Tour of the World' built by the Compagnie des Messageries Maritimes (**107**). In this structure, inspired by Jules Verne's *Around the World in Eighty Days*, where a Hindu pagoda, a Chinese temple and a Muslim mosque stood side by side, there were panoramas, jugglers and geishas. Jean Lorrain, who was so fond of travelling by sea, made frequent visits to another enormous diorama situated opposite the Kasbah of Algiers, perhaps because from there he could imagine himself looking on to the Algerian coast from a ship:

> We see the deep blue and the enamel hardness of the open Mediterranean. Billows roll wildly in festoons of foam; glimmers of light fall from a stormy sky which gives them a silvery hue; they unleash a swirl of molten lead under a white horizon of vapours. The noise of the steam-engine, which turns the invisible cylinders on which all these scenes unfold, adds to the illusion: it is just like the throbbing of a steamboat's engine, the continuous, vibrating effort of a propeller. One is on board a steamer.

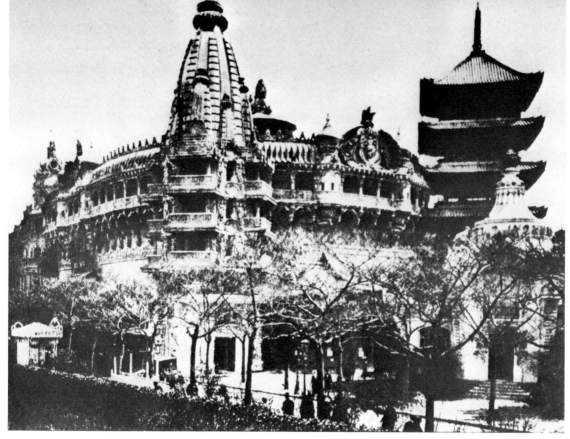

107 The Tour of the World. The buildings surrounding this enormous panorama were in a multitude of exotic styles. Here a Khmer temple stands next to a Japanese pagoda.

108 Entrance of the Chinese pavilion. Dark red wood and green tiles. To the right, the tea-rooms. This was one of the most successful pavilions in the foreign section.

Lorrain says that the pitching of a ship was so well simulated that some of the ladies present were seasick.

This vast exotic section of the exhibition was of considerable political importance. Europe now felt that it belonged to a world in which there was nothing left to discover and that the great powers were in the process of dividing the world among themselves. It also became conscious of an educational mission, which financial interests and a military administration made less effective than was suggested by the statistics displayed in the various pavilions; in any case the French felt that the idea of the 'white man's burden' was being adequately fulfilled by the missionaries.

In the pavilions of the Trocadéro visitors discovered new kinds of music and other new art forms. The history of art now extended from the friezes of Angkor to the bronzes of Benin. Exoticism ceased to be an enchanting source of inspiration, as reflected in the novels of Pierre Loti or in Bizet's *Les Pêcheurs de Perles*, and became the science of ethnography. Verhaeren, describing the exotic dances and music in an article written for *Le Mercure* towards the end of the exhibition, empha-

利樂民國

sized the impact (as one would say today) on European culture of this unknown world:

And the music, like flowing water, animates these fluid [Javanese] dances, these calm, chaste and tranquil dances; it has neither beginning nor end; one would say that it forms part of the unceasing movement of the universe. Similarly, the dancing-girls whirl and vibrate as if the force of gravitation were being accomplished through them. These dances relate to thought as much as the dances of Seville relate to passion. . . . As one surveys these different expressions of exotic art, one is increasingly convinced that the word beauty must assume an ever wider meaning to embrace the supreme manifestations of universal artistic thought. Those who wish to endow it solely with a character of order and balance stunt its meaning to the point of making it incomprehensible to nearly all mankind. Its significance must be broadened as much as possible, above all to include the notion of excess and extravagance.

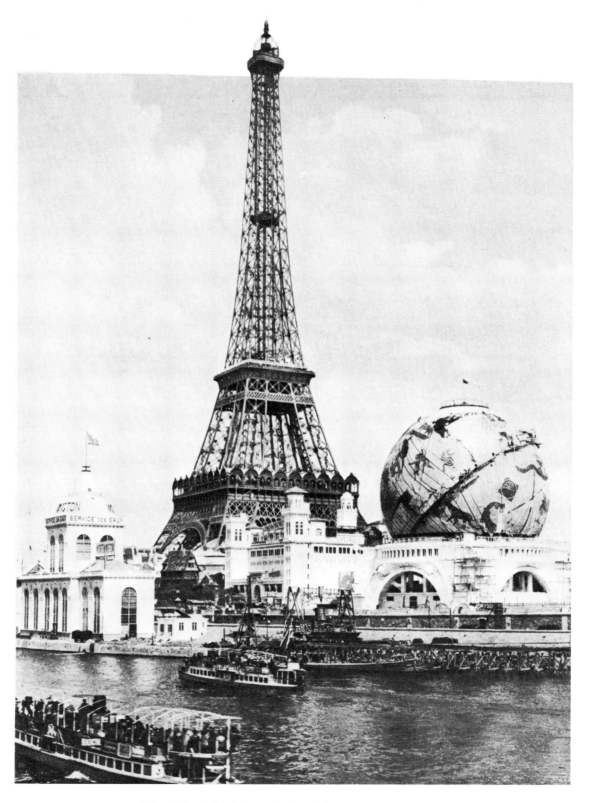

109　The Celestial Globe and the Eiffel Tower on the left bank.

9

ENTERTAINMENTS

THE RUE DE PARIS

From the gigantic 'Parisienne' on the Porte Binet to the ivory Salomes of Dampt and Chalon in the showcases of the Pavilion of Decorative Arts, the exhibition of 1900 was dominated by woman—Loïe Fuller personifying electricity, the big-bosomed females representing Fame in the pictures of the official artists, the Baroque caryatids from Austria, the *Jugendstil* Valkyries from Germany, the bronze nymphs round the fountains and the stone nymphs in front of the palaces, the figures of Japanese mousmees and Egyptian almahs carved in the wood of the exotic pavilions. Neither History nor Science escaped this feminization of even the most

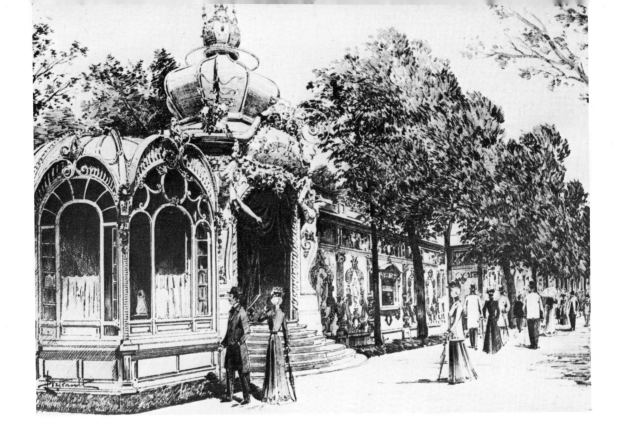

serious allegories. Naturally, the sections reserved for pleasure and entertainments were also, and to an even greater degree, dedicated to the Parisian Venus. It should not be forgotten that at this time the great courtesans, Liane de Pougy, Émilienne d'Alençon and La Belle Otero, were international celebrities.

At the close of the nineteenth century there was an explosion of eroticism in theatres and magazines. This obsession found vivid expression in the engraving by the then famous artist Félicien Rops, entitled *Pornocrates*: a woman who is naked except for hat, gloves and black stockings, leading a pig on a leash. The average Frenchman recognized himself willingly in this animal. 'Quel cochon!' was no more an insult than to describe a painting or a show as 'cochon'. On the contrary, the term was used to extol the virtues of Gallic virility. It is therefore hardly surprising that all the pavilions devoted to entertainments could well have had Rops' engraving as their signboard. The majority of these theatres, *chansonniers* and travelling shows were to be found in the Rue de Paris, which ran along the Cours la Reine on the right bank. 'It's more like the Rue de Montmartre', exclaimed Parisians repelled by the vulgarity of most of the establishments. It reminded them of the *chansonniers* and fair-booths erected on the Boulevard Barbès for the carnival, the most famous of which was La Goulue's booth, immortalized by Toulouse-Lautrec. The Rue de Paris was very lively in the evenings; it had a festive air with its Japanese lanterns in the trees. La Roulotte tried to lure customers inside with

110 (*left*) Marionette theatre or 'Bonshommes Guillaume'. An attraction on the Rue de Paris built in the Viennese *pâtisserie* style.

111 (*right*) The Palais de la Danse. A plaster figure of Loïe Fuller dominated this sort of Neo-Rococo Trianon where ballets were represented with wax dancers.

the beating of its big drums and its tambourines. There was a clever marionette show, the 'Bonshommes Guillaume' (**110**), a Palais de Danse dominated by a plaster figure of Loïe Fuller (**111**), a theatre where realistic and sometimes horrific scenes were performed, the Grand Guignol, a theatre for burlesque entertainments which was remarkable for its frieze by Bellery Desfontaines with life-size figures of Parisian personalities, and an aquarium where, by the use of mirrors, ladies in green tights, with their legs in the form of a fish-tail, seemed to be frolicking among the octopuses and lobsters. Observing the sea-horses, Jules Renard noted: 'Straight as tie-pins'. The Théâtre de Tableaux Vivants, built in the Pompeian style, offered scenes in the manner of Bouguereau or Gérôme, presented by girls with dishevelled hair falling over flesh-coloured tights.

But few people ventured into these pavilions, though the price of admission was modest, for the exhibition itself was much more extraordinary than anything these showmen could offer. (The Rue de Paris was always full, however, for provincials could there assume an air of debauchery without spending much. It was also the main centre for soliciting at the exhibition.) The chief reason for this failure was the fact that visitors preferred to go to Montmartre, where they could find such world-famous establishments as the Moulin Rouge, the Rat Mort and the Chat Noir. Moreover, the artistes who performed at these establishments could be quite sure that people would go to see them in Montmartre and that they had nothing

to gain by going down to the Seine. Only the mediocrities tried their luck there, among them a certain 'Félicia Mallet, anti-Semite singer'!

The only place of amusement which was an unqualified success was Le Manoir à l'Envers (The Upside-Down Manor) (**112**). One entered this building through the roof. The furniture was suspended in the air and in the drawing-room people could walk round a chandelier whose lamps illuminated their feet; through the ventilator holes of the cellar there was a view of the surrounding district.

The Maison du Rire (House of Laughter) was more successful than most of its rivals, for it benefited from the popularity of the journal *Le Rire*, founded six years earlier and which had published drawings by Toulouse-Lautrec, Forain, Caran d'Ache, Vallotton and the young Cappiello. Side by side with works of quality the usual vulgarities were to be found here. The decoration of this little theatre had been entrusted to a very witty designer, Lucien Métivet, who adapted the Modern Style to humorous and historical fantasies. All round the building, parodying the ceramic decoration of the Grand Palais, ran a frieze which showed all the nations of the world going to the exhibition (**123**). The capitals, caryatids and rosettes represented Parisian women in the latest fashions. Inside, panels also by Métivet depicted the various types of song: the satirical song of the Chat Noir, the humorous soldiers' song, the love-song of Delmet, and so on. Since the success of Bruant and Yvette Guilbert some twelve years earlier, the *chansonniers* had multiplied and Montmartre had been invaded by imitations of the Chat Noir. As in that famous cabaret, the entertainments of the Maison du Rire included shadow-theatre shows and a puppet-show, in addition to *chansonniers* of various degrees of fame.

OTHER ATTRACTIONS

Many other amusements were to be found outside the Rue de Paris, notably at the foot of the Eiffel Tower. There was a Venetian diorama with trips in gondolas; the Palais de la Femme, one of the most successful of the Modern Style structures at the exhibition, was a disappointment to those who hoped to find it full of low

112 The Manoir à l'Envers (Upside-Down Manor). One of the most popular attractions; visitors could walk among the chandeliers and the furniture was suspended from the ceiling.

neck-lines—on the contrary, it was intended to demonstrate that 'woman can raise herself to the level of man and emulate him in his achievements'. In the entrance hall stood figures of famous women, with the Empress Theodora next to Harriet Beecher Stowe. Sporting types were drawn to the pavilions of the Automobile Club and the Alpine Club with its dioramas (Mont Blanc, Gavarnie, and so on).

Rather more extraordinary was the Palais des Mirages, a hexagonal Moorish pavilion (**114**).

Each of the six horseshoe soffits springs from a group of three columns and stalactites hang from the gilded vault. The immense sheets of glass which form the walls of the room reflect an infinity of vaults, soffits and columns. One would think that one was in the middle of the marble forest of the mosque of Córdoba. Suddenly, the depths are illuminated; the arches are fringed with a lace of fire; blue and red stars light up in the long avenues; multicoloured chandeliers appear on the curves of the arches; the columns themselves are illumined by a transparent effect and change from marble to alabaster and from alabaster to malachite. The designs are diversified. The shades of colour alternate. It is a cold and silent pyrotechnic display which modulates with strange dissonances of colour (André Hallays).

M

Entertainments

114 Palais des Mirages. This Alhambra, with its per-
spectives endlessly multiplied by mirrors, was a great
popular success.

The cinematograph was used to complete the optical effects in the various pavilions.
1900 was the year in which the magic lantern made way for the cinema. The
Cineorama made it possible—

> to pass, within a few minutes, from the imposing spectacle of the open sea,
> battered by the tempest, to the vast horizons of the desert, furrowed by caravans;
> to see, after the gay fantasies of an Italian carnival, the manoeuvres of war with
> cavalry charges, cannons in action, fusillades and assaults; to come out of the
> popular markets of the old Flemish towns and watch a bullfight in Spain; to
> experience, by the magic of an aerial crossing which demolishes distances, the
> most astounding selection of vivid impressions—this is what the Cineorama
> has been able to achieve, thanks to the recent works and the ingenious apparatus
> whose construction has taken years (Hachette Guide).

To complete the illusion, a phonograph fitted with an amplifier reproduced songs
and national anthems from the countries shown. Photographs of actors were

113 François Flameng: Poster in the Photo-Cinéma-
Théâtre. A phonograph reproduced the voices of the actors
as the films were shown. All the stars of theatre and song are
portrayed here.

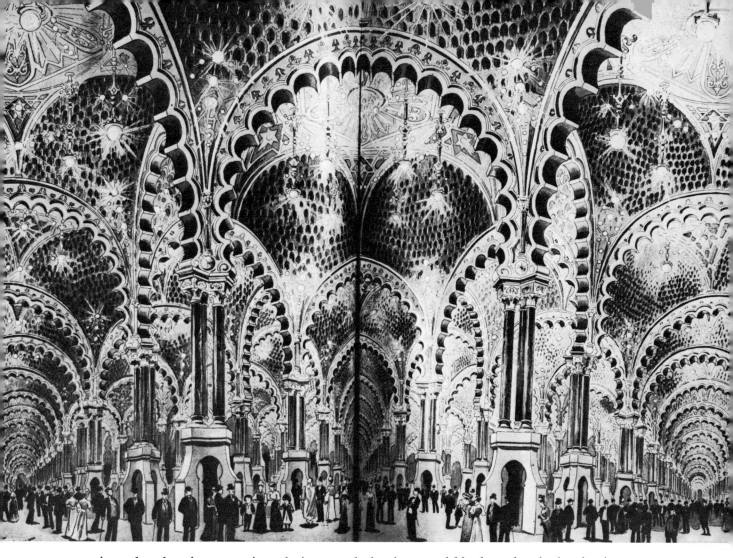

projected and at the same time their recorded voices could be heard—the beginnings of audio-visual entertainment (**113**).

 Side by side with the plaster Panorama of Rome, a film by Lumière showed 'Pope Leo XIII in private'. The Panorama of Rome was situated outside the exhibition proper, for there were still large stretches of vacant land around the Champ de Mars. The Avenue de Suffren had been transformed into a rather disreputable fairground, for the population of Grenelle enjoyed a certain notoriety. Here visitors could see Vesuvius erupting in Paris, under a dome forty-five metres high, and a kind of poor man's Old Paris, 'La Cour des Miracles'. Near the Seine was the Celestial Globe (**109**), forty-six metres in diameter, where spectators revolved in an Earth eight metres in diameter. There was an epicycle, a hypocycle, a panorama of Fashoda and another of the St Gotthard mountains, exotic taverns scattered everywhere, and a distinctly sinister Arab bar. The merry-go-rounds were described thus by Jean Lorrain:

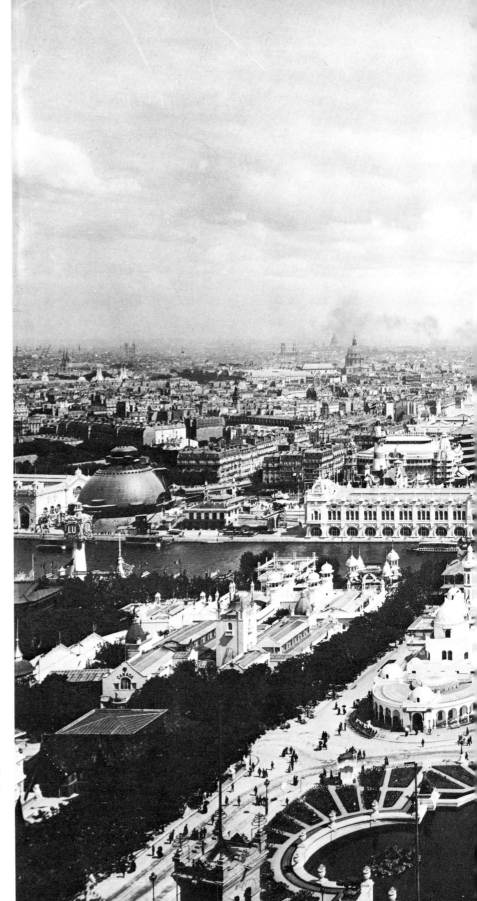

115 Panoramic view of the Champ de Mars from the Trocadéro Palace. On the right bank of the Seine are the colonial section, the two white Algerian pavilions in the centre, and the Indo-China pavilion in the right foreground. The palaces of the Champ de Mars are on the left bank as are the Eiffel Tower, the chimneys of the electric power works and the Great Wheel.

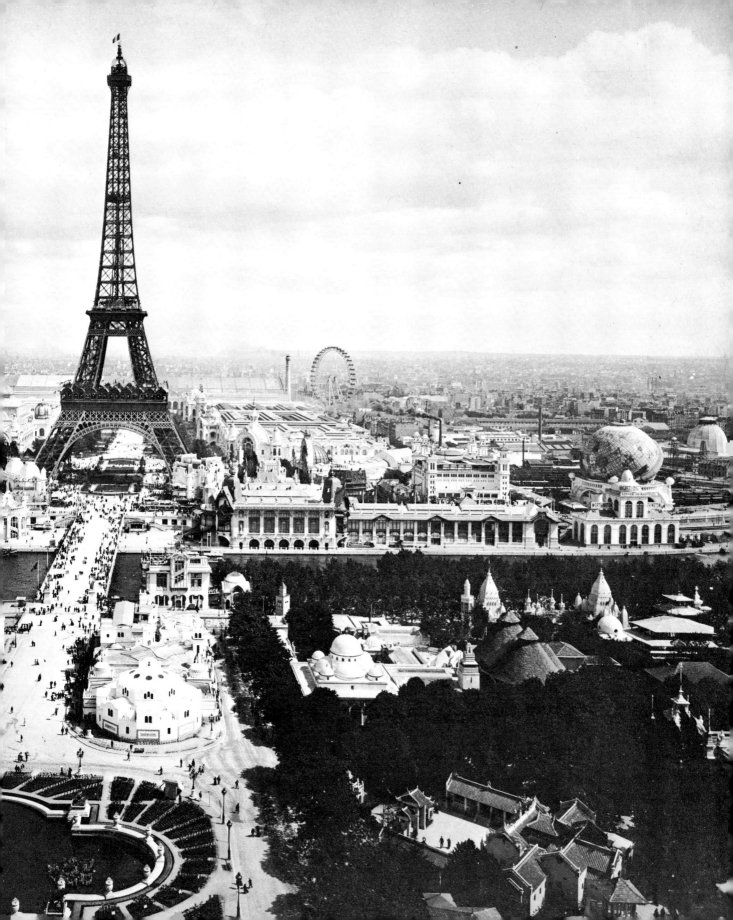

In an apocalyptic uproar, the merry-go-rounds of pigs, giraffes, camels, automobiles and bicycles, the circular rotation of the Russian mountains, all revolving, blazing, glowing and sparkling, glittering with tinsel, gilding and mirrors, carrying along in a truly Dantean cycle swirling skirts, dazzling breast-plates, gleaming helmets, flowing blouses and streaming flames of silk and hair, manes, mantles and buns. The electric light fires colours and silhouettes in a blaze of white; the heavy atmosphere reeks of red wine, sweat, musk and petroleum. Fantastic pigs go by, ridden by negroes (the Senegalese of the Trocadéro) of a sombre splendour in their flying white gandouras; all the souks of Tunis, all the streets of Algiers, turbans and chachiyas, gallop past furiously, some on ostriches, some on the leopards of the neighbouring roundabouts; all the soldiers on leave, all the women of the Gros-Caillou, stand in lines, full of enthusiasm, and, crowned with flowers, with two little Arabs in burnous, in one of the cars of the Big Dipper, I recognize the snake-charmer of the Djelbirb garden in Tunis, the ragged conjuror with jet-black eyes from the Place des Conteurs.

The crowds loved the Great Wheel, 106 metres in diameter, with 80 cars each holding 20 persons, revolving slowly, illuminated against the sky of Paris. After the exhibition it was bought by a Viennese and re-erected at the entrance to the Prater.

Parents took their offspring to the Swiss Village, where they found fresh air, fresh milk and snow-capped peaks which ventilated their lungs after the dust of the exhibition. The Swiss Village was a prodigious *trompe-l'œil*:

Of all the attractions at the Exhibition, the greatest in extent, the most curious and interesting as a novelty and an example of difficulties overcome, the most picturesque and lifelike, is undoubtedly the Swiss Village, occupying an area of 21,000 square metres along the Avenue de Suffren and the Avenue de La Motte-Piquet, with chains of mountains, a waterfall 34 metres high, a torrent, a lake, pine-forests, chalets, meadows, herds, and a whole town of old architecture. The Swiss Village is Switzerland in Paris; it is the living synthesis of this original little country whose natural beauties are the admiration of thousands

and thousands of tourists who flock there every summer from all parts of the world. The two engineers and architects who designed and executed this mighty project, MM. Charles Henneberg and Jules Allemand of Geneva, have carried their passion for truth so far that they have had transported from the most remote valleys of Switzerland the chalets and little rustic cottages where one sees, in their traditional costumes, more than 300 peasants—herdsmen, craftsmen, wood-carvers, basket-makers, weavers, embroiderers and lace-makers—working as they do in their own villages. In the Fribourg Dairy they make the celebrated, the inimitable and delicious Gruyère cheese. In the hospitable Inn of the Treib, with its pointed roof reflected in the water of a little lake beside which stands the chapel of William Tell, one can drink Swiss beer and wines. In the Creamery Chalet (cups of milk, Kohler chocolate) one can hear a trio of Swiss singers every day. In the historic Inn of the Bourg St-Pierre one can eat at the same table at which Napoleon ate when he crossed the Great St Bernard. Side by side with the old arcaded houses of Thun and Berne are the turreted houses of Schaff-hausen. On the village square one can watch national dancing, shepherds wrestling, and so on. The Town, the Village and the Mountains form a trilogy: here one sees, in succession, the three characteristic aspects of Switzerland. The Mountains form the setting. The workmen spent three years erecting the scaffoldings and constructing the skeleton of this chain of mountains, which has cost over a million francs. These Babylonian structures have been covered with boards; where you see greenery, trays have been placed to hold loam, Alpine plants and pines; where the rock is bare and sheer, it has been modelled on the rocks of the Alps themselves (Hachette Guide).

Jean Lorrain loved to relax in the Swiss Village after dallying in the seedy cafés of the exotic sections:

The pasteboard Appenzel had its own charm, enlivened by strapping Swiss shepherds grappling with our gymnasts; it all smacked of William Tell, Chillon, Fuelen and Gessler. At first, rocks, chalets and chapels. In the middle, big, clumsy

116 The Escalator. This cartoon, published in the *Journal de la Vie Parisienne*, shows the sort of comic situation that occurred on the three platforms moving at different speeds: on the left, English tourists, then a group of *demi-mondaines*, and a provincial family. Acquaintances made on the escalator were often pursued in the shade of the little cafés on the Champ de Mars.

lads with milky eyes tinged with azure, all hale and hearty, fond of heavy food and bowlfuls of wine, rugged, fair-haired fellows in linen pants come to grips with the gymnasts, who are more slender and supple, but who nevertheless get the worst of it; our wrestlers are always falling first, for the shepherds are stubborn and quite ferocious when they get a hold. How they go at it! No 'faking', it's all over quickly and then they go on stuffing themselves, knocking their skulls against the rails and sometimes against the platform where the other wrestlers are sitting.

THE WORLD OF FEYDEAU

To understand the atmosphere as the visitors flocked to the exhibition's various amusements one must turn to the farces of Feydeau and Courteline. Feydeau's well-do-do bourgeoisie and Courteline's lower middle class present the same characters: the generous husband deceived by a flighty or wanton wife who is always spending money, or who is comically jealous, insufferable brats and an equally intolerable mother-in-law, the blundering country cousin, the artless girl who is not as simple as she looks, and a confidante who might be a wardrobe dealer or a fortune-teller, not to mention the always incredible number of servants, the dubious relatives, the paramours and the deserted mistresses, and the illegitimate children whom the family happen to encounter at the most awkward moments. The exhibition of 1900, with its vast crowds of such diverse social origins, produced many unexpected meetings of this kind, spiced with an exotic flavour. The escalator, with its pavements moving at three different speeds, caused many an incident worthy of the vaudeville, separating families, sending old men sprawling, delighting the children and reducing their nannies to despair (**116**). In fact, this new means of transport was the jolliest attraction at the exhibition; it went all round the Invalides to the Champ de Mars, enabling visitors to go quickly from the Esplanade to the Palais de l'Électricité. From the upper stage of the escalator tourists could see right into the apartments along the embankment, and this caused a certain

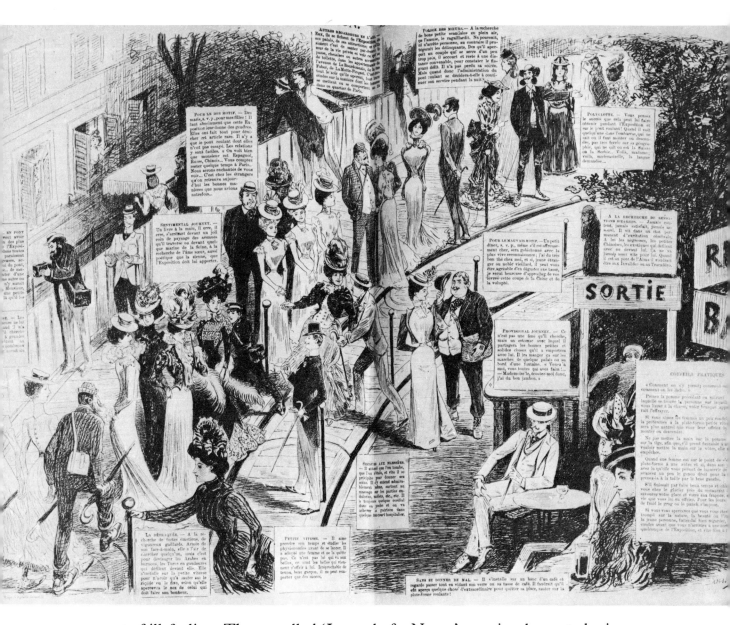

amount of ill-feeling. The so-called 'Journal of a Negro', previously quoted, gives a rather naïve view of the problem:

At one time, it was man who moved over the ground; but such is our mastery of matter that it is now the ground which moves under man. Someone has had the clever idea of making the escalator run along the Avenue La Bourdonnais. This enables strangers to see the interiors of Parisian dwellings. Many travellers have no relations in Paris; however long they stay, they see only cafés, theatres

117, 118 The most fashionable restaurant at the exhi-
bition was the Pavillon Bleu (*right*) on the Pont d'Iéna.
The Viennese tea-shop (*far right*) was a charming circular
building decorated with a faience frieze. It is a rare
example of domestic Art Nouveau which was often imita-
ted in bakeries situated in fashionable districts and in the
restaurants of watering-places.

and streets, and this gives them no idea of family life. By spending a whole day on
the escalator they can learn something of the habits of the residents. However,
many tenants, just to be awkward, deliberately keep their windows closed while
the escalator is in operation. I can see why they want to shut the bedroom
window, even during the day: it is, perhaps, from an understandable feeling of
modesty. But it seems to me that they could be compelled to leave the other
windows of their apartments open as long as the Exhibition lasts.

The escalator was also a favourite haunt of pickpockets who, while pretending to
help a lady to change from one stairway to another, would snatch her handbag.

Gastronomy, which played an even larger part in French life at that time than
it does today, was represented in all its aspects, from the luxury restaurant to the
beer-saloon and even the cheap cafés where people could bring their own food. The
smartest restaurant, the Pavillon Bleu (**117**), with its bright blue Modern Style
volutes, stood beside the river. From its terraces customers had an excellent view of
the illuminations as they listened to a gipsy orchestra. (There was a veritable
invasion of gipsies, genuine and bogus, at this time. One of them, the superb Rigo,
had made off with a very wealthy American, the Princesse de Chimay, née Clara
Ward.) The Pavillon Bleu attracted the same clientele as Maxim's, famous *demi-
mondaines*, men-about-town, the inevitable Jean Lorrain, but also the fashionable
world. In contrast, the Restaurant Tyrolien, a scrupulously exact reproduction of
the real thing, with comely waitresses and lads in *lederhosen*, was frequented be-
cause of the fresh rustic fare it offered. The Pâtisserie Viennoise (**118**) and the
Ceylonese Salon de Thé were also a great success. But the exotic restaurants did
badly, for people were suspicious of the nameless sauces disguising dishes that were
neither fish nor fowl. After visiting the Algerian souks, the 'negro' visitor at the
exhibition remarked:

I have not been able to find in any restaurant either couscous, camel's milk or
date brandy; there is nothing but fillet steaks with potato and beer. This proves
that French cuisine is the best of all, since every nation adopts it.

However, all these restaurants were too expensive for the families who came on excursion trains and who preferred to have a cold snack under a tree; then they would set off again to see the *Terreneuva*, moored opposite the Merchant Navy pavilion, with its captain and crew who were dreadfully bored so far from their beloved Brittany. Or these provincials would go to stare, like curious animals, at the soldiers guarding the Senegalese and Indo-Chinese pavilions. On public holidays extra trains unloaded thousands of visitors of this kind. The Agriculture festival, on 19 September, was the most brilliant of these occasions: a procession of flower-strewn waggons which were pulled by children also decorated with flowers and from which women dressed as flowers threw more flowers at the public; vine-harvest waggons each representing a famous vineyard; wine-harvesters singing drinking-songs with the accent of the particular region; a waggon of orchids presented by the Indo-Chinese section; and the much-applauded Monte Carlo waggon, drawn by sailors of the Merchant Navy and laden with carnations. On the snapshots of the crowd taken as the waggons passed one can recognize all the characters of Courteline's comedies. (People of the clay of Feydeau's characters, who did not associate with the vulgar throng, were invited on to the balconies of the palaces bordering the Champ de Mars.) Civil servants mingled with the provincials, peasants in smocks, country priests, gendarmes and sisters of charity

187

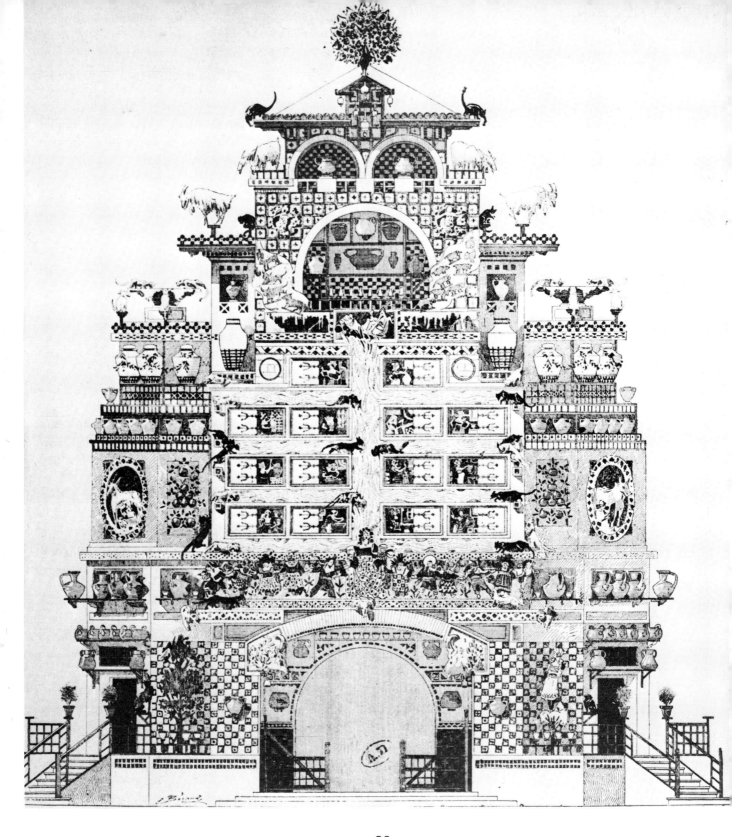

188

119 The Dairy, by Binet. This building erected inside the Machine Gallery was covered with slabs of faience and decorated with faience animals. The influence of Dutch decoration with Delft tiling is evident.

120 Traschel: Palais des Extases. The fanciful designs of this architect, who was close to the spirit of the Symbolists and a friend of Peladan, attracted much interest in the Swiss section.

surrounded by orphans—a jovial, hard-working, thrifty, patriotic and devout France for whom these processions were reminiscent of Corpus Christi and the Fourteenth of July.

Feydeau's world had few official festivities to enjoy. In its public celebrations the Republic was distinctly democratic, for it did not want to repeat the mistake of the 'Fête Impériale'. There were no magnificent evenings at the Élysée and few galas at the Opéra. As the Comédie Française had been damaged in a fire in March, its members were sometimes invited to give poetry-readings at the ministries. The most successful of these gatherings was the 'Fête des Provinces' at the Ministry of Foreign Affairs, with regional songs and dances; but the fashionable world was of no interest to the government, and in any case fashionable people would not have accepted its invitations.

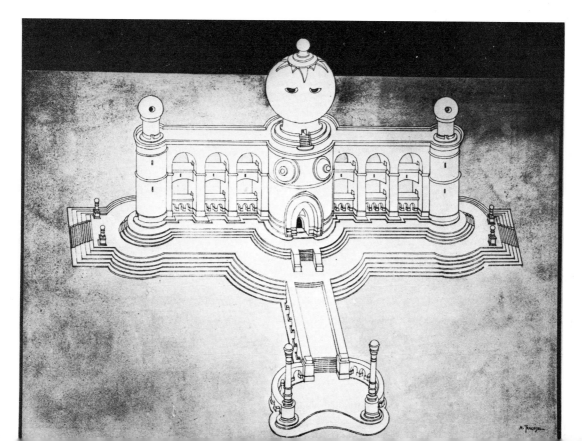

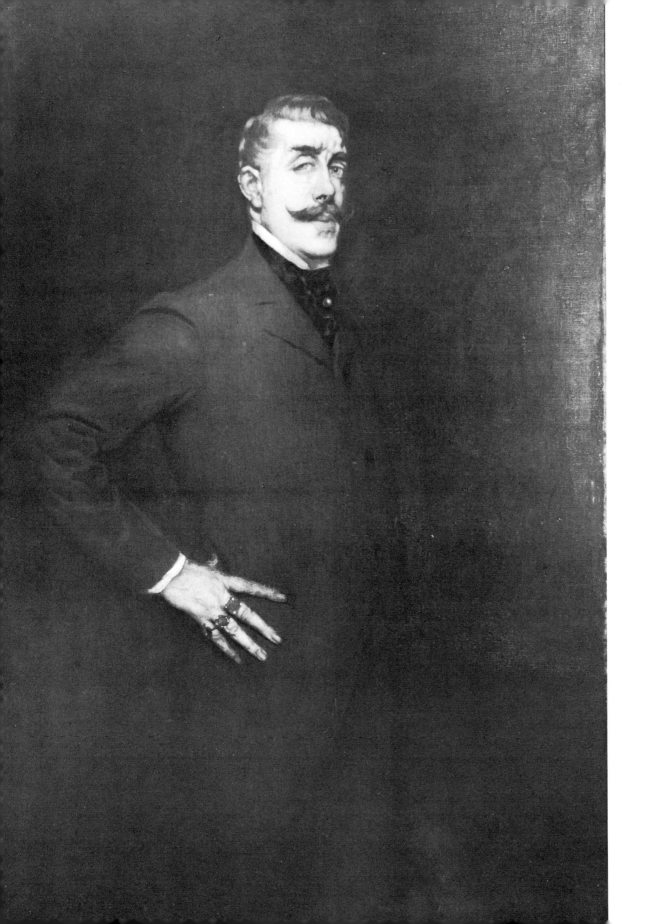

10

ᴛʜᴇ Public

OFFICIAL VISITORS

The success of the exhibition was so universal that the French could afford to ignore the relative unimportance of the official visitors. Despite renewed prosperity, it was a far cry from the concourse of crowned heads which the Paris of 1867 had witnessed. An elegant private mansion on the Avenue du Bois had been specially prepared to receive the heads of State, but it was used only twice, for King Oscar of Sweden and for the Shah of Persia. There was little similarity between the two visits. That of the Swedish king, all pomp and ceremony, satisfied the Republic's need to play the host to monarchs; the visit of the Shah was marked by

121 (*opposite*) Portrait of Jean Lorrain painted in 1895 by Antonio de La Gandara.

122 C. Léandre: Caricature of Queen Victoria published in *Le Rire*.

disorder and fear, a fear which proved justified when an anarchist made an attempt on the Shah's life. Sullen and closely surrounded by an inordinately large retinue totally lacking in prestige, the Shah went round the exhibition several times and relaxed in his country's pavilion, a reproduction of a palace in Isfahan. For a long time it was hoped that the Tsar would come, but there were only grand dukes and a horde of Russian dignitaries who, under the cloak of excessive politeness, hardly concealed their contempt for the official world of the Third Republic. Wilhelm II, it was said, was dying to be invited, but the memory of the incidents which, ten years earlier, had bedevilled his mother's incognito visit to the vanquished capital, and the fear of some monumental indiscretion on Wilhelm's part, banished any idea of an invitation. The Prince of Wales had come several times to inspect the construction work of the exhibition, since he was president of the British section, assisted by his brother-in-law, the Marquess of Lorne, as vice-president, and by the Duke of Devonshire. Then the Boer War poisoned relations between France and Britain. French satirical journals published scurrilous caricatures of Her Britannic Majesty (**122**) and ribald allusions to her son's amorous escapades. And so the future

Edward VII decided that he would not set foot in Paris in 1900. Several British exhibitors withdrew. Queen Victoria heroically cancelled her trip to Nice and went instead to Ireland. 1900 was thus the only year when the Prince of Wales did not go to Paris, but this did not prevent the crowds from recognizing him every time they saw a bearded, pot-bellied and well-dressed stranger at the exhibition, and shouting 'Long live Kruger!' Leopold II, King of the Belgians, came regularly in a semi-incognito capacity; inevitably he was particularly interested in the African section. The Queen of Saxony, the Crown Prince of Italy and various South American presidents were meagre compensation for this dearth of monarchs.

On the other hand, there were so many conferences of one kind or another (127 in all) that they could not all be accommodated in the vast and ugly Palais des Congrès. The most important were the conferences of Agriculture, Public Assistance and Private Charity, Motoring, Applied Chemistry, Pure Chemistry, Electricity, Education (several different topics under this heading), the Status and Rights of Women, Cheap Housing, Medicine, Mutual Insurance, Photography, Physics, the Press Associations, Commercial Travellers and Representatives, and so on.

The conference delegates came from Europe and America, usually accompanied by their families. They were conscientious visitors and could be found in the least frequented pavilions, such as the Pavilion of Social Hygiene, and even in the annexe in the Bois de Vincennes where workmen's dwellings, model railway-stations and dirigible balloons were on show. The Parisians only made the effort to go out to Vincennes to watch the motor-racing (**53**).

The most extraordinary conference was that of the mayors of France, held on 22 September and attended by 20,777 mayors. President Loubet, seated between the oldest and the youngest of these dignitaries, presided over the gigantic banquet held in their honour in a tent erected in the middle of the Tuileries. The tables were arranged in *départements*, each with its own senators and deputies. Most of the guests had never before left their provinces. The mayors of Brittany came in national costume, accompanied by the sounds of Breton bagpipes. The banquet, surely one

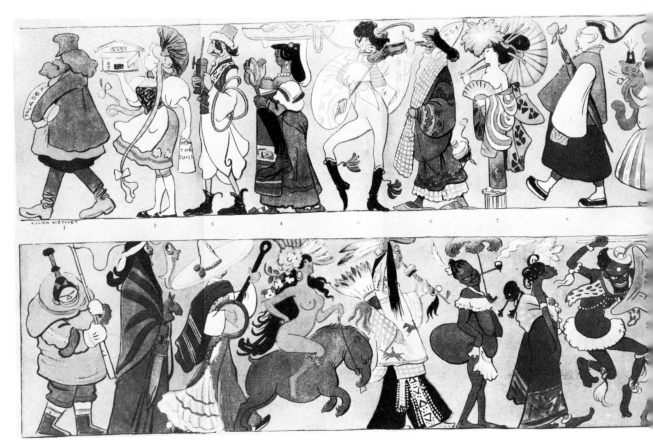

123 Lucien Métivet. This gaily coloured frieze adorned the façade of the Maison du Rire in

of the biggest ever held, involved over a thousand servants and the mobile kitchens of all the regiments of the Parisian region. The weather was still very hot. The speeches, interspersed with the *Marseillaise*, kept the delegates at their tables until five o'clock in the afternoon. The most resourceful of the guests ended the day at the Folies Bergères; the rest went in a party to visit the exhibition, and in particular the pavilions of their own provinces.

THE CROWDS

During the summer of 1900 the whole of France came to the exhibition (**124**). Many a Frenchman has grandparents who still have a hazy memory of its dust, heat and fireworks; for three months nearly every day was the Fourteenth of July. André Hallays observed the visitors from the provinces:

the Rue de Paris. It represents all the nations of the world flocking to the exhibition.

They, too, feel the need to escape from the turmoil of the crowds and to be themselves again in their own homes. Between the palaces of the Esplanade and the Rue de Constantine some restaurants have been built like those of Brittany, Provence, Berry, Poitou, etc. It is a sinister place. All these little yards cluttered with taverns, kiosks, water-closets and bogus ruins are dusty when the sun is shining and are transformed into swamps at the slightest shower. The miserable trees of the Esplanade, caught up in the plaster of the constructions, are a sorry sight. But around midday you can see processions of Bretons making their way to the taverns where the bagpipe-players can be heard; loyal natives of Poitou go to the house of Mélusine; and in the Provençal farmhouse I can assure you that the customers have an accent. Only the *bouillabaisse* draws a few addicts who are not 'locals' to this depressing place. But the fame of *bouillabaisse* extends beyond frontiers and across seas: it is worldwide.

195

124 Huard: *The Public*. The provincial old lady says to her husband: 'I am sure, Philémon, that there are fewer people than in '67.'

Jean Lorrain has left a vivid picture of these thronging crowds:

From the heights of the Trocadéro to the end of the Champ de Mars, a human tide, an ocean of curious heads remains transfixed, engulfed by the sheer mass of the various groups, awaiting the promised spectacle. These crowds! You couldn't separate them with a pin! The Whitsun excursion trains have been pouring out whole convoys since the morning. . . . All these people, this fair-ground crowd, have been dining outside, on benches or chairs, or sitting on the ground as they do in the Bois de Vincennes or the Bois de Boulogne; not one of M. Picard's pilgrims has gone back to dine at home or at a hotel—they have all brought their baskets of food, with the inevitable slice of sausage and the saveloy with garlic. And so the enormous throng smells. 'Ça fouette' ['It stinks'], to use the colourful slang of the workshop. The acrid smell of the dust is mingled with the odour of a dirty steamer which is peculiar to the crowd, for everybody has been walking about since dawn. But, in the excitement of finally seeing the water tower and the electricity working, they all overcome their weariness, waiting happily, staring and gaping.

Fortunately, every provision had been made for the comfort of visitors, so the Hachette Guide assures us; there were several post-offices, and telephone kiosks were scattered everywhere (a great novelty). There was another novelty: the garages for bicycles and automobiles (the garage on the Champs-Élysées could accommodate 500 bicycles and 1,000 motor cycles or small cars): 'In addition, these garages are provided with every modern comfort: lounges, cloakrooms, lavatories, wash-basins, showers, shoe-cleaners, accessory shops, a dark room for photographers, telephone, *poste restante*, etc.' Nothing was left to chance: 'Hygienic water-closets (W.C.), very numerous, so numerous that we cannot give a list of them here; most of them are indicated on our Plans. Rates vary according to the class: ordinary, 10 centimes; with wash-basin, 65 centimes; de luxe, with hot water, etc., 75 centimes.'

The poet Émile Verhaeren, author of *Les Villes Tentaculaires*, gives a more lyrical and probably more accurate picture of the crowds at the exhibition:

Today the palaces cluster together, seeking one another, drawn to one another, facing one another, dazzling one another, envious of one another and intoxicated with their mutual din. Their splendour is in the crowd, which they summon and from which they borrow their beauty, just as those of earlier times sought theirs in solitude. The crowd animates the avenues, terraces and esplanades with its colourful masses. It fills the vacuum which the violent decorations, the ramps, the flights of steps and the barriers have left in a monstrous assemblage of iron and plaster.

The crowd is beautiful, gay, alive. It breathes in millions of waves, to which it gives a rhythmic regularity when it is quiet. It is a mighty and thrilling spectacle when its enthusiasm rises from instinct to thought.

THE PARISIANS

At first the Parisians, bored with the whole affair even before it had begun, and deriding it for political reasons, shunned the exhibition; then they came, attracted chiefly by Lorrain's articles in *L'Écho de Paris,* and many of them spent all their

summer evenings there. The exhibition finally became fashionable. Lorrain tells us what society people considered worth admiring:

Friday, 1 June.—The Great Bazaar. What they say and think about it all, what one must see: the tapestries woven in gold thread in the Spanish pavilion; the Emperor's Watteaus in the German pavilion; the Spaniards in festive mood; the ciboriums, the church ornaments and the ceremonial vestments decorated with enamels in the Hungarian pavilion; the British furniture; the Danish earthenware; ecstasy for Finland is considered appropriate. Observe the atmosphere of calm and integrity radiated by the nations of the North; come to relax in the cool shade of their virtue after the brutal lewdness of the Orient, a subject of much talk and gossip. . . . One should not boast of dining every evening at the Exhibition, otherwise people might think you have no family or are out of favour with your relations; avoid saying 'We are visiting our thirtieth restaurant' in case the reply is: 'That says a lot for your stomach.'

So that the exhibition should receive the sanction of fashionable society, Madeleine Lemaire, the painter of flowers at whose house Proust met the most brilliant of his friends, gave a costume ball with the exhibition as its theme. She herself appeared as the 'Parisienne' on the Porte Binet; her daughter Suzette, well over thirty but still hoping to catch a husband, was the Fairy Electricity. Count Robert de Montesquiou, dressed as a maharajah, glittered in the jewellery which he had borrowed from Sarah Bernhardt. A box was occupied by a grand duchess and a few other royal personages, the guests filing past with bows and curtsies.

The *demi-mondaines*, whose position was at this time semi-official, had raised their prices. A caricature shows two of these courtesans looking at an enormous brand-new bed: 'You have changed your bed?—Yes, I hope to entertain a lot this summer.' The young Paul Morand was already acquainted with these celebrities:

My father took me to see Cléo de Mérode who, jealous of the Javanese dancing-girls, danced with gold serpents on her wrists and gold circlets round her hair,

125 Oscar Wilde by Cappiello. This unpublished sketch of Wilde was drawn by the caricaturist of the *Belle Epoque* in a café shortly before the writer's death.

lost, somehow, in this Far East. An old gentleman looked at her with lustful eyes, turned round, saw my father and, with a smile, whispered in his ear: 'Saltavit et Placuit'. The old gentleman was Anatole France.

These stars of fashionable Paris, walking along the Rue de Paris or emerging from the elegant Pavillon Bleu, were recognizable to the general public through the albums of Sem and the drawings of Cappiello (**106**, **125**), dining regularly at Maxim's, associating with generals' wives and frequenting the races. There was Liane de Pougy, Cléo de Mérode and Émilienne d'Alençon; the music critic Willy and his young wife, Colette; Jean Lorrain trying to smother with couscous the odour of the ether which he consumed in his fruit salad; Feydeau, the melancholy author of zany comedies; and Montesquiou, divided between curiosity and insolence, and followed by an exotic, handsome young man, Gabriel d'Hurry. But how many unfamiliar faces one finds among these caricatures! Like official painting, fashionable Paris had its nonentities.

The exhibition of 1900 did not, alas, have an Offenbach and did not leave behind it the memory of an elegant, cosmopolitan carnival, as the 1867 exhibition had done. Its visitors belonged to a more serious generation and the more frivolous among them, as they walked round the palaces and watched the nocturnal festivities, felt that they were witnessing the dawn of a new world. The majority of visitors, moreover, belonged to the lower bourgeoisie.

199

CLOSING TIME

The autumn of 1900 saw the continuation of an exceptional summer. The foliage along the avenues assumed the same pale golden tints as the domes which four months of dust had robbed of their brilliance. In the flower-beds, the geraniums were replaced by chrysanthemums, and the Japanese pavilion gave a private party in honour of these flowers which became such a prominent feature of the Modern Style. Jean Lorrain was seen there with a mauve chrysanthemum in his buttonhole, mauve like his heavy, night-bird's eyelids. His last visit was to the Jewellery Pavilion on the Esplanade des Invalides, where he sought a final thrill of ecstasy from the glassware of Gallé. From the Pont Alexandre the poet Verhaeren pondered for the last time on the architecture which resembled the gilded, distant edifices in the background of Turner's paintings:

> Oh, this city of plaster and iron has reigned over the earth like a beneficent force; it was like peace among men, fragile but wonderful. . . . It can be compared to an immense mantle that has been spread over the nations, and in which the holes made in the Transvaal and China did not prevent the warmth from reaching to the marrow or its beauty from shining forth . . . the autumn has given it a wonderful funeral. . . . In the October dawns the Seine would cast off its mists, in a setting of minarets and pagodas whose marvellous absurdity astounded one and seemed to belong to a dream-world. In the evening, against a sunset full of molten metals, coppers and bronzes, veiled with tumultuous vapours, resembled the monstrous efforts of Cyclops constructing and amalgamating strange monuments for some people of the future which, in its vastness, would embrace all the peoples of the world. . . . Beauty is not all in one place. It is not in Athens; it resides, just as supreme, in India and China. It is growing in New York and in the formidable structures of San Francisco. It is constantly renewed like everything which is thought . . . (*Le Mercure de France*).

Wednesday 7 November was the last free day of the exhibition. On that day M. Lépine, the prefect of police, fearing an anarchist demonstration or an outbreak of violence by rowdy elements, ordered all the pavilions of the luxury industries to be closed. However, everything went smoothly. A crowd of lower-middle-class Parisians and suburban dwellers (but not many from the working class) poured into the pavilions which had been most talked about: the German and Russian pavilions and the Palais de l'Électricité. The Algerians managed to sell a few used carpets, but no real business was done during these latter days of the exhibition; prices remained high and unsold articles were returned to their country of origin. Most of the amusements had closed down before the autumn in order to avoid swelling an already heavy deficit. There were interminable queues at the bus-stops; the crowds poured into the Métro at the Rond-Point des Élysees and Concorde stations, and pickpockets reaped a rich harvest of half-empty wallets; the keepers of the public conveniences took in as much money as on the best days of the exhibition. A belated visit by the President of the Republic to Vincennes failed to 'bring the dreary annexe to life'.

On 11 November a gala evening at the Opéra, with actors from the Comédie Française taking part, brought the organizers and the leading exhibitors together. Even those sections of the press most hostile to the government had long ceased criticizing the exhibition. As closing-day approached, all the newspapers expressed unanimous satisfaction. France had won a great and peaceful victory.

On 12 November there were even more visitors than on the free day: 369,535.

An enormous and excited crowd had rushed to the Champ de Mars, which was illuminated as if for a festival, and it waited with the feeling of vague and anxious curiosity that one experiences when something is about to come to an end. . . . Suddenly, the Eiffel Tower cannon reverberated, repeating its death-knell every quarter of an hour, then the last explosion burst forth like a final lament; all the lights were extinguished and the drums ominously beat the retreat; it was all over and the crowd, gripped by an unconquerable emotion, roared 'Long live France!' ('The End of a Dream' in *Le Correspondant*).

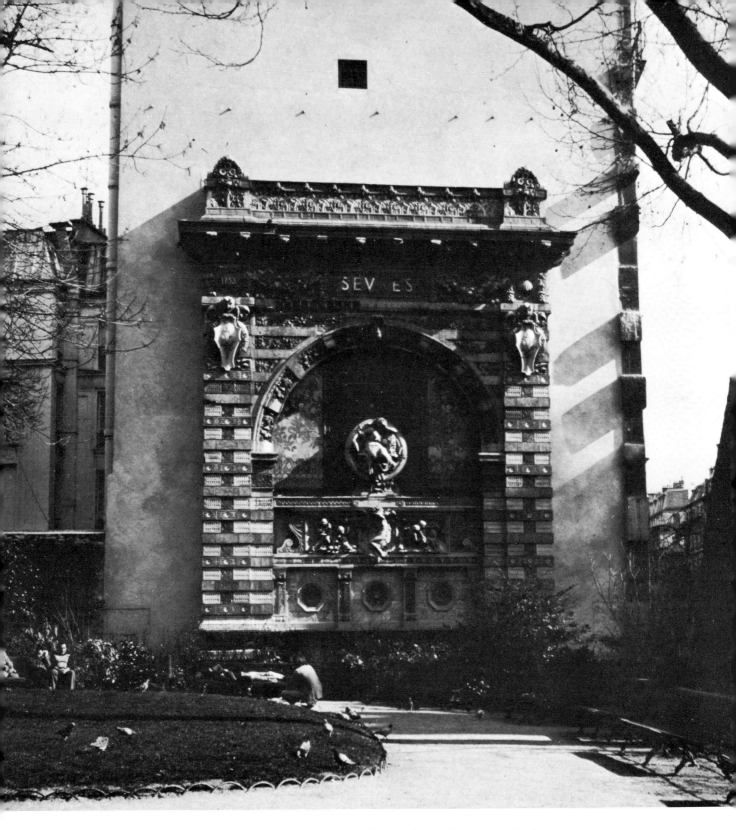

126 Façade of the Sèvres pavilion as it can be seen in Paris today.

11

THE BALANCE SHEET

SOME FIGURES · Seventy-six thousand exhibitors, thirty-six thousand for France and forty thousand from abroad, contributing the results of their efforts; . palaces full of marvels in a dream-city;—all the nations vying one with another; such were the sights to be seen in the review of civilization provided by the Exhibition of 1900. And so, rather than admiration for so much beauty, the sentiment which it has inspired has been respect. Opposition has been taken by surprise and then overcome. The grandeur of ideas has prevailed over the grandeur of things, and no one has felt able to stand aloof from the movement of the world.

The Balance-sheet

127 Official diploma designed by Camille Boignard, a disciple of Bouguereau, who was insensible to Art Nouveau and closer to the designers of bank-notes.

The optimism of these opening lines of a work entitled *L'Exposition du Siècle* (The Exhibition of the Century) seemed justifiable when M. Picard published the accounts:

In the month of October 1903, *Le Figaro* announced that the settlement of the Exhibition accounts would be completed on 31 December, that it would leave a profit of several millions and, finally, that the Exhibition of 1900 would be found to have brought in as much as all the others put together. This forecast was not to be wholly fulfilled. If the preliminary estimate fixes the receipts at 126,318,168 francs 50 centimes, and the expenses at 119,225,727 francs 13 centimes, thus leaving a surplus of 7,092,461 francs 37 centimes, this surplus, even if M. Alfred Picard raises it to nine and a half millions by including all the additions to the original amount paid out of the profits, is still less than the surplus of the 1889 exhibition alone (ten millions), and is far from equalling the total profits of all previous exhibitions. But it is none the less true that, contrary to all expectation, the Exhibition of 1900 not only covered its expenses, but produced a profit which was certainly not less than five millions.

According to the official figures, there were from 15 April to 12 November 37,041,019 paying visitors in Paris and 1,986,158 paying visitors at the Bois de Vincennes, that is to say 39,027,177 admissions using 47,076,539 tickets. . . . The biggest day at the beginning of the Exhibition was 3 June, Whit Sunday: a night entertainment was given; there were 515,700 admissions, including 459,636 paying visitors.

The satisfaction evident in these lines was certainly not shared by the organizers of the amusements either within or outside the walls of the exhibition. Restaurants, theatres and dioramas did poor business. They had been charged far too much for the ground leased to them and building costs had proved much higher than antici-pated. And then the crowds, tempted from all directions, had been confused by an *embarras de choix*. Only the Great Wheel and a few cafés had been profitable. The entrepreneurs who provided the entertainments, and their shareholders, were the only ones left with unhappy memories of the exhibition.

The official report notes the 15 million tickets left unused out of the 65 million issued. What it omits to say is that an enormous number of free tickets had been placed at the disposal of Members of Parliament, who proceeded to distribute them liberally to influential electors. The newspapers had also been given far too many free tickets and the embassies, naturally enough, obtained theirs from their own nationals. Consequently, nearly half the total number of visitors were entitled to at least one free admission. Only those far from the corridors of power failed to receive anything. This generosity proved expensive, but, together with a lavish allocation of prizes, it was excellent propaganda. So that everybody would go home happy, there were as many prizes as exhibitors. The manufacturer of Turkish delight in Smyrna, the exporter of caviar in Baku, the cigar-manufacturer in Havana, the distiller of apéritifs in Turin, the vendor of Panama hats in Guayaquil and the lace-maker in Bruges could all add to their firm's name the words: 'Gold (or

bronze) medal at the Exhibition of 1900'. The distribution of prizes took place in the Salle des Fêtes in August, in overpowering heat. There were speeches and anthems. The audience was spared the reading of the prize-list, which would have taken several hours: 'The awards were extremely numerous. In his speech M. Millerand announced 2,827 first prizes, 8,166 gold medals, 12,244 silver medals, 11,615 bronze medals and 7,938 honourable mentions, in all 42,790 awards.'

POLITICAL RESULTS

This generosity was good politics; with their free tickets or bronze medals, all concerned could look back on the exhibition with happy memories. M. Loubet became the first really popular President and Waldeck Rousseau, who never succeeded in pleasing the French, at least managed to remain in power. The Third Republic, having finally accomplished the mighty enterprise, was restoring France to her rank as a great power. Britain was soon to seek her friendship once more (the triumphal welcome accorded to President Kruger at the end of 1900 was an eruption of no real significance). When Queen Victoria was buried, France buried all the accumulated rancour which had been directed at her kingdom.

France's demonstration of well-regulated prosperity impressed the less fortunate countries, who were soon asking for loans. French investors allowed themselves to be tempted by the promises of Latin America and the Levant. As for the colonies, they were, it was insisted at the time, proud to be French. In any case, the brilliance of the colonial section of the exhibition was for many years to come regarded as justification of the policy of expansion launched twenty years earlier by Jules Ferry. The exhibition made Frenchmen aware of their overseas empire. The enemies of the regime, those who had begun by disparaging the whole enterprise, were thus made to look foolish in the eyes of the public. In *La Revue Blanche* of 15 June, a young journalist, Julien Benda, who was to become the most interesting intellectual of the Left between the two world wars, expressed his pleasure at the ill-humour of militarism, clericalism and the academic world (the forces of 'obscurantism', as the

radicals used to say). The conclusion of his article reveals the democratic optimism which prevailed at this time:

> Can it be denied that, on the day when humanity shows a sensibility such that the blazing view from the top of the Trocadéro is declared more beautiful than the onslaught of two cavalry regiments killing each other, militarism will be irrevocably doomed? Well, humanity is preparing to take a step towards such a sensibility, a step the decisiveness of which does not escape perceptive militarists.

The exhibition supplied the pacifists with a powerful argument just at the time when the first international peace conference was being held at The Hague, a conference unfortunately launched by Russia, whom nobody trusted, and composed of mediocre politicians. The following lines by the critic Gustave Geffroy complete Benda's line of thought. Art and democracy were to lead to universal peace:

> Let the crowd also look at the crowd, for it is the life, the source of all this work, the *raison d'être* of all this art. Let it listen to the educators who have emerged from it; let it become aware of its destiny and its role. . . . It is a coming together of races, a universal harmony. Let this force espouse the cause of art and ideas against the steel shells!

The same optimism is to be found in the writings of Verhaeren, who envisaged the world of the future without fear:

> The era of the Coliseums has returned; the era of mass piled upon mass, the era of forces multiplied a hundredfold and of mountainous buildings. However, thanks to the new industries, thanks to the supple, bold and elastic strength of iron, it is the forest as much as the mountain, the forest with its trunks but also with its light, rambling creepers whose teeming image will haunt the builders.

These three quotations reveal the importance of the role played by the exhibition of 1900 in the growth of an international democratic ideal. The same arguments were

successfully adopted by the politicians; after 1900 the French electorate moved towards the Left.

THE AESTHETIC BALANCE-SHEET

Verhaeren was sure that a new art—Art Nouveau, as it is now known—'with its light, rambling creepers', would be the art of the future city. On the contrary, as has already been shown, the exhibition of 1900 marked the decline of an art that was too delicate to be entrusted to the crowds; with the Turin exhibition of 1902 and the St Louis (Missouri) exhibition of 1904, at which the Modern Style ran riot, it was doomed to be no more than a style for exhibitions and casinos, a style which the leading architects of France, Italy and Great Britain soon abandoned, although Gaudí in Barcelona, Olbrich in Darmstadt and Saarinen in Helsinki continued to produce architecture which still aroused admiration.

The general public's distaste for the style stemmed from its confusion between the few genuine Art Nouveau edifices and the elaborate concoctions of the architects of the Beaux-Arts who were anxious to appear modern. What had been taken for architecture was nothing more than a plaster façade stuck on a framework of iron to which it bore little relation, a ravishing decoration when illuminated by Bengal lights at a firework display, but dismal as an empty fair-booth once the show was over.

A consequence of greater importance in the history of art than the ephemeral vogue of Art Nouveau, and which sprang from the concentration in one place of so many works of art, ancient and modern, European and exotic, was the birth of a new aesthetic system. Henceforth, it was impossible to begin a history of art in Greece, or even in Egypt, and conclude with Ingres or Renoir; it was now necessary to include the art of hitherto neglected continents. Chinese and Japanese works of art were no longer being regarded merely as trinkets but as masterpieces; when they saw the fetishes brought back by missionaries, people dared to speak of a 'negro art', and when they saw the Inca sculptures sent by Peru, they began to regret the annihilation of a whole civilization; beauty was now recognized even in a machine

or in a piece of rough crystal. All this undoubtedly owed much to the Goncourts, to Ruskin and even to Walt Whitman, and to the earlier exhibitions, but it finally gained acceptance with the exhibition of 1900, a prodigious display of all the earth's riches seen with the optimism of an aesthetic naturalism.

VERDICTS

The demolition of the exhibition buildings began the day after it closed, with the removal of the statue of the 'Parisienne' and the dismantling of the Porte Binet. But the demolition of the palaces on the Champ de Mars took several years; the authorities could not make up their minds whether to demolish the Machine Gallery of 1889. The architect Franz Jourdain described its demolition as an 'act of artistic sadism'.

It became clear, however, that after such a success France would not want to make the effort for another exhibition in 1911, and in 1905 the demolition workers set about the Palais de l'Électricité. In the meantime, the Château d'Eau had been transformed into a veritable jungle: bushes were growing out of the basins and brambles were clinging to the statues. The attendants had brought wild rabbits there which began to multiply, and for five years the Champ de Mars was like a bird sanctuary. Then huge blocks and private mansions were erected which reduced the vast esplanade. Eventually, only the Grand and the Petit Palais and the Pont Alexandre were left standing. Another memento of the exhibition can still be seen in Paris: the ceramic façade of the pavilion of the Manufacture Nationale of Sèvres, stuck on a building overlooking the square of Saint-Germain-des-Prés (**126**).

The ephemeral city did not vanish into oblivion with the cart-loads of rubble and the thousands of packing-cases that were despatched to their distant countries of origin. All who had loved it cherished glowing memories. But, as the years passed, people became accustomed to marvels. Electricity, once a magical phenomenon, became a part of everyday life. Similarly, the idea of a city of the future dedicated to art in a world of enduring peace was swept away as the armaments race gathered momentum around the year 1910.

The Balance-sheet

In 1930 Paul Morand mocked the exhibition of 1900 with the affectionate irreverence that a young man might show towards an absurd but lovable grandmother. A little later, Jacques Émile Blanche wrote: 'This date has become a butt and a goldmine for memorialists, humorists, the novel, the scurrilous song and the cinema. The date 1900 will henceforth be associated with the grotesque at its zenith—Hector Guimard's lamps at the entrances of the Métro, vermicelli-macaroni architecture, Gallé of Nancy.'

On the eve of yet another exhibition, that of 1937, which occupied exactly the same sites as the exhibition of 1900, but which was really an anachronism in a Europe conscious of impending doom and still undermined by the effects of the Depression, a book by a M. Boye appeared, devoted to international exhibitions and containing the following judgement, quite a fair one at a time when Art Nouveau counted for nothing:

> The Exhibition of 1900 revealed a powerful upsurge of creative sap, but no sign of harmony or balance. It expressed no doctrine, no firm discipline. The generations of today are entitled to censure it for its mistakes, its complacent imaginings: was not one of its successes the 'Palace of Illusions'? Its pavilions of plaster were too often palaces of fantasy: the fantasy of universal peace, of the primacy of science, of prosperity, happiness and indefinite progress; the belief that the twentieth century would bring the union of all in love and justice; that the Exhibition of 1900, the child prodigy—and the prodigal child—of four universal exhibitions, was the greatest and the most beautiful, when it was merely the wildest, the gayest, the most extravagant in materials and ideas ever recorded in the history of Exhibitions.

But, once again, the author was not giving sufficient credit to the artistic fervour of the men who organized the exhibition. It was not until the admirable exhibition of the 'Sources of the Twentieth Century', held in Paris in 1960, that justice was finally done to this immense undertaking. In the catalogue M. François Mathey writes:

The distance of time now enables us to see more clearly the great originality of the research which affected and orientated—'from the imitation of nature to creation'—all the decorative arts of the time. This was a superb effort, an enterprise of great courage and boldness, a true revolution. In 1900, the fire, as Le Corbusier wrote, 'was kindled in the mind'.

What, then, was the artistic balance-sheet of the Paris exhibition of 1900? Did all this effort, all these diverse trends set side by side, all this semi-secret experimentation displayed for the amusement of an enormous public, change the evolution of styles and mark a new stage in the History of Art?

Although, as has been seen, few of the buildings represented a contemporary art in their entirety, the exhibition was remembered by visitors as the apotheosis of the 'New Art'. An art elaborated in refined circles for an intellectual public was vulgarized when it was suddenly applied indiscriminately to the most disparate edifices and objects. For this reason it seems appropriate, before 1900, to speak of 'Art Nouveau', with all that movement's striving for innovation, its poetry and also its social ideal; and, after 1900, of the 'Modern Style', which was a commercialization of the discoveries begun some ten years earlier. Art Nouveau was the fruit of the artist's studio, the Modern Style the result of mass production; this is clearly seen in Gallé's glassware, exquisite in invention and craftsmanship when the artist himself fashioned it into poetic forms, but merely charming and tasteful when the studio became a little industry, when mass production prevailed over workmanship. Artists such as Gallé, Lalique and Majorelle became the prisoners of their own success and then saw their work discredited by facile imitations.

It is not surprising that, only ten years or so after it became the Modern Style, Art Nouveau had come to be regarded as precious and even, quite unjustly, vulgar. This rapid decline was closely bound up with the public's loss of interest in Symbolist painting and poetry. In his book *Dreamers of Decadence* the author has compared Symbolist art, which blossomed at the end of the 1880s, to an enclosed garden where the 'souls' wounded by the materialist, mechanized nineteenth

century found a refuge, a place where they could dream. Half-tints and blurred lines evoked a world of fantasy. Music enjoyed pride of place. The artists who were elaborating Art Nouveau went to this garden to seek inspiration; they had found the principles of their art in the works of William Morris, the Japanese and Viollet-le-Duc. Their preoccupations tended to be scientific, however, whereas the Symbolists had been fascinated by metaphysics. The creators of Art Nouveau were sustained by what Schmutzler so appropriately called 'biological romanticism'. They were also socially committed. Architects such as Van de Velde and Guimard were directing their energies to the city of the future and their experiments reflected a kind of socialism; the gospel of Work had come from the world of Zola. The Symbolists, on the whole, had remained unconcerned with such matters; they had been seeking inner essences, while Art Nouveau was above all a surface art which adapted itself quite easily, like a climbing plant, to forms alien to it. The very fact that, at the exhibition of 1900, it had such vast surfaces to cover resulted in a proliferation of forms that eventually came to seem parasitic, for the stylized interlacings and plants were often applied to buildings designed by exponents of Historicism, transient structures, some of them delightful, which are now described as Neo-Rococo and which were imitated by the architects of tea-rooms and private mansions. Thus, the interlacings and irises that seemed the epitome of refinement in the Solvay mansion designed by Van de Velde were soon considered facile in a casino; they went out of fashion almost as quickly as a woman's hat.

The evolution of styles from the exhibition of 1900 to the bare Decorative Arts style, Art-Deco, seen at the Exhibition of Decorative Arts in 1925 can be traced in the exhibitions that immediately followed the Paris exhibition. Simplicity prevailed; the straight line replaced the spiral and stylization was further simplified. This lesson in simplicity had come, as has been seen, from the German and Austrian decorative sections of the Paris exhibition. It could be said that the first building in the Decorative Arts style was Olbrich's Secession pavilion erected in Vienna in 1899. The lesson had been understood as early as the Turin exhibition of 1902, in Raymondo d'Aranca's rotunda which foreshadowed the railway station in Milan

(the rest of this exhibition, however, marked the triumph of the short-lived, over-loaded 'Liberty style'). Straight lines were to be found also in the architecture and decoration of Mackintosh in Glasgow. At the Darmstadt exhibition of 1907 the straight line predominated in all Olbrich's buildings. In 1900 only Saarinen's pavilion had represented a modern art that went beyond Art Nouveau. The first houses designed by Perret show that, although he followed certain principles of Art Nouveau, he rejected everything that might suggest that style in his decoration; here, again, the straight line prevailed.

After 1910 the fashion set by the Russian Ballet soon caused the pale delicacies of Art Nouveau to melt like water-ices in the sun. The Modern Style, which the French, in their hatred of Germany, called the 'Munich style', continued to deform everyday objects and to cover wallpapers and plaster friezes with arbitrary stylizations; in short, bad taste had triumphed together with its customary accomplice, sentimentality. Today these two characteristics are bringing the decadent, industrialized phase of Art Nouveau, the flotsam of which can be found at the flea-market and in the shops of fashionable antique-dealers, a renewed favour under the name of *kitsch*. This word means both comical and touching, ridiculous and erotic, and the use of the female body in ash-trays or in bedside lamps by the disciples of Chalon and Roche is a typical example. The pictures on calendars and in the Christmas numbers of the leading magazines were caricatures of Symbolist paintings, and sometimes the work of the same artists who, in their youth, had created the poetic originals. Indeed, the Paris exhibition of 1900 is a gold-mine for the collector of *kitsch*, for it offered all the naïveties of eroticism and patriotism.

But *kitsch* was merely a caricature sketched by a great painter in the margin of a canvas, the bizarre detail in an imposing composition. If one were to paint an allegory of the Paris exhibition, in the manner of the artists who decorated its pavilions, one would imagine a woman such as the 'Parisienne' on the Porte Binet, endowed with all the discoveries of the nineteenth century and dressed in the ravishing garments of an ephemeral fashion, holding out her arms to the twentieth century and illuminated by the new energy, Electricity.

ACKNOWLEDGEMENTS

Most of the illustrations are taken from contemporary magazines, but the publishers would also like to thank the following for kindly giving permission for the reproduction of works in their possession:
John Jesse, Esq., London (1); R.I.B.A., London (3); Museum für Kunst und Gewerbe, Hamburg (49, 63, 69, 89, XVI); Musée des Arts Décoratifs, Paris (72–3, 76, 79, 88, VIII, IX–XI, XIV, XV); M Robert Walker, Paris (85); Mlle Yvette Barran, Paris (86); Bibliothèque d'Art et d'Archéologie, Paris (91); Musée Rodin, Paris (95–7); Galleria Nazionale d'Arte Moderna, Rome (92, 98); Museum of Fine Arts, Berne (93); National Portrait Gallery, London (94); M Ladeuille, Paris (102); M Jullian, Paris (121); M Juven, Paris (122); Cappiello Collection (125); Musée de l'École de Nancy (XII); Musée de Rouen (XIII).

Sources of photographs where not supplied by the above are as follows:
Phaidon archives (1, 95–7); R. Lalance, Paris (4–9, 11–14, 18, 24, 31–4, 36–48, 50–62, 64–8, 70–1, 74–5, 77–8, 80–4, 87, 90, 99–114, 116–21, 123–7, I–XI, XIV); Alekan, Paris (10, 15–17, 19–23, 25, 28–30); Roger-Viollet, Paris (26–7, 35, 115); Christie, London (85); J-F. Ferré, Paris (86); Hélène Adant, Paris (88); Snark International, Paris (91); Alinari, Rome (92); Atelier Photo Chadefaux et Basnier, Paris (122, XV); Giraudon, Paris (XII).

INDEX